ART AND THE PUBLIC SPHERE

ART AND THE PUBLIC SPHERE

EDITED BY W. J. T. MITCHELL

The University of Chicago Press

Chicago and London

The essays in this volume originally appeared in various issues of *Critical Inquiry*. Acknowledgment of the original publication date may be found on the first page of each essay.

The University of Chicago Press, Chicago, 60637
The University of Chicago Press, Ltd., London
© 1990, 1991, 1992 by the University of Chicago
All rights reserved. Published 1992
Printed in the United States of America
ISBN (cl.) 0-226-53210-0
ISBN (pa.) 0-226-53211-9

96 95 94 93 92 5 4 3 2 1

Library of Congress Cataloging-in-Publication Data

Art and the public sphere / edited by W. J. T. Mitchell.
 p. cm.
 Essays previously published in the journal Critial inquiry.
 Includes bibliographical references.
 ISBN 0-226-53210-0 (cloth). — ISBN 0-226-53211-9 (pbk.)
 1. Public art—Public opinion. I. Mitchell, W. J. Thomas, 1942–.
N8825.A76 1992 92-32387
701'.03—dc20 CIP

Contents

Introduction: Utopia and Critique

W. J. T. Mitchell

It is no longer news to see art in the news. Controversies over public support and reception of the arts have become a staple of the mass media in the late twentieth century. In the U.S., cultural institutions like the National Endowment for the Arts and the National Endowment for the Humanities, principal sponsors for state-supported production of and research in the arts, have been targeted for political takeovers by right-wing political interests.[1] Monumental expressions of American national mourning like the Vietnam Veterans Memorial and the AIDS Quilt have focussed public controversy and private emotion with an intensity unheard of in "public art" projects.[2] In Germany, the memorializing of the Holocaust in public monuments has involved unprecedented levels of complexity and public debate over the general role of art in public places and the specific responsibility of a nation to remember its own shame. In Europe more generally, the collapse of the communist regimes in the late 1980s was visibly enacted for international media audiences in the ritual demolition of the monuments of Marxism-Leninism. The Berlin Wall, for so many years the site of "unofficial" images of public art in the form of graffiti and unauthorized murals, became at the fall of the East German

1. On the takeover of the NEH, see Stephen Burd, "Chairman of Humanities Fund Has Politicized Grants Process, Critics Charge," *The Chronicle of Higher Education*, 22 Apr. 1992, pp. A1, A32–A33. On the NEA, see Judith T. Phair, "The Battle for Support: Pro and Anti-NEA Forces Wage Grass-Roots Campaign," *Public Relations Journal* (Aug. 1990): 18–36.

2. See Charles Griswold's essay on the VVM in this volume, and Jeff Weinstein, "Names Carried into the Future: An AIDS Quilt Unfolds," in *Art in the Public Interest*, ed. Arlene Raven (Ann Arbor, Mich., 1989), pp. 43–53.

government both an object to be smashed and a repository of trophies for both public and private commemoration. In China, the rise and fall of the democracy movement in May of 1989 was displayed as a media spectacle for the West in the erection and destruction of the "Goddess of Liberty." Even in the relatively cloistered spaces of the School of the Art Institute of Chicago, a student project to appropriate the American flag for a work of conceptual art became a national scandal that provoked calls for a constitutional amendment to protect the flag from disfiguration.

It is obvious, of course, that each of these events has occurred in a distinct cultural space, each with its own specific history and political determinants, and there is no sense in trying to reduce them to a single historical cause. At the same time, there is no denying the fact that their juxtaposition in historical time and in the experiential spaces of mass audiences has been one of the most salient facts of international visual culture in our time. The proximity, importance, and visual impact of these events has, at the very least, raised anew some of the fundamental questions about art and the public sphere: What is the "public," for art or for anything else? Is there any such thing as a public sphere in the cultures of late capitalism? Are we witnessing the liquidation of the public sphere by publicity, the final destruction of the possibility of free public discussion, deliberation, and collective determination by a new culture of corporate, military, and state media management, and the emergence of a new world order in which public art will be the province of "spin doctors" and propagandists? Or does the internationalization of global culture provide opportunities for new forms of public solidarity to emerge, and leave openings for the intrusion of new forms of public resistance to homogenization and domination?

If traditional studies of "public art" might be characterized as inquiries into the relation of beauty and bureaucracy, the subject of this book might be thought of as the relation between beauty and publicity. This book is not just about public art in the traditional sense—that is, art that is commissioned, paid for, and owned by the state. Instead, the contributors to this volume have addressed themselves to a set of issues that seem at once more enduring and more timely: the problem of artistic production and spectatorship in relation to changing and contested notions of the public sphere. That does not mean that state-sponsored art or the relation of artists to various forms of public authority is irrelevant; only that it does not provide the theoretical or practical horizon of inquiry. If public art, as Arlene Raven has suggested, "isn't a hero on a horse anymore,"[3] that is not only because of changes in artistic practice, but because the conditions and possibilities of public life, its relation to privacy, to professions, to secrecy, to what are called "special interests" or "partial publics," and (above all) to the power of publicity, have undergone such profound and varied trans

3. Raven, introduction, *Art in the Public Interest*, p. 1.

formations in the late modern era. One way to put this is to say that it is not just "art" that has a "history" for which other histories form an explanatory context or background. The very conditions that allow art to come into being—the sites of its display, circulation, and social functionality, its address to spectators, its position in systems of exchange and power—are themselves subject to profound historical shifts.

The unavoidability of the public sphere as a general issue for the arts, an issue that goes well beyond "public art" in the narrow or traditional sense, is thus the unifying agenda of these essays. Within this agenda, however, a dialectic emerges between what I will call "utopian" and "critical" relations between art and its public: on the one hand, art that attempts to raise up an ideal public sphere, a nonsite, an imaginary landscape (we might imagine here the classical image of a temple entrance or plaza filled with wise women and men engaging in enlightened discourse); on the other hand, art that disrupts the image of a pacified, utopian public sphere, that exposes contradictions and adopts an ironic, subversive relation to the public it addresses, and the public space where it appears. These alternatives are not, of course, mutually exclusive. The "utopian" image, for instance, may well have a critical relation to the world it negates; the explicitly critical, disruptive, or satiric work may, at certain moments, open up a site of public experience that approximates universal inclusiveness and collective emotion.

Many of the artistic and critical gestures discussed in this volume attempt to locate the convergence of the utopian and the critical, the intersection of aesthetic disinterest and the most violent and passionate expressions of public and private interest. The Vietnam Veterans Memorial, for instance, seems perfectly poised between utopia and critique: it can be experienced both as an object of national mourning and reconciliation that is absolutely inclusive, embracing, and democratic, and as a critical parody and inversion of the traditional war memorial. Richard Serra's *Tilted Arc* can be seen as a classic instance of the high modernist transformation of a utilitarian public space into an aesthetic form (with predictable reactions from the philistines), or as a signal that modernism can no longer mediate public and private spheres on its own terms, but must submit itself to social negotiation, and anticipate reactions ranging from violence to indifference.

Public art "proper," whether the hero on the horse or the abstract ornament in the urban corporate plaza, may well be a historical anomaly or a contradiction in terms. As anomaly, it manifests a utopian ideal, what Jürgen Habermas has called "the bourgeois public sphere," an all-inclusive site of uncoerced discussion and opinion formation, a place that transcends politics, commerce, private interests, and even state control.[4] As

4. See Jürgen Habermas, *The Structural Transformation of the Public Sphere: An Inquiry into a Category of Bourgeois Society*, trans. Thomas Burger (Cambridge, Mass., 1989). See also

contradiction, its function is, in Vito Acconci's words, "to de-design . . . like a wart, on a building . . . like a leech to an empty wall . . . like a wound" or "a burrow or a foxhole or a lair." This realistic, critical, anti-utopian view of public art as something that "comes in through the back door like a second-class citizen" is what makes possible, in Acconci's view, its function as "the voice of marginal cultures, as the minority report, as the opposition party."[5] To this I would add only that the pulling down of public art is as important to its function as its putting up. Utopia and contradiction are not alternative functions of public art, but different ways of describing its actual marginality and impossibility, its minority status, while indicating its imaginary centrality and possibility as a site for critical performance. The fundamental message of this book, then, is the forcing of a basic choice in the way we think about art and the public sphere: either there is no such thing as public art, or all art is public art.

The contributors to this volume include both artists and critics, historical scholars and theorists. The "fields" covered range from the phenomenology of the public memorial to the legal intricacies of state-sponsored art. Critical and historical topics include the relations of public art and cinema, antifascist memorials, urban garbage receptacles, and skypoems. Artistic proposals range from large-scale utopian landscape and architectural projects, to the place of "marginal" and "minority" interventions in public places. Speculative architectural concepts are juxtaposed with real-world controversies about the conflicting rights and interests of artists and the various "publics" they address. The aim is not comprehensiveness, but a provocation to rethink the conceptual and physical locations of art and its possible publics, and to connect these with the momentous cultural transformations that are remaking the social orders of the present, while reconfiguring our understanding of the past.

Art and the Public Sphere originated with a special issue of *Critical Inquiry* on "Public Art" based on a symposium, "Art and Public Spaces: Daring to Dream," organized for Sculpture Chicago by John Hallmark Neff in August 1989. The contributors to that issue included Neff, Michael North, W. J. T. Mitchell, Vito Acconci, Agnes Denes, and Ben Nicholson. That issue has been augmented by later contributions to *Critical Inquiry* by Barbara Kruger, Richard Serra, Barbara Hoffman, James Young, and David Antin, and an earlier contribution by Charles Griswold, all of which are reprinted here, and by the contribution of Virginia Maksymowicz, which is published here for the first time. I'm grateful for the advice and encouragement of many friends and colleagues in this proj-

Richard Sennett, *The Fall of Public Man* (New York, 1976), and Oskar Negt and Alexander Kluge, *The Public Sphere and Experience* (forthcoming).

5. Vito Acconci, "Public Space in a Private Time," pp. 000, in this volume.

ect, including Lauren Berlant, Bill Brown, Arnold Davidson, Miriam Hansen, Robert Morris, John Hallmark Neff, and Joel Snyder. I would also like to acknowledge the financial support we received from the Skidmore, Owings, and Merrill Foundation Institute (now the Chicago Institute for Architecture and Urbanism), and the people associated with SOMFI/CIAU, especially John Whiteman, Janet Abrams, Sonia Cooke, and Jane Allen. Finally, many thanks to the editorial staff of *Critical Inquiry:* James W. Williams, David Schabes, John O'Brien, and Jessica Burstein.

—W. J. T. Mitchell

Daring to Dream

John Hallmark Neff

In the absence of shared beliefs and even common interests, it should not be surprising that so much of the well-intentioned art acquired for public spaces has failed—failed as art and as art for a civic site. The conventional wisdom of simply choosing "the best artist" and then turning him or her loose to create a work within time and budget guidelines lost much credibility with the drama of Richard Serra's *Tilted Arc* commission: the process of selection, erection, litigation, rejection, and removal of the sculpture from the Federal Building plaza in New York City. The new conventional wisdom? The jury, not the artist, was ultimately responsible. For Serra did precisely the kind of work for which he is respected worldwide but in a context and for a specific public whose requirements, in their view, were not met but even abrogated by what Serra had done so well: made a Serra.

The issues raised by this particular controversy as well as by the very different response now accorded the once-controversial Vietnam Veterans Memorial by Maya Lin, together with firsthand frustration with the selection process for public commissions, were some of the specific reasons for organizing the day-long symposium held 16 September 1989 in First Chicago Center under the auspices of Sculpture Chicago, a biennial exhibition and educational series.

The apparent inability of either the public client or the art world selection panels to present a legible, self-critical program for public art suggested that those involved in the selection process needed to draw from outside sources for fresh ideas. Hence the invitations to Michael North and W. J. T. Mitchell for papers that would go beyond the usual

Critical Inquiry 16 (Summer 1990)

fare of such symposia. Their papers confront the unavoidable questions: what role, if any, could "art" play in a public context today? Are "monuments" and "memorials" really possible within the alleged vacuum of mutually respected beliefs? Is it possible for sculpture or even site-specific work to avoid the obsolesence of supposedly "public" art if the work has no intellectual or contextual resonance beyond itself? Is artwork in public venues justified at such a low level of ambition?

Artists Agnes Denes and Vito Acconci and architect Ben Nicholson were also invited to speak. They have histories of asking hard questions, of demanding more from art than formal perfection, and of a broad and continued interdisciplinary interest. For Acconci, his roots in poetry and performance, and his early installation and temporary "works" in museums and public places have recently led to a number of permanent commissions; much of his work, however, remains on paper. For Denes, whose earthworks, books, drawings, and prints reveal her philosophical as well as scientific interests, most but not all of her comprehensive proposals remain dreams, a hypothetical public sculpture of the future realizable today. For Nicholson, the already-blurred line between architects and artists nearly vanishes in his drawings for buildings that contain the narrative and critical symbols one associates today with sculpture and photographic installations. His participation resulted from a casual remark in conversation about a televised interview with a brave priest who used his robes to shelter children from sniper fire in the middle of the Cabrini-Green housing project, an incident that led Nicholson to ask himself: why shouldn't architecture play a similar role in society? For all three artists the issues of public art go far beyond aesthetics and require an openness to possibilities, not the least of which is daring to dream.

Given the current practice and group dynamics of the public art selection process, the possibilities offered by these contributors are guaranteed no hearing by those who make the final decisions. In a remarkably short time, a jury is asked to negotiate the mental, social, and physical parameters of a public commission. Because juries must also address the practicalities of funding and legal and contractual detail, by the time artists are discussed and selected the commission is often fatally compromised. Too little time is spent in dreaming, in

John Hallmark Neff, director of The First National Bank of Chicago's art program, is a former director of the Museum of Contemporary Art, Chicago. He is the author of *Anselm Kiefer: Brüch und Einung* (1988), and he is currently working on a book on Max Neuhaus and a catalogue essay for the forthcoming Agnes Denes retrospective exhibition.

brainstorming, in kicking around what may seem to be hopelessly impractical, even nonsensical, ideas. Instead, the negotiation between the potential work of art and the "situation" begins with half the store given away. The selection process begins not on the level of strategies but on the level of tactics, of reasons to say no.

The premise of the symposium was a simple one: to use this session as an opportunity to step back from the mechanics of public art and dream. Wasn't it time to risk dreaming again, dreaming in the spirit of Bloch's practical utopianism in order to reconceptualize the possibilities of works of art within the social and political arena? The following papers provide the potential patron or selection panel with a useful alternative for their deliberations: the beginnings of a new theoretical as well as practical basis for rethinking what public art could be. In very different ways the papers remind us that there is no credible substitute for the imagination. They affirm that the process of commissioning public art must begin with dreams.

The Public as Sculpture: From Heavenly City to Mass Ornament

Michael North

The most notable development in public sculpture of the last thirty years has been the disappearance of the sculpture itself. Ever since Jean Tinguely's *Homage to New York* destroyed itself at the Museum of Modern Art in 1960, sculptors have tried to find new ways to make the sculptural object invisible, immaterial, or remote. Where the sculpture did have some material presence, it often took unexpected forms. As Rosalind Krauss says, "Rather surprising things have come to be called sculpture: narrow corridors with TV monitors at the ends; large photographs documenting country hikes; mirrors placed at strange angles in ordinary rooms; temporary lines cut into the floor of the desert."[1]

However various these experiments may seem, they began with a single motive: to escape the constraints of the pedestal, the gallery, and finally of art itself. To prevent this new work from becoming just another commodity in the market, artists either produced works so intangible or remote they could not be bought and sold, or disseminated their ideas in so many reproducible forms they could not be

1. Rosalind E. Krauss, *The Originality of the Avant-Garde and Other Modernist Myths* (Cambridge, Mass., 1985), p. 277. For the Tinguely sculpture, see Henry M. Sayre, *The Object of Performance: The American Avant-Garde since 1970* (Chicago, 1989), p. 3. For other examples see the list compiled in Lucy R. Lippard, *Changing: Essays in Art Criticism* (New York, 1971), pp. 261–64. Lippard played a role in a major debate over the "dematerialization of art" that also included Harold Rosenberg's *The Anxious Object: Art Today and Its Audience* (New York, 1964), and Michael Fried's "Art and Objecthood," *Artforum* 5 (June 1967): 12–23.

Critical Inquiry 16 (Summer 1990)

monopolized.[2] The political nature of these motives also meant that much of this "sculpture" could be considered "public." Changing the nature of the art meant changing the role of the audience as well, questioning the purely contemplative role the observer plays in the conventional setting of the museum or gallery. According to Henry Sayre, "As the avant-garde work of art denies its own autonomy, it implicates the audience in its workings."[3] As the aesthetic focus shifts from the object to the experience it provokes, the relationship of the two goes beyond mere implication: the public *becomes* the sculpture. Artists, like Richard Serra, whose goal is to illuminate the material nature of space and the often tenuous materiality of the observer's own body, have made "the viewer, in effect, the subject of the work," to quote Douglas Crimp.[4]

This idea, that sculpture becomes public by taking the spatial experience of its audience as a subject, is so seductive it has influenced everything from Serra's steel fortresses to the benign and cheery works featured in many shopping malls. If anything unifies the whole range of contemporary sculpture from minimalism to the political agitation of Krzysztof Wodiczko, it is the idea enunciated best by Krauss, that contemporary sculpture takes as its subject "the public, conventional nature of what might be called cultural space."[5] The shift Krauss describes from the inner space of the artist's psyche to the exterior space of public convention dissolves the old opposition between artist and audience and makes all sculpture potentially public. The gap

2. For a discussion of this motive and the works emanating from it, see Barbara Rose, *American Art since 1900*, rev. ed. (New York, 1975), pp. 222–23, 274–84. The earthworks of the late sixties and early seventies exemplify both tactics, since these huge constructions could rarely be visited and were therefore only available in the form of documents. The two aspects of the earthwork are related dialectically: the actual construction is far more precious, unique, and removed from use than a conventional painting or sculpture, but these qualities are disseminated in forms that undermine them by subjecting them to reproduction, often in temporary media. For all this, as Lippard has pointed out, " 'temporary, cheap, invisible, or reproducible art has made little difference in the way art and artist are economically and ideologically exploited' " (quoted in Sayre, *The Object of Performance*, p. 15).

3. Sayre, *The Object of Performance*, p. xiv.

4. Douglas Crimp, "Serra's Public Sculpture: Redefining Site Specificity," in Krauss, *Richard Serra / Sculpture* (exhibition catalog, Museum of Modern Art, New York, 27 Feb.–13 May 1986), p. 43. See also Krauss's essay, "Richard Serra/Sculpture," p. 28.

5. Krauss, *Passages in Modern Sculpture* (New York, 1977), p. 270.

Michael North is associate professor of English at the University of California, Los Angeles. He is the author of *The Final Sculpture: Public Monuments and Modern Poets* (1985) and is currently completing a study of the politics of Yeats, Eliot, and Pound.

between art and audience is closed by bringing the audience into the art, by making spatial experience the very subject of the art. In this way, contemporary sculpture promises to overcome the conflicts that have jeopardized the very idea of public art, and yet the old controversies over public sculpture continue to be replayed. If the motive of contemporary sculpture is that of "'actively bringing people into a sculptural context,'" as Serra says of *Tilted Arc*, why does so much of the public still feel walled out?[6]

Some answers might emerge if we consider the long history of the metaphor of the public as sculpture. Even postmodern works evoke this history, though perhaps without knowing it. For example, at Documenta 7 in Kassel in 1982, Joseph Beuys exhibited a massive work called *7000 Oaks*, which consisted of seven thousand large basalt stones arranged in a triangular pile pointing to a single oak tree. Individuals or organizations were to buy this pile, stone by stone, and in so doing sponsor the replanting of Kassel, one oak for every stone. This work dramatically realizes the disappearance of the sculptural object, since it would in fact vanish, bit by bit, in the process of being bought.[7] It also illustrates in its workings the replacement of that object by the audience, for the real work of art here is the community's replanting of Kassel. Though Beuys was certainly interested in the trees, his real purpose was to awaken individuals to community action and thus to make what he called "'social sculpture.'"[8] The disorderly pile of stones would give way gradually to a coherent social structure, to what Beuys called elsewhere "'social architecture,'" in which each individual would take the place of a single stone.[9]

Given Beuys's well-known religiosity, it is entirely possible that he is consciously evoking the biblical prototype of his two metaphors, social sculpture and social architecture. The most succinct version is to be found in 1 Peter: "Come to him, to that living stone, rejected by men but in God's sight chosen and precious; and like living stones be yourselves built into a spiritual house" (1 Pet. 2:4–5). The metaphor is most

6. Quoted in Grace Glueck, "Serra Work Stirs Downtown Protest," *New York Times*, 25 Sept. 1981, sec. 3, late city edition.

7. In his account of the work, Andreas Huyssen calls it an "art for vanishing." He emphasizes the difference between this work and those protectively enclosed in the galleries of Documenta 7 (Huyssen, *After the Great Divide: Modernism, Mass Culture, Postmodernism* [Bloomington, Ind., 1986], p. 179). He apparently did not witness Beuys's rage when the pile was spray-painted bright pink. See Noel Frackman and Ruth Kaufmann, "Documenta 7: The Dialogue and a Few Asides," *Arts Magazine* 56 (Oct. 1982): 91–97.

8. Quoted in Eric Michaud, "The Ends of Art according to Beuys," trans. Krauss, *October*, no. 45 (Summer 1988): 41. See also p. 44, and Stefan Germer, "Haacke, Broodthaers, Beuys," *October*, no. 45 (Summer 1988): 68.

9. Götz Adriani, Winfried Konnertz, and Karin Thomas, *Joseph Beuys: Life and Works*, trans. Patricia Lech (New York, 1979), pp. 225, 257.

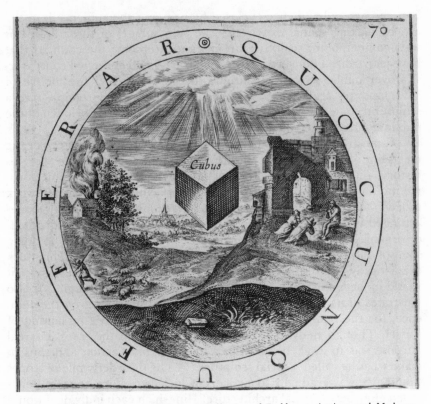

FIG. 1.—From George Wither, *A Collection of Emblemes, Ancient and Moderne* (1635). Photograph courtesy of the Department of Special Collections, University Research Library, University of California, Los Angeles.

fully elaborated by Paul in his letters to the troubled congregations of the early church. In his epistle to the Ephesians, Paul tells his readers they "are no longer strangers and sojourners," but "fellow citizens with the saints and members of the household of God built upon the foundation of the apostles and prophets, Christ Jesus himself being the cornerstone, in whom the whole structure is joined together and grows into a holy temple in the Lord; in whom you also are built into it for a dwelling place of God in the Spirit" (Eph. 2:19–22; see also 1 Cor. 3:9). Paul uses the metaphor of the congregation as a building, with the individual as a single stone, to compose a miscellaneous gathering of converts into a single church and to give hope to the spiritually and politically homeless by linking their church to the chosen people of the Old Testament. The congregation, which at this stage may not have had a physical building at all, becomes a figurative building and finally a metaphor of the Heavenly City.

In early Christian writing, therefore, the metaphor was used to define what Augustine called *civitas:* " 'a multitude of reasonable beings

voluntarily associated in the pursuit of common interests.'"[10] In this form, it became a commonplace of devotional writing, appearing in standard emblem books through the seventeenth century. For example, George Wither's *Emblemes* (1635) depicts a foursquare cubic stone hovering in space and below it a poem that concludes:

> *Lord*, let us into such like *Stones* be squar'd:
> Then, place us in thy spirituall *Temple*, so,
> That, into one firme *Structure*, we may grow.[11]

Naturally, the metaphor was put to good use whenever actual building projects had to be consecrated. When Abbot Suger, who directed the building of St.-Denis, the first Gothic cathedral to be completed, wanted to sanctify his construction, he turned to Ephesians 2:19.[12] Three centuries later, the great building projects of Pope Nicholas V were accompanied by versifications of the same passage, including a poem by Cardinal Juan de Torquemada that depicted the congregation as a building whose "walls are faith made up of stones that are squared and solid."[13]

In his work, Beuys implicitly appeals to this Christian ideal of a communitarian social structure exemplified by a beautiful building in which each stone is necessary to the whole. But the Abbot Suger and Pope Nicholas V were also using the metaphor of the congregation as a building to legitimate their power as social architects.[14] When the metaphor was adapted to secular building projects, its repressive possibilities became fully apparent. Around 1460, Filarete composed a treatise on architecture addressed to Francesco Sforza in which a great prince tells his heir, "'A domain is like a wall made of many and various *ragioni* (orders) of stones. . . . As it is necessary for you to maintain all the qualities of stone in this wall, so it is necessary for you to maintain

10. Quoted in James Dougherty, *The Fivesquare City: The City in the Religious Imagination* (Notre Dame, Ind., 1980), p. 24. See Augustine, *City of God*, bk. 19, sec. 24. For Augustine's use of Ephesians 2:19, see Otto von Simson, *The Gothic Cathedral: Origins of Gothic Architecture and the Medieval Concept of Order*, 2d ed. (New York, 1962), p. 130 n. 103.

11. George Wither, *A Collection of Emblemes, Ancient and Moderne* (1635; Columbia, S.C., 1975), p. 228. For other instances of this emblem, see the entry under "Cubus" in Arthur Henkel and Albrecht Schöne, *Emblemata: Handbuch zur Sinnbildkunst des XVI. und XVII. Jahrhunderts* (Stuttgart, 1967), pp. 7–8. See also the discussion of Wither's emblem in William A. McClung, *The Architecture of Paradise: Survivals of Eden and Jerusalem* (Berkeley, 1983), pp. 54, 61. McClung notes the relevance of the emblem to the Heavenly City of Revelation 21, but it is obvious that Wither's verse is a virtual paraphrase of Ephesians 2:19.

12. See von Simson, *The Gothic Cathedral*, p. 130.

13. Carroll William Westfall, *In This Most Perfect Paradise: Alberti, Nicholas V, and the Invention of Conscious Urban Planning in Rome 1447–55* (University Park, Pa., 1974), p. 55.

14. See, for example, von Simson, *The Gothic Cathedral*, p. 140.

and to preserve all your people according to their quality. . . . See to it that you are the master and the architect of this wall.'"[15] Here the metaphor confirms the power of a secular master and maintains the boundaries between the ranks below him. The logical end of this version of the metaphor was reached three centuries later, when Giambattista Vico reinterpreted the ancient story in which the music of Amphion charms actual stones into forming the walls of Thebes. Vico read the story allegorically, with Amphion in the role of an ancient king and the stones as what he called "the doltish plebeians."[16] In the course of time, the emblem of Christian community had become an allegory of despotism.

Something of this historical ambiguity survives in Beuys's work, exposing an ambiguity in the contemporary metaphor of the public as sculpture. Almost from the beginning of his tenure as professor of monumental sculpture at Düsseldorf, Beuys made workshops and conferences part of his art. Rather than erecting monuments, Beuys seriously intended to make the people into a monument, a social work of art, one that would be constructed by each individual as "'sculptor or architect of the social organism.'" At the same time, he said these individual efforts were to result in the "'TOTAL ART WORK OF THE FUTURE SOCIAL ORDER.'"[17] How individual freedom is to be squared with the totality of the social system, how there might be many architects or sculptors of a single total work, Beuys left to the imagination of his audience. But the implications of the Total Work of Art, suggesting the complete integration of each detail into the whole, seem to conflict with Beuys's overt message of freedom. As history shows, the metaphor of the public as sculpture contains both possibilities, community solidarity on one hand and autocracy on the other.

The role of the metaphor in modern politics has been equally ambiguous. In the *Social Contract*, Jean-Jacques Rousseau used the metaphor of the public as a building to argue that laws must conform to the common sense of the people, who are the "immovable keystone" of that building.[18] In 1830, Charles Duveyrier combined Rousseau's build-

15. Quoted in Westfall, "Chivalric Declaration: The Palazzo Ducale in Urbino as a Political Statement," in *Art and Architecture in the Service of Politics*, ed. Henry A. Millon and Linda Nochlin (Cambridge, Mass., 1978), p. 39. According to Westfall, Filarete puts these words in the mouth of Francesco, but he does so only by means of a complicated allegorical ventriloquism involving a golden book about a prince who very much resembles Francesco. See *Filarete's Treatise on Architecture*, trans. John R. Spencer, 2 vols. (New Haven, Conn., 1965), 1:288.

16. *The New Science of Giambattista Vico*, trans. Thomas Goddard Bergin and Max Harold Fisch (Ithaca, N.Y., 1968), p. 44.

17. Quoted in Caroline Tisdall, *Joseph Beuys* (New York, 1979), pp. 268, 269.

18. Jean-Jacques Rousseau, *On the Social Contract*, trans. and ed. Donald A. Cress (Indianapolis, 1987), p. 48. See also bk. 2, chap. 12.

ing with his other common symbol of the people, the body politic, to form a gigantic statue of liberty, which was not merely to inspire the people but actually to contain them.[19] Duveyrier's project for a new French capital included a colossal temple in the shape of a woman whose flowing robes were to house galleries, theaters, and promenades. That the polity could be represented as a single gigantic individual indicated the respect for individual rights on which it rested. That this huge individual could also contain the multitude showed symbolically that this respect for individual rights was in fact the principle that unified the citizenry. When the Washington Monument was dedicated in 1885, Robert C. Winthrop praised the obelisk in similar terms, noting that it was not a monolith but a composite of many individual blocks and thus could symbolize "'our cherished National motto, E PLURIBUS UNUM.'"[20] Here, in these usages evocative of the great revolutions of the eighteenth century, the metaphor of the citizen as building block of the social sculpture loses for a moment its repressive implications because the whole is but the part made great.[21]

Thus the aesthetic avant-garde of the early twentieth century could make the metaphor part of a call for a new revolution and a new visionary utopia. In Germany, on the eve of the First World War, Bruno Taut proposed a Cathedral of the Future, a communitarian symbol that became a kind of trademark of the Bauhaus.[22] In calling for new, secular, revolutionary cathedrals in which the people would become "'organic members [Glieder] of a great architectural structure,'"[23] Taut returned to the very metaphor that had sanctified the Gothic cathedral itself. This belief, that society might be regenerated by making its members parts of a great work of art, was so strong that

19. See Maurice Agulhon, *Marianne into Battle: Republican Imagery and Symbolism in France, 1789–1880*, trans. Janet Lloyd (Cambridge, 1981), p. 57. A whole history of this particular version of the metaphor of the public as sculpture might be written, from Alexander's plan to turn the cape of Athos into an inhabitable city-statue (see Ernst Bloch, *The Utopian Function of Art and Literature: Selected Essays,* trans. Jack Zipes and Frank Mecklenburg [Cambridge, Mass., 1988], p. 191) to Corbusier's anthropomorphic plan for Chandigarh. This history would perhaps center on the Neoplatonic idea, found in Ficino and Pico, that the world is itself a statue, sculpted by God.

20. Quoted in Charles L. Griswold, "The Vietnam Veterans Memorial and the Washington Mall: Philosophical Thoughts on Political Iconography," *Critical Inquiry* 12 (Summer 1986): 716 n. 9.

21. As Wassily Kandinsky puts it, "raising marble is evidence that a number of men have reached the point where the one they would now honour formerly stood alone" (Kandinsky, *Concerning the Spiritual in Art* [1912; New York, 1964], p. 27).

22. See Marcel Franciscono, *Walter Gropius and the Creation of the Bauhaus in Weimar: The Ideals and Artistic Theories of Its Founding Years* (Urbana, Ill., 1971), pp. 91–99, and Hans M. Wingler, *The Bauhaus: Weimar, Dessau, Berlin, Chicago* (1962; Cambridge, Mass., 1978), p. 31.

23. Quoted in Barbara Miller Lane, *Architecture and Politics in Germany, 1918–1945* (Cambridge, Mass., 1985), p. 49.

as late as 1944 another spokesman of the modern movement, Sigfried Giedion, could seriously hope for "collective emotional events, where the people play as important a role as the spectacle itself, and where a unity of the architectural background, the people and the symbols conveyed by the spectacles will arise."[24]

Giedion's formula for a new social art shows that at least some of the elements of postmodern art like that of Beuys were in fact pieties of modernism. But there is another, more gruesome irony in Giedion's statement. That he might have called in 1944 for "collective emotional events" in which people merge with the architectural background implies a certain political amnesia. For the Nazis had made such "collective emotional events" a key part of their domination of Germany. Films like Leni Riefenstahl's *Triumph of the Will* have preserved for all time the carefully orchestrated combination of massed crowds and heroic architecture that was Albert Speer's contribution to modern art.[25] The Nazi propaganda masters specialized in what Robert R. Taylor has called "'human architecture,'"[26] and it was Joseph Goebbels himself who gave our metaphor its most chilling modern expression: "'The statesman is an artist too. For him the people is neither more nor less than what stone is for the sculptor.'"[27]

Thus the utopian program of aesthetic modernism was realized in an ironic form by totalitarian governments. The audience entered the work of art, became the work of art, but only as what Siegfried Kracauer called "mass-ornaments," "human ornaments" that denote "the omnipotence of dictatorship."[28] But such human ornamentation was not only to be found in Nazi Germany. Kracauer originally used the term "mass ornament" in 1927 to describe the Tiller Girls, an American chorus line popular in Germany. For Kracauer, this form of dance, based on a simultaneous duplication of steps and gestures by an entire line of performers, represented the modern degradation of the individ-

24. Sigfried Giedion, "The Need for a New Monumentality," *Harvard Architecture Review* 4 (Spring 1984): 60. Though originally delivered in 1944, this talk remained unpublished until 1984.

25. According to John Elderfield, Speer's "Light Cathedral" of 1938 was a direct copy of Gabo's "Light Festival" of 1929 and a descendant of the Bauhaus Cathedral of the Future. See Elderfield's "Total and Totalitarian Art," *Studio International* 179 (Apr. 1970): 154.

26. Robert R. Taylor, *The Word in Stone: The Role of Architecture in the National Socialist Ideology* (Berkeley, 1974), caption to pl. 45. For discussions of the Nazi tendency to see "the German people themselves [as] architectural elements," see pp. 169 n. 49 and 163.

27. From Goebbels's novel *Michael* (1929). Quoted in Elizabeth M. Wilkinson and L. A. Willoughby's introduction to Friedrich Schiller, *On the Aesthetic Education of Man*, trans. and ed. Wilkinson and Willoughby (Oxford, 1982), p. cxlii.

28. Siegfried Kracauer, *From Caligari to Hitler: A Psychological History of the German Film* (Princeton, N.J., 1947), pp. 94–95, and quoted in Karsten Witte, "Introduction to Siegfried Kracauer's 'The Mass Ornament,'" *New German Critique* 5 (Spring 1975): 61.

ual into a mere cog in the social machine: in such spectacles, individual human beings "are mere building blocks, nothing more. The construction of an edifice depends on the size of the stones and their number. It is the mass which makes the impact. Only as parts of a mass, not as individuals who believe themselves to be formed from within, are human beings components of a pattern."[29] What Taut had dreamed of, a great edifice composed of individuals as building blocks, Kracauer saw already achieved in the regimentation of capitalism, which had merely to be radicalized to become the Nazi spectacle.

When Beuys called his work "social sculpture" or "social architecture," he perhaps should have trembled at the complexity of the historical and political background thus evoked. The similarity between his "social architecture" and the "human architecture" of the Nazis shows how ambiguous the relationship is between the avant-garde and power. In fact, the whole turn from sculpture-as-object to public-as-sculpture was anticipated by the governments of the West. In France, Germany, England, and the United States, there was a rage for commemorative statues that began in the last decades of the nineteenth century and peaked about 1914. After that time, according to Eric Hobsbawm, the emphasis shifted from statuary to great empty urban spaces in which massed crowds were to provide the aesthetic impact.[30] Government was, therefore, several decades ahead of the avant-garde in discovering that the audience could be given the role once assigned to the sculpture. The statue of democracy erected recently by the students in Tiananmen Square may have signified not just a taste for sculptural allegory but also the rebellion of the crowd against its own service as human sculpture in the square. The question facing artists like Beuys is how to keep the communitarian hopes and the revolutionary implications of the metaphor of social sculpture alive when the autocratic possibilities of the metaphor are so painfully realized.

The sharpness of this dilemma was made visible in a recent show at the Hirshhorn Museum and Sculpture Garden in Washington, a show that included works by Vito Acconci, Siah Armajani, Alice Aycock, Lauren Ewing, Robert Morris, and Dennis Oppenheim. Though the projects submitted were shown in museum space, at least four of the

29. Kracauer, "The Mass Ornament," trans. Barbara Correll and Zipes, *New German Critique* 5 (Spring 1975): 68.

30. Eric Hobsbawm, "Mass Producing Traditions: Europe, 1870–1914," in *The Invention of Tradition*, ed. Hobsbawm and Terence Ranger (Cambridge, Mass., 1983), p. 304. Hobsbawm draws an important distinction between spaces like the Ringstrasse in Vienna, which was to be read for its allegorical significance, and later spaces like Red Square in Moscow, the Sportpalast in Berlin, and the Vélodrome d'Hiver in Paris, which made their impact through human ornamentation. His analysis of sports events, public holidays, and monumental constructions parallels that of Kracauer. For statistics showing that the installation of commemorative statues reached a peak in the first decade of this century, see p. 164.

participating artists have either proposed or created similar works for outdoor public installation. In fact, Acconci's most recent show, at the Museum of Modern Art, was called "Public Places."[31] Most of the installations in the Hirshhorn show attempt to represent public places as well, thus illustrating how the relationship of sculpture to public space has been turned inside out. The sculpture is no longer an object installed in the center of a public space; public space has instead become the subject, and thus the centerpiece, of the sculpture.

Perhaps the most revealing of these works is Acconci's *Fan City*. As many as sixteen people work together to put this construction through its paces. As they manipulate it, nylon banners unfold to form a series of tents and an aluminum silhouette rises to the ceiling. On one hand, then, the piece seems to evoke revolutionary projects like Duveyrier's, in which collaboration results in the elevation of an ideal individual whose freedom is the principle that unifies the community. On the other hand, however, the banners reveal when unfurled a series of epithets: "Beggars," "Cripples," "Blacks," "Aliens," and so on. As Howard Fox says in his catalogue of the exhibition, in *Fan City* "everybody is an outcast."[32] Collaboration, in this case, produces division and thus negates itself. The aluminum figure may then represent a false ideal created by the expulsion of everyone who does not fit a predetermined stereotype.

The piece is apparently meant to criticize a kind of unacknowledged prejudice that is exposed when the viewer, despite his or her efforts, waves a banner bearing an offensive term. In this it resembles another Acconci piece, a swing surrounded by a collapsed house decorated with stars and stripes. When the viewer sits in the swing, the house rises into place, revealing to those outside, but not to the one inside, a hammer and sickle. In both cases, the viewer is made to wave the flag of a faith he or she may not share. Though these pieces rely on the viewer's initiative, and on collaboration between one viewer and others, the viewer is in fact entirely helpless in the hands of the sculptor. If these pieces are meant to expose the power of cultural stereotypes, they do so only by exerting the artist's power over the viewer. Acconci describes these works in terms of captivity or victimization: "By becoming active, the person becomes the victim of a cultural sign."[33] But the irony redounds on Acconci himself because it thwarts

31. See Brooks Adams, "Public-Address Systems," *Art in America* 76 (Oct. 1988): 162–67.

32. Howard N. Fox, *Metaphor: New Projects by Contemporary Sculptors* (exhibition catalog, Hirshhorn Museum and Sculpture Garden, Washington, D.C., 17 Dec. 1981–28 Feb. 1982), p. 33; hereafter abbreviated *M*.

33. Sylvère Lotringer, "Vito Acconci: House Trap," interview with Acconci, *FlashArt* 147 (Summer 1989): 127. According to Acconci, this interview was in fact conducted in the early eighties.

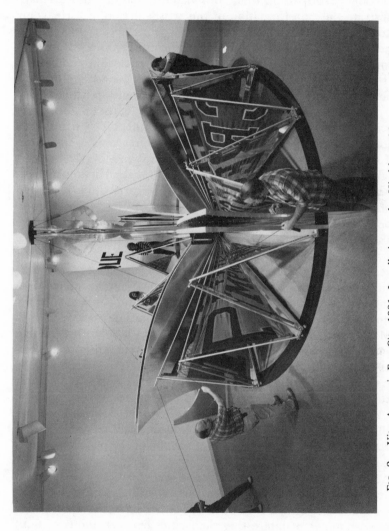

FIG. 2.—Vito Acconci, *Fan City*, 1981. Installation at the Hirshhorn Museum and Sculpture Garden, Smithsonian Institution, "Metaphor: New Projects by Contemporary Sculptors," 17 Dec. 1981–28 Feb. 1982.

his often-stated desire to achieve in his work "a community meeting-place."[34] As he says himself of some earlier work: "What I wanted was a meeting place; what I got was an altar-like adulation space with the artist as hero."[35] When the viewers pull the handles that open *Fan City,* they not only participate in their own victimization but also dramatically illustrate the transformation of the artist's dream of a Heavenly City into a space of mass ornamentation.

The rest of the Hirshhorn exhibition reveals in a variety of forms a very similar situation. Works that attempt to enclose a community within the space of the sculpture wind up looking almost like prisons. For example, only the most benign social values motivate the work of Siah Armajani. His goal is to build "'open, available, useful, low, near, common, public gathering places. Gathering places which are neighborly'" (*M,* p. 38). Thus he has specialized in artistic transfigurations of American vernacular forms such as log cabins, covered bridges, and Shaker meetinghouses. Armajani's project for the Hirshhorn exhibition was a lounge for the museum employees, carried out largely in bare pine. Nothing could be further, it seems, from the installation constructed by Lauren Ewing, who, like Alice Aycock, has been working for some time in fanciful representations of institutional buildings. Having already created a library and a powerhouse, Ewing installed at the Hirshhorn a Benthamite prison, in which a cylindrical guard tower and a bullhorn confront a curved cellblock. Ewing is interested in something called "'infrapsychic molding'" (*M,* p. 55), and this work vividly and simply represents the political situation Kracauer denounced in "The Mass Ornament." The identical cellblock windows bespeak the regimented uniformity of modern life, while the curved facade keeps each individual equidistant from the center of power, the upright guard tower, and thus within range of surveillance and propaganda. To enter Armajani's carefully disordered jumble of benches and stools is to inhabit a metaphor of the Heavenly City, where freedom and security magically coincide. To walk through the dead space between Ewing's guard tower and her cellblock is to become one of the mass ornaments of a totalitarian state.

Thus the Hirshhorn exhibition seems to juxtapose the two extremes that can be touched when the experience of public space becomes the object of art, when the public becomes a sculpture. But there are a number of interesting similarities between the two. Both rely on simple monochrome shapes without detail or ornamentation. In Armajani's case these simplicities denote a modest populism, while in Ewing's work they indicate the bleak puritanism of the total state. Both works use language, for Armajani a poem by Walt Whitman, for Ewing

34. Quoted in Sayre, *The Object of Performance,* p. 6.
35. Lotringer, "Vito Acconci," p. 124.

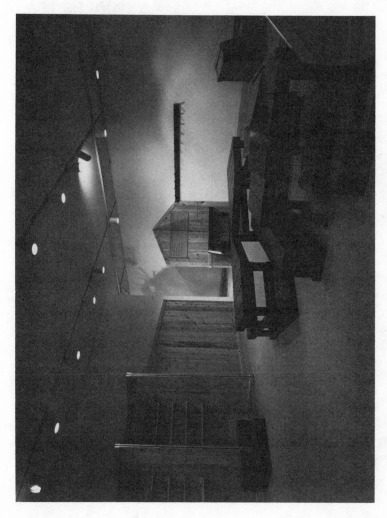

Fig. 3.—Siah Armajani, *Hirshhorn Employee Lounge*, 1981. Installation at the Hirshhorn Museum and Sculpture Garden, Smithsonian Institution, "Metaphor: New Projects by Contemporary Sculptors," 17 Dec. 1981–28 Feb. 1982.

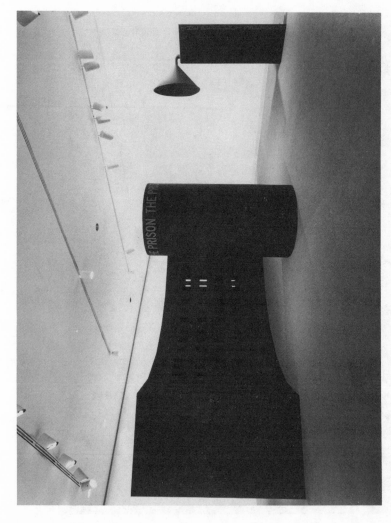

FIG. 4.—Lauren Ewing, *Auto-Plastique: The Prison*, 1981. Installation at the Hirshhorn Museum and Sculpture Garden, Smithsonian Institution, "Metaphor: New Projects by Contemporary Sculptors," 17 Dec. 1981–28 Feb. 1982.

certain terms and titles including *Auto-Plastique,* the actual name of the piece. In both cases, the lettering is posted quite high up, though a small part of the Whitman quotation does run along the baseboard of Armajani's room. Ewing's letters are meant, in their size and position, to represent the kind of language that might come out of the bullhorn, a stencil of which is painted as part of the title, but it is hard to tell why Armajani should have elevated Whitman's poem. Armajani, like Ewing, is fond of stencilled lettering, a form that has a kind of popular anonymity in his case and a threatening, official anonymity in hers.

These similarities indicate that the two projects, seemingly so different, are in fact linked, however ironically. The artistic devices Armajani chooses to evoke an ideal communitarian life can also be used, as Ewing's installation shows, in the very totalitarian spaces from which he recoils. The very techniques he chooses to represent commonality can also represent the conformity that Ewing means to expose. These similarities suggest that in attempting to provide a communal experience, Armajani ironically provides what already exists in suffocating abundance, public spaces that take the public in hand. Though Armajani's seating is arranged in a pattern of quite pleasant disorder, which is clearly meant to represent the free and easy social relations that should occur in the space, a close look reveals that the seating is fixed in place, so that the users of the room are condemned to enjoy just this particular disorder, as they are condemned to enjoy the openness of Whitman's verse, even if they prefer John Milton or Ogden Nash.

The relationship between Armajani and Ewing exposes the ambiguous nature of contemporary attempts to make sculpture public by making the public part of the sculpture. These works contain the same unpleasant surprise found inside *Fan City,* a package promising a communal meeting place that opens to reveal an alienating regimentation. Some of the public discomfort with contemporary public sculpture may come therefore from a feeling that there is not much to choose between the role offered to it in the real versions of spaces like Ewing's prison and that offered by art, if even the works that promise the Heavenly City turn their viewers into human ornaments. Yet the history of these metaphors suggests that the process might be reversed again and their original promise realized. Two final examples indicate how sculpture might use public space in a different way.

These two works, Maya Lin's Vietnam Veterans Memorial and Hans Haacke's *Und ihr habt doch gesiegt,* seem on the surface to have nothing to do with one another. One is the well-known double slash of black-polished granite, the other a temporary installation in Graz, Austria that reproduced, fifty years after the fact, a Nazi monument. Yet both works represent important applications of contemporary aesthetics to public sites: Lin's memorial because of its obvious debt to

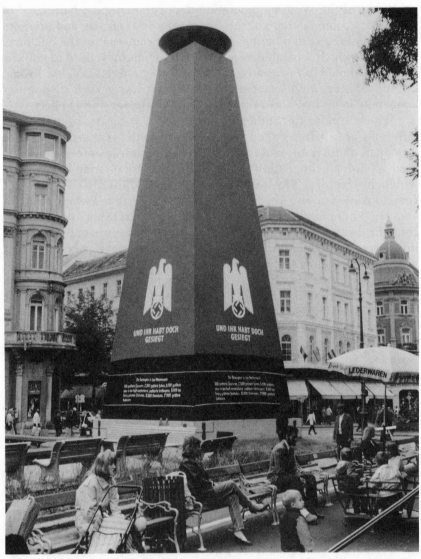

FIG. 5.—Hans Haacke, *Und ihr habt doch gesiegt.* Project realized in downtown Graz, as part of the exhibition "38–88 Points of Reference," under the auspices of the twentieth anniversary of the Styrian Autumn, an annual culture festival in Graz, Austria, Oct.–Nov. 1988. Photo: © by Hans Haacke. All rights reserved. Reprinted by permission of the artist.

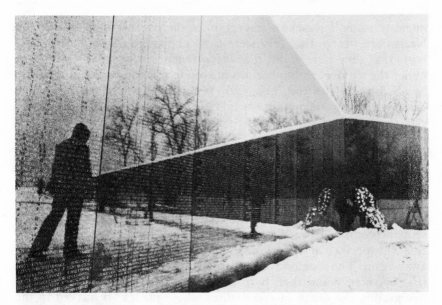

FIG. 6.—Maya Lin, *Vietnam Veterans Memorial*, 1982. Photo: Dolores Neuman.

the earthworks of the sixties and seventies; Haacke's installation because it is one of the most recent works by an artist whose past includes minimalism, conceptualism, pop art, and political agitation. More important, both works place their viewers in a public space that is articulated in terms of political controversy so that to view the piece is not simply to experience space but also to enter a debate.

Lin and Haacke both deftly situate their works so as to expose spatial relationships that are also historical and political. The Vietnam Veterans Memorial materializes at the intersection of an angle described by the monuments to Washington and Lincoln. If it thus places the Vietnam War in a symmetrical relationship to the rest of American history, it also suspends it between a symbol of unity, the great obelisk whose many blocks signify *E pluribus unum*, and a symbol of discord, Lincoln brooding over the Civil War.[36] The two wings of the memorial seem almost to represent two sides of a conflict, two positions in an argument, two ways of looking at the war. A spatial configuration thus reveals a historical irony or doubleness, just as Haacke's obelisk reveals beneath the contemporary geography of Graz another geography, precisely fifty years old, studded with swastikas and Nazi slogans. Like his Nazi predecessor, but with quite different motives, Haacke covered the Column of the Virgin Mary in Graz's main street with a cloth-and-wood obelisk, and he placed on it the motto ("And You Were Victorious after All") that had come in fifty years to have an extremely

36. See Griswold, "The Vietnam Veterans Memorial," pp. 693–98.

intricate irony.[37] Haacke's reerection of the obelisk suggests that the Nazis were wrong, that they were not to be victorious, but simultaneously that they were right, that there remains a layer of Nazism just under the surface, an implication proven true when the work was firebombed by an Austrian neo-Nazi. Yet this act completed the irony, since destroying the monument in 1988 served exactly the same interests that erected it in 1938. Silence and ignorance work now as triumphal militarism did then.

Both works achieve their aesthetic distinction and their emotional power from their political complexity. The common dogma that public monuments depend on public agreement is belied by these works, which show instead that monuments achieve a public resonance by taking up topics too important for agreement. Lin's granite walls represent the course of the Vietnam War from its secret beginnings to its final, unspectacular end, growing and growing and then dwindling away again. The memorial thus depicts the shape of a war determined first by secrecy and then by public opposition. Without in any way denigrating the death of the soldiers whose names are carved in the granite, Lin also creates a monument to debate and controversy. Haacke cannot commemorate debate, since the erection of the original obelisk was part of an artistic and military demonstration designed to cow opposition. As Werner Fenz, organizer of the exhibition that included Haacke's work, observed, "It was precisely the use of art in public spaces that, under the Nazis, was subject to a finely worked-out system of strict ideological rules."[38] But in reerecting the obelisk, Haacke attempts to turn this project inside out, to expose the way the Nazis used public space to brutalize the public, and thus turn mass ornamentation against itself.

The two works both make the public part of the sculpture itself, but they do so in ways that work against mass ornamentation. Part of the power of Lin's memorial comes from the sheer extent of the space that is covered by the names of the dead. But if the dead make their impression through sheer bulk, that bulk has power because the viewer is forced to realize that each name represents a once-living individual. Since the names are listed by date of death and not by rank or military unit, the dead are presented as individuals and not as members of a group. The memorial thus overcomes the anonymity of the body count and concentrates an almost insupportable emotion in the space between each individual and the mass of fifty-eight thousand. But the living public also enters the work, reflected as it is in the highly polished gran-

37. For descriptions and analyses of this work, including Haacke's own, see *October*, no. 48 (Spring 1989): 69–87.

38. Werner Fenz, "The Monument Is Invisible, the Sign Visible," trans. Maria-Regina Kecht, *October*, no. 48 (Spring 1989): 78.

ite. In fact, Donald Kunze has recently pointed out that the two wings of the piece reflect one another and in so doing create another *V* in virtual space behind the actual one, forming a huge ghostly *X* at the very center of which the reflections of the public enter the virtual space that seems to exist in the earth behind the memorial.[39] Living and dead confront one another within the sculpture in a space neither living nor dead. In this way, the sculpture superimposes the living public on the dead, giving rise to a variety of emotions from shame to reconciliation to pride, all of which are far more complex and full of conflict than anything evoked by the all-too-obvious bronze troopers.

Haacke's obelisk makes similar use of the public. In 1938, the obelisk had an important role in a major Nazi spectacle in which massed individuals in and out of uniform played the same aesthetic role as the massed flags and banners lining the streets. When the work was re-created, the streets around it were filled again, only this time with argument. In this, Haacke managed to realize the ambition of some of his earliest conceptual pieces, which were based on opinion polls taken at various museums. In those early works, public opinion became the work of art, which Haacke materialized in one case by making a street map out of photographs of the residences of people who had visited his show at the Howard Wise Gallery in New York.[40] But the public in this "sculpture" was still inert, and the polling methods, which were at least partially satirical, still reduced their human material to the same kinds of categories used in other marketing. In Graz, on the other hand, the public was animated, and most of the power of the work lay in the different effects the same aesthetic object had in its two different installations. Just as in Lin's memorial, the living and the dead faced each other across an aesthetic space, which was charged with the same hardly reconcilable feelings. Like the Vietnam Veterans Memorial, Haacke's work manages to superimpose one public space on another and in so doing suggests a community whose nature is open to question, whose history presents certain alternatives for choice. A monument like this does not represent the continuity of the present with the past but rather the chance, through an awakened public opinion, to break a dependence on the past reinforced by silence.

Such works help us discover what separates the original meaning of the public as sculpture from its autocratic applications. In its ancient form, the metaphor signified the voluntary association of different

39. Donald Kunze, "Architecture as Reading; Virtuality, Secrecy, Monstrosity," *Journal of Architectural Education* 41 (Summer 1988): 28. Kunze claims that this virtual space is not "cultural" but perceptual and in so doing undermines the usefulness of his argument.

40. See *Hans Haacke: Unfinished Business,* ed. Brian Wallis (Cambridge, Mass., 1986), pp. 78–79.

individuals in a common public forum. In the liberal form introduced at the end of the eighteenth century, the metaphor did not stand simply for agreement, commonality, or continuity, but rather for debate; it signified a space in which different opinions could meet and contend according to commonly accepted rules. In these works by Lin and Haacke, it is not the public experience of space but rather public debate that becomes a work of art. They make manifest an important truth about public space, that unless it is embedded in a larger public sphere that values debate, a public sphere like that defined by Jürgen Habermas in which private people use their reason to discuss and reach conclusions, then it will always be decorated by mass ornaments, no matter what sort of art is put into it.[41] Works like *Fan City* or *Auto-Plastique* suggest that such a sphere does not now exist in our entirely regimented society, but this very criticism implies that the artist has achieved the independence necessary to reflection. If this autonomy could be seen not as the antithesis of, but rather as an analogy for, the freedom of the individual viewer, then art might renew public space instead of merely decorating it with mass ornaments.

41. See Jürgen Habermas, *The Structural Transformation of the Public Sphere: An Inquiry into a Category of Bourgeois Society,* trans. Thomas Burger and Frederick Lawrence (Cambridge, Mass., 1989).

The Violence of Public Art:
Do the Right Thing

W. J. T. Mitchell

In May 1988, I took what may well be the last photograph of the statue of Mao Tse-tung on the campus of Beijing University. The thirty-foot-high monolith was enveloped in bamboo scaffolding "to keep off the harsh desert winds," my hosts told me with knowing smiles. That night, workers with sledgehammers reduced the statue to a pile of rubble, and rumors spread throughout Beijing that the same thing was happening to statues of Mao on university campuses all over China. One year later, most of the world's newspaper readers scanned the photos of Chinese students erecting a thirty-foot-high styrofoam and plaster "Goddess of Liberty" directly facing the disfigured portrait of Mao in Tiananmen Square despite the warnings from government loudspeakers: "This statue is illegal. It is not approved by the government. Even in the United States statues need permission before they can be put up."[1] A few days later the newspaper accounts told us of army tanks mowing down this statue along with thousands of protesters, reasserting the rule of what was called law over a public and its art.

The Beijing Massacre, and the confrontation of images at the central public space in China, is full of instruction for anyone who

I would like to thank John Neff and Sculpture Chicago for inviting me to speak at a conference, "Public Art: Daring to Dream," for which an early draft of this essay was written. My thanks also to Joel Snyder, Miriam Hansen, Lauren Berlant, and Arnold Davidson for constant chiding and encouragement, and to David Schabes for his assistance in locating documents. "Goddess of Liberty": AP/Wide World Photos.

1. Quoted in Uli Schmetzer, "Torch of China's Lady Liberty Rekindles Fervor," *Chicago Tribune*, 31 May 1989, sec. 1.

Critical Inquiry 16 (Summer 1990)

wants to think about public art and, more generally, about the whole relation of images, violence, and the public sphere.[2] "Even in the United States" political and legal control is exerted, not only over the erection of public statues and monuments but over the display of a wide range of images, artistic or otherwise, to actual or potential publics. Even in the United States the "publicness" of public images goes well beyond their specific sites or sponsorship: "publicity" has, in a very real sense, made all art into public art. And even in the United States, art that enters the public sphere is liable to be received as a provocation to or an act of violence.

Our own historical moment seems especially rich in examples of such public acts and provocations. Recent art has carried the scandals

2. For an excellent discussion of the way the events in China in June 1989 became a "spectacle for the West," overdetermined by the presence of a massive publicity apparatus, see Rey Chow, "Violence in the Other Country: Preliminary Remarks on the 'China Crisis,' June 1989," *Radical America* 22 (July–Aug. 1988): 23–32.

W. J. T. Mitchell, editor of *Critical Inquiry*, is Gaylord Donnelly Distinguished Service Professor of English and art at the University of Chicago. He is the author of *Iconology: Image, Text, Ideology* (1986), and *Picture Theory* (forthcoming), and editor of *Landscapes and Power* (forthcoming).

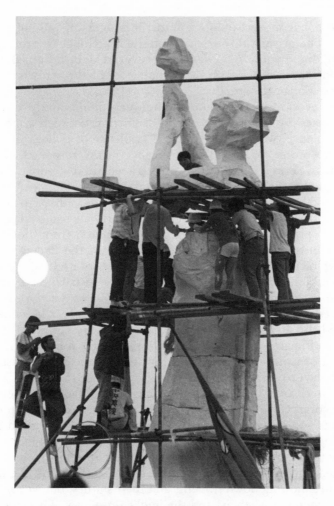

previously associated with the cloistered spaces of the art world—the gallery, the museum, and the private collection—into the public sphere. And the public, by virtue of governmental patronage of the arts, has taken an interest in what is done with its money, no matter whether it is spent on traditional public art—in a public place as a public commission—or on a private activity in a private space that just happens to receive some public support or publicity. The controversy over Richard Serra's *Tilted Arc* sculpture in a public plaza in New York City marks one boundary of this phenomenon. Serra's is a traditional work of public art; it provoked another engagement in what Michael North has called the "tiresome battle, repeated in city after city . . . whenever a piece of modern sculpture is installed outdoors."[3] But now

3. Michael North, *The Final Sculpture: Public Monuments and Modern Poets* (Ithaca, N.Y., 1985), p. 17. *Tilted Arc* is "traditional" in its legal status as a commission by a public,

the battle has moved indoors, into the spaces of museums and art schools. The privacy of the exhibition site is no longer a protection for art that does symbolic violence to revered public figures like the deceased mayor of Chicago, or to public emblems and icons like the American flag or the crucifix.

The erosion of the boundary between public and private art is accompanied by a collapsing of the distinction between symbolic and actual violence, whether the "official" violence of police, juridical, or legislative power, or "unofficial" violence in the responses of private individuals. Serra's *Tilted Arc* was seen as a violation of public space, was subjected to actual defacement and vandalism by some members of the public, and became the subject of public legal proceedings to determine whether it should be dismantled.[4] The official removal of an art student's caricature of Mayor Harold Washington from the School of the Art Institute of Chicago involved not just the damaging of the offensive picture but a claim that the picture was itself an "incitement to violence" in the black community. A later installation at the same school asking *What Is the Proper Way to Display the American Flag?* was construed as an invitation to "trample" on the flag. It immediately attracted threats of unofficial violence against the person of the artist and may ultimately serve as the catalyst not simply for legislative action but for a constitutional amendment protecting the flag against all acts of symbolic or real violence. The recent response to Andres Serrano's crucifix in a jar of urine and the closing of the Mapplethorpe show at the Corcoran Gallery indicate the presence of an American public, or at least of some well-entrenched political interests, that is fed up with tolerating symbolic violence against religious and sexual taboos under the covers of "art," "privacy," and "free speech," and is determined to fight back with the very real power of financial sanctions. We may not have tanks mowing down students and their statues, but we are experiencing a moment when art and the public (insofar as it is embodied by state power and "public opinion") seem on a collision course.

The association of public art with violence is nothing new. The fall of every Chinese dynasty since antiquity has been accompanied by the destruction of its public monuments, and the long history of political

governmental agency. In other ways (style, form, relation to site, public legibility) it is obviously nontraditional.

4. Serra described his intention "to dislocate or alter the decorative function" of the Federal Building plaza in an interview with Douglas Crimp ("Richard Serra's Urban Sculpture: An Interview," *Arts Magazine* 55 [Nov. 1980]: 118), but he rejected Crimp's suggestion that he was attempting to "block the conventional views" available in the plaza: "the intention is to bring the viewer into the sculpture. . . . After the piece is erected, the space will be understood primarily as a function of the sculpture." For an excellent account of this whole controversy and the ill-considered decision to remove *Tilted Arc*, see *Public Art, Public Controversy: The "Tilted Arc" on Trial*, ed. Sherrill Jordan et al. (New York, 1987).

and religious strife in the West could almost be rewritten as a history of iconoclasm. There is also nothing new about the opposition of art to its public. Artists have been biting the hands that feed them since antiquity,[5] and even the notion of an "avant-garde" capable of scandalizing the bourgeoisie has been dismissed, by a number of critics, to the dustbin of history. The avant-garde, in Thomas Crow's words, now functions "as a kind of research and development arm of the culture industry."[6] Oppositional movements such as surrealism, expressionism, and cubism have been recuperated for entertainment and advertising, and the boldest gestures of high modernism become the ornaments of corporate public spaces. If traditional public art identified certain classical styles as appropriate to the embodiment of public images, contemporary public art has turned to the monumental abstraction as its acceptable icon. What Kate Linker calls the "corporate bauble" in the shopping mall or bank plaza need have no iconic or symbolic relation to the public it serves, the space it occupies, or the figures it reveres.[7] It is enough that it remain an emblem of aesthetic surplus, a token of "art" imported into and adding value to a public space.

The notorious "anti-aesthetic" posture of much postmodern art may be seen, in its flouting of the canons of high modernism, as the latest edition of the iconoclastic public icon, the image that affronts its own public—in this case, the art world as well as the "general" public. The violence associated with this art is inseparable from its *publicness*, especially its exploitation of and by the apparatuses of publicity, reproduction, and commercial distribution.[8] The scandalousness and obtrusive theatricality of these images hold up a mirror to the nature of the commodified image, and the public spectator addressed by advertising, television, movies, and "Art" with a capital *A*. If all images are for sale, it's hardly surprising that artists would invent public images that are difficult (in any sense) to "buy." Postmodern art tries, among other things, to be difficult to own or collect, and much of it succeeds, existing only as ruined fragments or photographic "documentation." Much

5. G. E. Lessing notes that beauty in visual art was not simply an aesthetic preference for the ancients but a matter of juridical control. The Greeks had laws against caricature, and the ugly "dirt painters" were subjected to censorship. See Lessing's *Laocoon: An Essay upon the Limits of Painting and Poetry*, trans. Ellen Frothingham (1766; New York, 1969), pp. 9–10.

6. Thomas Crow, "Modernism and Mass Culture in the Visual Arts," in *Pollock and After: The Critical Debate*, ed. Francis Frascina (New York, 1985), p. 257.

7. See Kate Linker's important essay, "Public Sculpture: The Pursuit of the Pleasurable and Profitable Paradise," *Artforum* 19 (Mar. 1981): 66.

8. Scott Burton summarizes the "new kind of relationship" between art and its audience: "it might be called public art. Not because it is necessarily located in public places, but because the content is more than the private history of the maker" (quoted in Henry M. Sayre, *The Object of Performance: The American Avant-Garde since 1970* [Chicago, 1989], p. 6).

of it also "fails," of course, to be unmarketable and thus "succeeds" quite handsomely as an aesthetic commodity, as Andy Warhol's work demonstrates. The common thread of both the marketable and the unmarketable work of art is the more or less explicit awareness of "marketability" and publicity as unavoidable dimensions of any public sphere that art might address. "Co-optation" and "resistance" are thus the ethical-political maxims of this public sphere and the aesthetic it generates.

The violence associated with this art may seem, then, to have a peculiarly desperate character and is often directed at the work itself as much as its beholder. Sometimes a self-destructive violence is built into the work, as in Jean Tinguely's self-destroying machine sculpture, *Homage to New York*, or Rudolf Schwarzkogler's amputation of his own penis, both of which now exist only in photographic documentation.[9] More often, the violence suffered by contemporary art seems simultaneously fateful and accidental, a combination of misunderstanding by local or partial publics and a certain fragility or temporariness in the work itself. The early history of Claes Oldenburg's monumental *Lipstick* at Yale University is one of progressive disfigurement and dismantling. Many of the works of Robert Smithson and Robert Morris are destroyed, existing now only in documents and photographs. The openness of contemporary art to publicity and public destruction has been interpreted by some commentators as a kind of artistic aggression and scandalmongering. A more accurate reading would recognize it as a deliberate vulnerability to violence, a strategy for dramatizing new relations between the traditionally "timeless" work of art and the transient generations, the "publics," that are addressed by it.[10] The defaced and graffiti-laden walls that Jonathan Borofsky installs in museum spaces are a strategy for reconfiguring the whole relation of private and public, legitimate and "transgressive" exhibition spaces. Morris's 1981 proposal to install the casings of nuclear bombs as monumental sculpture at a Florida VA hospital was both a logical extension of a public sculpture tradition (the public display of obsolete weapons) and a deadpan mimicry of the claim that these weapons "saved American lives" in World War II.[11]

The question naturally arises: Is public art inherently violent, or is it a provocation to violence? Is violence built into the monument in its

9. See Sayre, *The Object of Performance*, pp. 2–3.

10. For a shocking example of an artist's misrepresentation of these issues, see Frederick E. Hart, "The Shocking Truth about Contemporary Art," *The Washington Post*, 28 Aug.–3 Sept. 1989, national weekly edition, op-ed. sec. It hardly comes as a surprise that Hart is the sculptor responsible for the figural "supplement" to the Vietnam Veterans Memorial, the traditional monumental figures of three soldiers erected in the area above and behind the memorial.

11. See Robert Morris, "Fissures," unpublished manuscript.

very conception? Or is violence simply an accident that befalls some monuments, a matter of the fortunes of history? The historical record suggests that if violence is simply an accident that happens to public art, it is one that is always waiting to happen. The principal media and materials of public art are stone and metal sculpture not so much by choice as by necessity. "A public sculpture," says Lawrence Alloway, "should be invulnerable or inaccessible. It should have the material strength to resist attack or be easily cleanable, but it also needs a formal structure that is not wrecked by alterations."[12] The violence that surrounds public art is more, however, than simply the ever-present possibility of accident—the natural disaster or random act of vandalism. Much of the world's public art—memorials, monuments, triumphal arches, obelisks, columns, and statues—has a rather direct reference to violence in the form of war or conquest. From Ozymandias to Caesar to Napoleon to Hitler, public art has served as a kind of monumentalizing of violence, and never more powerfully than when it presents the conqueror as a man of peace, imposing a Napoleonic code or a *pax Romana* on the world. Public sculpture that is too frank or explicit about this monumentalizing of violence, whether the Assyrian palace reliefs of the ninth century B.C., or Morris's bomb sculpture proposal of 1981, is likely to offend the sensibilities of a public committed to the repression of its own complicity in violence.[13] The very notion of public art as we receive it is inseparable from what Jürgen Habermas has called "the liberal model of the public sphere," a dimension distinct from the economic, the private, and the political. This ideal realm provides the space in which disinterested citizens may contemplate a transparent emblem of their own inclusiveness and solidarity, and deliberate on the general good, free of coercion, violence, or private interests.[14]

The fictional ideal of the classic public sphere is that it includes everyone; the fact is that it can be constituted only by the rigorous exclusion of certain groups—slaves, children, foreigners, those without property, and (most conspicuously) women. The very notion of the

12. Lawrence Alloway, "The Public Sculpture Problem," *Studio International* 184 (Oct. 1972): 124.

13. See Leo Bersani and Ulysse Dutoit, "The Forms of Violence," *October*, no. 8 (Spring 1979): 17–29, for an important critique of the "narrativization" of violence in Western art and an examination of the alternative suggested by the Assyrian palace reliefs.

14. Habermas first introduced this concept in *The Structural Transformation of the Public Sphere: An Inquiry into a Category of Bourgeois Society*, trans. Thomas Burger and Frederick Lawrence (Cambridge, Mass., 1989). First published in 1962, it has since become the focus of an extensive literature. See also Habermas's short encyclopedia article, "The Public Sphere," trans. Sara Lennox and Frank Lennox, *New German Critique* 1 (Fall 1974): 49–55, and the introduction to it by Peter Hohendahl in the same issue, pp. 45–48. I owe much to the guidance of Miriam Hansen and Lauren Berlant on this complex and crucial topic.

Aerial view of the Vietnam Veterans Memorial. Photo: Richard Hofmeister, Smithsonian Institution's Office of Printing and Photographic Services. From *Reflections on the Wall: The Vietnam Veterans Memorial* (Harrisburg, Pa., 1987).

"public," it seems, grows out of a conflation of two quite different Latin words, *populus* (the people) and *pubes* (adult men). The word *public* might more properly be written with the *l* in parentheses to remind us that for much of human history political and social authority has derived from a "pubic" sphere, not a public one.[15] This seems to be the case even when the public sphere is personified as a female figure. The famous examples of female monuments to the all-inclusive principle of public civility and rule of law—Athena to represent impartial Athenian justice, the Goddess of Reason epitomizing the rationalization of the public sphere in revolutionary France, the Statue of Liberty welcoming the huddled masses from every shore—all presided over political systems that rigorously excluded women from any public role.[16]

Perhaps some of the power associated with the Vietnam Veterans Memorial in Washington, D.C., comes from its cunning violation and

15. See Joan Landes, *Women and the Public Sphere in the Age of the French Revolution* (Ithaca, N.Y., 1988), p. 13.

16. Chow notes the way the "Goddess of Liberty" in Tiananmen Square replicates the "'*King Kong* syndrome,'" in which the body of the white woman sutures the gap between "enlightened instrumental reason and barbarism-lurking-behind-the Wall," the "white man's production and the monster's destruction" (Chow, "Violence in the Other Country," p. 26).

inversion of monumental conventions for expressing and repressing the violence of the pub(l)ic sphere. The VVM is antiheroic, antimonumental, a V-shaped gash or scar, a trace of violence suffered, not of violence wielded in the service of a glorious cause (as in the conventional war memorial).[17] It achieves the universality of the public monument not by rising above its surroundings to transcend the political but by going beneath the political to the shared sense of a wound that will never heal, or (more optimistically) a scar that will never fade. Its legibility is not that of narrative: no heroic episode such as the planting of the American flag on Iwo Jima is memorialized, only the mind-numbing and undifferentiated chronology of violence and death catalogued by the fifty-eight thousand names inscribed on the black marble walls. The only other legibility is that of the giant flat *V* carved in the earth itself, a multivalent monogram or initial that seems uncannily overdetermined. Does the *V* stand for Vietnam? For a Pyrrhic "Victory"? For the Veterans themselves? For the Violence they suffered? Is it possible, finally, to avoid seeing it as a quite literal antitype to the "pubic sphere" signified in the traditional phallic monument, that is, as the Vagina of Mother Earth opened to receive her sons, as if the American soil were opening its legs to show the scars inscribed on her private parts? Even the authorship of this polysemous and thoroughly feminized monument seems overdetermined in retrospect. Who would have predicted that the national trauma of the United States' catastrophic adventure in the Far East would be memorialized in a design by a twenty-one-year-old Asian woman?[18]

It should be clear that the violence associated with public art is not simply an undifferentiated abstraction, any more than is the public sphere it addresses. Violence may be in some sense "encoded" in the concept and practice of public art, but the specific role it plays, its political or ethical status, the form in which it is manifested, the identities of those who wield and suffer it, is always nested in particular circumstances. We may distinguish three basic forms of violence in the images of public art, each of which may, in various ways, interact with the other: (1) the image as an *act* or *object* of violence, itself doing violence to beholders, or "suffering" violence as the target of vandalism, disfigurement, or demolition; (2) the image as a *weapon* of violence, a device for attack, coercion, incitement, or more subtle "dislocations" of public spaces; (3) the image as a *representation* of violence, whether a realistic

17. See Charles L. Griswold, "The Vietnam Veterans Memorial and the Washington Mall: Philosophical Thoughts on Political Iconography," *Critical Inquiry* 12 (Summer 1986): 709. Griswold reads the VVM as a symbol of "honor without glory."

18. Maya Lin, then a twenty-one-year-old Yale University architecture student, submitted the winning design in what may have been the largest competition for a work of public art ever held: 1,421 designs were entered.

imitation of a violent act, or a monument, trophy, memorial, or other trace of past violence. All three forms are, in principle, independent of one another: an image can be a weapon of violence without representing it; it may become the object of violence without ever being used as a weapon; it may represent violence without ever exerting or suffering it. In fact, however, these three forms of violence are often linked together. Pornography is said to be a representation of and a weapon of violence against women, which should be destroyed or at least banned from public distribution.[19] The propaganda image is a weapon of war that obviously engages with all three forms of violence in various ways, depending on the circumstances. The relation of pornography to propaganda is a kind of allegory for the relation of "private" to "public" art: the former projects fetishistic images that are confined, in theory, to the "private sphere" of sexuality; the latter projects totemistic or idolatrous images that are directed, in theory, at a specific public sphere.[20] In practice, however, private "arousal" and public "mobilization" cannot be confined to their proper spheres: rape and riot are the "surplus" of the economy of violence encoded in public and private images.

These elisions of the boundary between public and private images are what make it possible, perhaps even necessary, to turn from the sphere of public art in its "proper" or traditional sense (works of art installed in public places by public agencies at public expense) to film, a medium of public art in an extended or "improper" sense. Although film is sometimes called the central public art of the twentieth century, we should be clear about the adjustments in both key terms—*public* and *art*—required to make this turn. Film is not a "public art" in the classical sense stipulated by Habermas; it is deeply entangled with the marketplace and the sphere of commercial-industrial publicity that replaces what Habermas calls the "culture-debating" public with a "culture-consuming" public. We need not accept Habermas's historical claim that the classic public sphere (based in the "world of letters") was "replaced by the pseudo-public or sham-private world of culture consumption"[21] to see that its basic distinction between an ideal, utopian public sphere and the real world of commerce and publicity is what underwrites the distinction between public art "proper" and the "improper" turn to film, a medium that is neither "public" nor "art" in this proper (utopian) sense.

19. See Catharine A. MacKinnon, *Feminism Unmodified: Discourses on Life and Law* (Cambridge, Mass., 1987), esp. pp. 172–73, 192–93.

20. For more on the distinction between totemism and fetishism, see my "Tableau and Taboo: The Resistance to Vision in Literary Discourse," *CEA Critic* 51 (Fall 1988): 4–10.

21. Habermas, *The Structural Transformation of the Public Sphere*, p. 160.

This juxtaposition of public art and commercial film illuminates a number of contrasting features whose distinctiveness is under considerable pressure, both in contemporary art and recent film practice. An obvious difference between public art and the movies is the contrast in mobility. Of all forms of art, public art is the most static, stable, and fixed in space: the monument is a fixed, generally rigid object, designed to remain on its site for all time.[22] The movies, by contrast, "move" in every possible way—in their presentation, their circulation and distribution, and in their responsiveness to the fluctuations of contemporary taste. Public art is supposed to occupy a pacified, utopian space, a site held in common by free and equal citizens whose debates, freed of commercial motives, private interest, or violent coercion, will form "public opinion." Movies are beheld in private, commercial theatres that further privatize spectators by isolating and immobilizing them in darkness. Public art stands still and silent while its beholders move in the reciprocal social relations of festivals, mass meetings, parades, and rendezvous. Movies appropriate all motion and sound to themselves, allowing only the furtive, private rendezvous of lovers or of autoeroticism.

The most dramatic contrast between film and public art emerges in the characteristic tendencies of each medium with respect to the representation of sex and violence. Public art tends to repress violence, veiling it with the stasis of monumentalized and pacified spaces, just as it veils gender inequality by representing the masculine public sphere with the monumentalized bodies of women. Film tends to express violence, staging it as a climactic spectacle, just as it foregrounds gender inequality by fetishizing rather than monumentalizing the female body. Sex and violence are strictly forbidden in the public site, and thus the plaza, common, or city square is the favored site for insurrection and symbolic transgression, with disfiguration of the monument a familiar, almost ritual occurrence.[23] The representation of sex and violence is licensed in the cinema, and it is generally presumed (even by the censors) that it is reenacted elsewhere—in streets, alleys, and private places.

I have rehearsed these traditional distinctions between film and public art not to claim their irresistible truth but to sketch the conven-

22. The removal of *Tilted Arc* is all the more remarkable (and ominous) in view of this strong presumption in favor of permanence.

23. The fate of the Berlin Wall is a perfect illustration of this process of disfiguration as a transformation of a public monument into a host of private fetishes. While the Wall stood it served as a work of public art, both in its official status and its unofficial function as a blank slate for the expression of public resistance. As it is torn to pieces, its fragments are carried away to serve as trophies in private collections. As German reunification proceeds, these fragments may come to signify a nostalgia for the monument that expressed and enforced its division.

tional background against which the relations of certain contemporary practices in film and public art may be understood—their common horizon of resistance, as it were. Much recent public art obviously resists and criticizes its own site and the fixed, monumental status conventionally required of it; much of it aspires, quite literally, to the condition of film in the form of photographic or cinematic documentation. I turn now to a film that aspires to the condition of public art, attempting a similar form of resistance within its own medium, and holding up a mirror to the economy of violence encoded in public images.[24]

In May 1989 I tried unsuccessfully to attend an advance screening of Spike Lee's *Do the Right Thing* at the University of Chicago. People from the university and its neighborhood had lined up for six hours to get the free tickets, and none of them seemed interested in scalping them at any price. Spike Lee made an appearance at the film's conclusion and stayed until well after midnight answering the questions of the overflow crowd. This event turned out to be a preview not simply of the film but of the film's subsequent reception. Lee spent much of the summer answering questions about the film in television and newspaper interviews; the *New York Times* staged an instant symposium of experts on ethnicity and urban violence; and screenings of the film (especially in urban theatres) took on the character of festivals, with audiences in New York, London, Chicago, and Los Angeles shouting out their approval to the screen and to each other.

The film elicited disapproval from critics and viewers as well. It was denounced as an incitement to violence and even as an *act* of violence by viewers who regarded its representations of ghetto characters as demeaning.[25] The film moved from the familiar commercial public sphere of "culture consumption" into the sphere of public art, the arena of the "culture-debating" public, a shift signalled most dramati-

24. By the phrase "economy of violence," I mean, quite strictly, a social structure in which violence circulates and is exchanged as a currency of social interaction. The "trading" of insults might be called the barter or "in kind" exchange; body parts (eyes, teeth notably) can also be exchanged, along with blows, glares, hard looks, threats, and first strikes. This economy lends itself to rapid, runaway inflation, so that (under the right circumstances) an injury that would have been trivial (stepping on someone's sneakers, smashing a radio) is drastically overestimated in importance. As a currency, violence is notoriously and appropriately unstable.

25. Murray Kempton's review ("The Pizza Is Burning!" *New York Review of Books*, 28 Sept. 1989, pp. 37–38), is perhaps the most hysterically abusive of the hostile reviews. Kempton condemns Spike Lee as a "hack" who is ignorant of African-American history and guilty of "a low opinion of his own people" (p. 37). His judgment of Mookie, the character played by Lee in the film, is even more vitriolic: Mookie "is not just an inferior specimen of a great race but beneath the decent minimum for humankind itself" (p. 37).

cally by its exclusion from the "Best Picture" category of the Academy Awards. As the film's early reception subsides into the cultural history of the late eighties in the United States, we may now be in a position to assess its significance as something more than a "public sensation" or "popular phenomenon." *Do the Right Thing* is rapidly establishing itself not only as a work of public art (a "monumental achievement" in the trade lingo), but as a film *about* public art. The film tells a story of multiple ethnic public spheres, the violence that circulates among and within these partial publics, and the tendency of this violence to fixate itself on specific images—symbolic objects, fetishes, and public icons or idols.

The specific public image at the center of the violence in *Do the Right Thing* is a collection of photographs, an array of signed publicity photos of Italian-American stars in sports, movies, and popular music framed and hung up on the "Wall of Fame" in Sal's Famous Pizzeria at the corner of Stuyvesant and Lexington in Brooklyn. A bespectacled b-boy and would-be political activist named Buggin' Out challenges this arrangement, asking Sal why no pictures of African Americans are on the Wall. Sal's response is an appeal to the rights of private property: "You want brothers up on the Wall of Fame, you open up your own business, then you can do what you wanna do. My pizzeria, Italian-Americans only up on the wall." When Buggin' Out persists, arguing that blacks should have some say about the Wall since their money keeps the pizzeria in business, Sal reaches for an all-too-familiar emblem of both the American way of life and of racial violence: his baseball bat. Mookie, Sal's black delivery boy (played by Lee) defuses

the situation by hustling Buggin' Out out of the pizzeria. In retaliation, Buggin' Out tries, quite unsuccessfully, to organize a neighborhood boycott, and the conflict between the black public and the white-owned private business simmers on the back burner throughout the hot summer day. Smiley, a stammering, semi-articulate black man who sells copies of a unique photograph showing Martin Luther King, Jr., and Malcolm X together, tries to sell his photos to Sal (who seems ready to be accommodating) but is driven off by Sal's son Pino. Sal is assaulted by another form of "public art" when Radio Raheem enters the pizzeria with his boom-box blasting out Public Enemy's rap song, "Fight the Power." Finally, at closing time, Radio Raheem and Buggin' Out reenter Sal's, radio blasting, to demand once again that some black people go up on the Wall of Fame. Sal smashes the radio with his baseball bat, Raheem pulls Sal over the counter and begins to choke him. In the melee that follows, the police kill Radio Raheem and depart with his body, leaving Sal and his sons to face a neighborhood that has become a mob. Mookie throws a garbage can through the window of the pizzeria, and the mob loots and burns it. Later, when the fire is burning down, Smiley enters the ruins and pins his photograph of King and Malcolm to the smoldering Wall of Fame.

Sal's Wall of Fame exemplifies the central contradictions of public art. It is located in a place that may be described, with equal force, as a public accommodation and a private business. Like the classic liberal public sphere, it rests on a foundation of private property that comes

Buggin' Out looks up at the Wall of Fame.

into the open when its public inclusiveness is challenged. Sal's repeated refrain throughout the film to express both his openness and hospitality to the public and his "right" to reign as a despot in his "own place" is a simple definition of what his "place" is: "This is America." As "art," Sal's Wall stands on the threshold between the aesthetic and the rhetorical, functioning simultaneously as ornament and as propaganda, both a private collection and a public statement. The content of the statement occupies a similar threshold, the hyphenated space designated by "Italian-American," a hybrid of particular ethnic identification and general public identity. The Wall is important to Sal not just because it displays famous Italians but because they are famous *Americans* (Frank Sinatra, Joe DiMaggio, Liza Minelli, Mario Cuomo) who have made it possible for Italians to think of themselves as Americans, full-fledged members of the general public sphere. The Wall is important to Buggin' Out because it signifies exclusion from the public sphere. This may seem odd, since the neighborhood is filled with public representations of African-American heroes on every side: a huge billboard of Mike Tyson looms over Sal's pizzeria; children's art ornaments the sidewalks and graffiti streaks subversive messages like "Tawana told the Truth" on the walls; Magic Johnson T-shirts, Air Jordan sneakers, and a variety of jewelry and exotic hairdos make the characters like walking billboards for "black pride"; and the sound-world of the film is suffused with a musical "Wall of Fame," a veritable anthology of great jazz, blues, and popular music emanating from Mister Señor Love Daddy's storefront radio station, just two doors away from Sal's.

Why aren't these tokens of black self-respect enough for Buggin' Out? The answer, I think, is that they are only tokens of self-respect, of black pride, and what Buggin' Out wants is the respect of whites, the acknowledgment that African-Americans are hyphenated Americans, too, just like Italians.[26] The public spaces accessible to blacks are *only* public, and that only in the special way that the sphere of commercial-industrial publicity (a sphere that includes, by the way, movies themselves) is available to blacks. They are, like the public spaces in which black athletes and entertainers appear, rarely owned by blacks themselves; they are reminders that black public figures are by and large the "property" of a white-owned corporation—whether a professional sports franchise, a recording company, or a film distributor. The public spaces in which blacks achieve prominence are thus only sites of publicity, or of marginalized arts of resistance epitomized by graffiti, not of a genuine public sphere they may enter as equal citizens. These spaces, despite their glamour and magnitude, are not as important as the humble little piece of "real America" that is Sal's Pizzeria, the semi-

26. I am indebted to Joel Snyder for suggesting this distinction between self-respect and acknowledgment.

private, semi-public white-owned space, the threshold space that
supports genuine membership in the American public sphere. The one
piece of public art "proper" that appears in the film is an allegorical
mural across the street from Sal's, and it is conspicuously marginalized;
the camera never lingers on it long enough to allow decipherment of its
complex images. The mural is a kind of archaic residue of a past
moment in the black struggle for equality, when black pride was
enough. In *Do the Right Thing* the blacks have plenty of pride; what they
want, and cannot get, is the acknowledgment and respect of whites.

The film is not suggesting, however, that integrating the Wall of
Fame would solve the problem of racism or allow African-Americans to
enter the public sphere as full-fledged Americans. Probably the most
fundamental contradiction the film suggests about the whole issue of
public art is its simultaneous triviality and monumentality. The Wall of
Fame is, in a precise sense, the "cause" of the major violence in the
narrative, and yet it is also merely a token or symptom. Buggin' Out's
boycott fails to draw any support from the neighborhood, which gener-
ally regards his plan as a meaningless gesture. The racial integration of
the public symbol, as of the public accommodation, is merely a token of
public acceptance. Real participation in the public sphere involves more
than tokenism: it involves full economic participation. As long as blacks
do not own private property in this society, they remain in something
like the status of public art, mere ornaments to the public place, enter-
taining statues and abstract caricatures rather than full human beings.

Spike Lee has been accused by some critics of racism for projecting
a world of black stereotypes in his film: Tina, the tough, foul-mouthed
sexy ghetto "babe"; Radio Raheem, the sullen menace with his ghetto
blaster; Da Mayor, the neighborhood wino; Mother Sister, the domi-
neering, disapproving matriarch who sits in her window all day posed
like Whistler's mother. Lee even casts himself as a type: a streetwise,
lazy, treacherous hustler who hoards his money, neglects his child, and
betrays his employer by setting off the mob to destroy the pizzeria. But
it is not enough to call these stereotypes "unrealistic"; they are, from
another point of view, highly realistic representations of the public
images of blacks, the caricatures imposed on them and acted out by
them. Ruby Dee and Ossie Davis, whom Lee cast as the Matriarch and
the Wino, have a long history of participation in the film proliferation
of these images, and Dee's comment on the role of black elders is quite
self-conscious about this history: "'When you get old in this country,
you become a statue, a monument. And what happens to statues? Birds
shit on them. There's got to be more to life for an elder than that.'"[27]
The film suggests that there's got to be more to life for the younger

27. Quoted in Spike Lee and Lisa Jones, *Do the Right Thing: A Spike Lee Joint* (New
York, 1989), caption to pl. 30.

generation as well, which seems equally in danger of being smothered by the straitjacket of stereotypes. It is as if the film wanted to cast its characters as public statues with human beings imprisoned inside them, struggling to break out of their shells to truly participate in the public space where they are displayed.

This "breaking out" of the public image is what the film dramatizes and what constitutes the violence that pervades it. Much of this violence is merely trivial or irritating, involving the tokens of public display, as when an Irish-American yuppie homesteader steps on Buggin' Out's Air Jordans; some is erotic, as in Tina's dance as a female boxer, which opens the film; some is subtle and poetic, as in the scene when Radio Raheem breaks out of his sullen silence, turns off his blaster, and does a rap directly addressed to the camera, punctuating his lines with punches, his fists clad in massive gold rings that are inscribed with the words LOVE and HATE. Negative reactions to the film tend to focus obsessively on the destruction of the pizzeria, as if the violence against property were the only "real" violence in the film. Radio Raheem's death is regularly passed over as a mere link in the narrative chain that leads to the climactic spectacle of the burning pizzeria. Lee has also been criticized for showing this spectacle at all; the film has routinely been denounced as an incitement to violence, or at least a defense of rioting against white property as an act of justifiable violence in the black community. Commentators have complained that the riot is insufficiently motivated, or that it is just there for the spectacle, or to prove a thesis.[28] In particular, Lee has been criticized for allowing Mookie's character to "break out" of its passive, evasive, uncommitted stance at the crucial moment, when he throws the garbage can through the window.

Mookie's act dramatizes the whole issue of violence and public art by staging an act of vandalism against a public symbol, and specifically by smashing the plate-glass window that marks the boundary between public and private property, the street and the commercial interest.

28. Terrence Rafferty ("Open and Shut," review of *Do the Right Thing, The New Yorker*, 24 July 1989, pp. 78–81) makes all three complaints: Rafferty (1) reduces the film to a thesis about "the inevitability of race conflict in America"; (2) suggests that the violent ending comes only from "Lee's sense, as a filmmaker, that he needs a conflagration at the end"; and (3) compares Lee's film unfavorably to Martin Scorsese's *Mean Streets* and *Taxi Driver*, where "the final bursts of violence are generated entirely from within." What Rafferty fails to consider is (1) that the film explicitly articulates theses that are diametrically opposed to his reductive reading (most notably, Love Daddy's concluding call "my people, my people," for peace and harmony, a speech filled with echoes of Zora Neale Hurston's autobiography); (2) that the final conflagration might be deliberately staged *as a stagey, theatrical event* to foreground a certain "requirement" of the medium; (3) that the psychological conventions of Italian-American neorealism with their "inner" motivations for violence are precisely what is in question in *Do the Right Thing*.

Most of the negative commentary on the film has construed this action as a political statement, a call by Spike Lee to advance African-American interests by trashing white-owned businesses. Lee risks this misinterpretation, of course, in the very act of staging this spectacle for potential monumentalization as a public statement, a clearly legible image readable by all potential publics as a threat or model for imitation. But the fact that this event has emerged as the focus of principal controversy suggests that it is not so legible, not so transparent as it might have seemed. Spike Lee's motives as writer and director—whether to make a political statement, give the audience the spectacle it wants, or fulfill a narrative design—are far from clear. And Mookie's motivation as a character is equally problematic: at the very least, his action seems subject to multiple private determinations—anger at Sal, frustration at his dead-end job, rage at Radio Raheem's murder—that have no political or "public" content. At the most intimate level, Mookie's act hints at the anxieties about sexual violence that we have seen encoded in other public monuments. Sal has, in Mookie's view, attempted to seduce his beloved sister (whom we have seen in a nearly incestuous relation to Mookie in an opening scene), and Mookie has warned his sister never to enter the pizzeria again (this dialogue staged in front of the pizzeria's brick wall, spray-painted with the graffito message, "Tawana told the Truth," an evocation of another indecipherable case of highly publicized sexual violence). Mookie's private anxieties about his manhood ("Be a man, Mookie!" is his girlfriend Tina's hectoring refrain) are deeply inscribed in his public act of violence against the public symbol of white domination.

But private, psychological explanations do not exhaust the meaning of Mookie's act. An equally compelling account would regard the smashing of the window as an ethical intervention. At the moment of Mookie's decision the mob is wavering between attacking the pizzeria and assaulting its Italian-American owners. Mookie's act directs the violence away from persons and toward property, the only choice available in that moment. Mookie "does the right thing," saving human lives by sacrificing property.[29] Most fundamentally, however, we have to say that Lee himself "does the right thing" in this moment by breaking the illusion of cinematic realism and intervening as the director of his own

29. This interpretation was first suggested to me by Arnold Davidson, who heard it from David Wellbery of the department of comparative literature at Stanford University. It received independent confirmation from audiences to this paper at Harvard, California Institute of the Arts, Williams College, University of Southern California, UCLA, Pasadena Art Center, the University of Chicago's American Studies Workshop, the Chicago Art History Colloquium, and Sculpture Chicago's conference. I wish to thank the participants in these discussions for their many provocative questions and suggestions.

work of public art, taking personal responsibility for the decision to portray and perform a public act of violence against private property. This choice breaks the film loose from the *narrative* justification of violence, its legitimation by a law of cause and effect or political justice, and displays it as a pure effect of *this* work of art in this moment and place. The act makes perfect sense as a piece of Brechtian theater, giving the audience what it wants with one hand and taking it back with the other.

We may call *Do the Right Thing* a piece of "violent public art," then, in all the relevant senses—as a representation, an act, and a weapon of violence. But it is a work of *intelligent* violence, to echo the words of Malcolm X that conclude the film. It does not repudiate the alternative of nonviolence articulated by Martin Luther King in the film's other epigraph (this is, after all, a film, a symbolic and not a "real" act of violence); it resituates both violence and nonviolence as strategies within a struggle that is simply an ineradicable fact of American public life. The film may be suffused in violence, but unlike the "black Rambo" films that find such ready acceptance with the American public, it takes the trouble to differentiate this violence with ethically and aesthetically precise images. The film exerts a violence on its viewers, badgering us to "fight the power" and "do the right thing," but it never underestimates the difficulty of rightly locating the power to be fought, or the right strategy for fighting it. A prefabricated propaganda image of political or ethical correctness, a public monument to "legitimate violence" is exactly what the film refuses to be. It is, rather, a monument of resistance, of "intelligent violence," a ready-made assemblage of images that reconfigures a local space—literally, the space of the black ghetto, figuratively, the space of public images of race in the American public sphere. Like the Goddess of Liberty in Tiananmen Square, the film confronts the disfigured public image of legitimate power, holding out the torch of liberty with two hands, one inscribed with HATE, the other with LOVE.

If *Do the Right Thing* has a moral for those who wish to continue the tradition of public art and public sculpture as a utopian venture, a "daring to dream" of a more humane and comprehensive public sphere, it is probably in the opening lines of the film, uttered by the ubiquitous voice of Love Daddy: "Wake up!" Public art has always dared to dream, projecting fantasies of a monolithic, uniform, pacified public sphere. What seems called for now, and what many of our contemporary artists wish to provide, is a *critical* public art that is frank about the contradictions and violence encoded in its own situation, one that dares to awaken a public sphere of resistance, struggle, and dialogue. Exactly how to negotiate the border between struggle and dialogue, between the argument of force and the force of argument, is an open question.

"It resituates both violence and nonviolence as strategies within a struggle that is simply an ineradicable fact of American public life."

Violence as a way of achieving racial justice is both impractical and immoral. It is impractical because it is a descending spiral ending in destruction for all. The old law of an eye for an eye leaves everybody blind. It is immoral because it seeks to humiliate the opponent rather than win his understanding; it seeks to annihilate rather than to convert. Violence is immoral because it thrives on hatred rather than love. It destroys community and makes brotherhood impossible. It leaves society in monologue rather than dialogue. Violence ends by defeating itself. It creates bitterness in the survivors and brutality in the destroyers. [Martin Luther King, Jr., "Where Do We Go from Here?" *Stride toward Freedom: The Montgomery Story* (New York, 1958), p. 213]

I think there are plenty of good people in America, but there are also plenty of bad people in America and the bad ones are the ones who seem to have all the power and be in these positions to block things that you and I need. Because this is the situation, you and I have to preserve the right to do what is necessary to bring an end to that situation, and it doesn't mean that I advocate violence, but at the same time I am not against using violence in self-defense. I don't even call it violence when it's self-defense, I call it intelligence. [Malcolm X, "Communication and Reality," *Malcolm X: The Man and His Times*, ed. John Henrik Clarke (New York, 1969), p. 313]

The Counter-Monument: Memory against Itself in Germany Today

James E. Young

1. Introduction

As part of Germany's "Skulptur Projekte 87," the American geometric minimalist Sol Lewitt installed a large block of black stones smack in the middle of the plaza in front of the Münster Palace and dedicated it to "the missing Jews" of Münster.[1] It sat like an abandoned black coffin amidst soaring mock-baroque facades and gas lamps, a black blight squatting in the center of a sunny and graceful university square. In time, *Black Form* was covered by graffiti-scrawls and political slogans, which further heightened the contrast between it and its elegant surroundings. Chauffeurs for

This essay is an expanded version of a paper delivered at a conference on "Objective, Subjective, Intersubjective Time" sponsored by the Interdisciplinary Humanities Center at the University of California, Santa Barbara, 20-22 April 1990. I am grateful to Paul Hernadi, the organizer of the conference, for inviting me, and to the other participants as well (Marianna Torgovnick, Charles Altieri, and Somer Bodribb in particular) for the rich exchange of ideas that led to this more fully developed thesis on memory and time. In addition, I would like to thank Jochen Gerz, Esther Shalev-Gerz, and Horst Hoheisel for so graciously providing me with documentary materials surrounding the construction of their memorials. Karl Weber at the Kulturbehörde in Hamburg was generous with both his wide knowledge of new German memorials and his extensive archival resources as was Ralf Busch at the Hamburger Museum für Archäologie. Finally, I thank the John Simon Guggenheim Foundation for the fellowship that made this writing possible.
1. For documentation of this and other memorials in "Skulptur Projekte 87," see Volker Plagemann, *Kunst im öffentlichen Raum: Anstosse der 80er Jahre* (Cologne, 1989), pp. 140–42.

Critical Inquiry 18 (Winter 1992)

university administrators complained that it left them no room to turn their limousines around after dropping off their charges; other citizens objected to the way it spoiled the aesthetic integrity of an expensive new plaza. Despite angry protests by the installation curator and anguished pleas from the artist, a jackhammer crew from the university demolished *Black Form* in March 1988. An absent people would now be commemorated by an absent monument.

Memory of the monument remained strong in the community's mind, however. Eight months later, during commemorations of Kristallnacht, the city council asked the artist to reconstruct what they called a new "wall work" (*Mauerstücke*). Still faithful to his geometric medium, Lewitt agreed to remake his *Black Form*, a bleak reminder, he said, that without Jewish children in town, the monument would mark the end of generations. Within days, the threat of its reappearance reignited the debate over how to commemorate the Holocaust without seeming to violate contemporary spaces. A seminar was planned, with philosophers and art historians invited to reflect on the exhibition background, the nexus between seeing and thinking. Only the Green party dissented from the process, not because its members weren't in sympathy with the monument but because they feared that the controversy, meetings, aesthetic debates, and bureaucratic wrangling had all but displaced study of the period itself. Commemoration of events leading to Kristallnacht and the Holocaust would be lost in a sea of controversy, they said: no history here, just the unseemly haggling over the forms now taken by historical memory.[2]

But perhaps no single emblem better represents the conflicted, self-abnegating motives for memory in Germany today than the vanishing monument. On the one hand, no one takes their memorials more seriously than the Germans. Competitions are held almost monthly across the "fatherland" for new memorials against war and fascism, or for peace; or

2. When Münster's city council voted finally not to reerect Lewitt's sculpture in that city, Hamburg's Kulturbehörde (Cultural Authority) invited the artist to build in Hamburg any version of the form he wished. On 9 November 1989, the same day the Berlin Wall was breached, a larger version of Lewitt's *Black Form* was dedicated in the Platz der Republik, opposite the town hall in Hamburg-Altona.

James E. Young is assistant professor of English and Judaic studies at the University of Massachusetts, Amherst. He is the author of *Writing and Rewriting the Holocaust: Narrative and the Consequences of Interpretation* (1988) and *The Texture of Memory: Holocaust Memorials and Meaning in Europe, Israel, and America* (forthcoming), from which this essay is drawn. He is also the curator of "The Art of Memory," an exhibition at the Jewish Museum of New York (forthcoming).

Sol Lewitt, *Black Form (Dedicated to the Missing Jews)*, Platz der Republik, Hamburg-Altona, Germany. Photo: Kulturbehörde Hamburg.

to mark a site of destruction, deportation, or a missing synagogue; or to remember a lost Jewish community. Students devote their summers to concentration camp archaeology at Neuengamme, excavating artifacts from another, crueler age. Or they take hammer and nails to rebuild a synagogue in Essen, or to build a monument at the site of Dachau's former satellite camp at Landsberg. Brigades of young Germans once again report dutifully to Auschwitz, where they now repair delapidated exhibition halls, tend shrubs around the barracks, and hoe weeds from the no-man's-land strip between formerly electrified fences. No less industrious than the generations preceding them, German teenagers now work as hard at constructing memorials as their parents did in rebuilding the country after the war, as their grandparents did in building the Third Reich itself.

Nonetheless, Holocaust memorial-work in Germany today remains a tortured, self-reflective, even paralyzing preoccupation. Every monument, at every turn, is endlessly scrutinized, explicated, and debated. Artistic, ethical, and historical questions occupy design juries to an extent unknown in other countries. In a Sisyphian replay, memory is strenuously rolled nearly to the top of consciousness only to clatter back down in arguments and political bickering, whence it starts the climb all over again. Germany's ongoing *Denkmal-Arbeit* simultaneously displaces and constitutes the object of memory. Though some, like the Greens, might see such

absorption in the process of memorial building as an evasion of memory, it may also be true that the surest engagement with memory lies in its perpetual irresolution. In fact, the best German memorial to the Fascist era and its victims may not be a single memorial at all, but simply the never to be resolved debate over which kind of memory to preserve, how to do it, in whose name, and to what end. Instead of a fixed figure for memory, the debate itself—perpetually unresolved amid ever-changing conditions— might be enshrined.

Given the state-sponsored monument's traditional function as self-aggrandizing locus for national memory, the essential, nearly paralyzing ambiguity of German memory comes as no surprise. After all, while the victors of history have long erected monuments to remember their triumphs, and victims have built memorials to recall their martyrdom, only rarely does a nation call on itself to remember the victims of crimes it has perpetrated. Where are the national monuments to the genocide of American Indians, to the millions of Africans enslaved and murdered, to the kulaks and peasants starved to death by the millions?[3]

Traditionally, state-sponsored memory of a national past aims to affirm the righteousness of a nation's birth, even its divine election. The matrix of a nation's monuments traditionally emplots the story of ennobling events, of triumphs over barbarism, and recalls the martyrdom of those who gave their lives in the struggle for national existence—who, in the martyrological refrain, died so that a country might live. In suggesting themselves as the indigenous, even geological outcrops in a national landscape, monuments tend to naturalize the values, ideals, and laws of the land itself. To do otherwise would be to undermine the very foundations of national legitimacy, of the state's seemingly natural right to exist.

What then of Germany, a nation justly forced to remember the suffering and devastation it once caused in the name of its people? How does a state incorporate its crimes against others into its national memorial landscape? How does a state recite, much less commemorate, the litany of its misdeeds, making them part of its reason for being? Under what memorial aegis, whose rules, does a nation remember its own barbarity? Where is the tradition for mea(morial) culpa, when combined remem-

3. In the rare event when a state does commemorate its crimes, it is nearly always at the behest of formerly victimized citizens. The memorial unveiled 30 October 1990 in Moscow, for example, dedicated to "the millions of victims of a totalitarian regime," was instigated by a group calling itself "Memorial," composed of scholars, cultural figures, dissidents, and former victims of Stalin's terror. Likewise, a monument to the civil rights movement in Montgomery, Alabama—inscribed with the names of those who died for the cause—was commissioned and constructed by the Southern Poverty Law Center there, which had chronicled and prosecuted civil rights cases. In neither the Soviet nor American case did the government initiate the monument, but in both instances representatives of the state later endorsed these memorials—a move by which both current governments sought to create an official distance between themselves and past, guilty regimes.

brance and self-indictment seem so hopelessly at odds? Unlike state-sponsored memorials built by victimized nations and peoples to themselves in Poland, France, Holland, or Israel, those in Germany are necessarily those of the persecutor remembering its victims. In the face of this necessary breach in the conventional "memorial code," it is little wonder that German national memory remains so torn and convoluted: it is that of a nation tortured by its conflicted desire to build a new and just state on the bedrock memory of its horrendous crimes.

One of the contemporary results of Germany's memorial conundrum is the rise of its "counter-monuments": brazen, painfully self-conscious memorial spaces conceived to challenge the very premises of their being. On the former site of Hamburg's greatest synagogue, at Bornplatz, Margrit Kahl has assembled an intricate mosaic tracing the complex lines of the synagogue's roof construction: a palimpsest for a building and community that no longer exist. Norbert Radermacher bathes a guilty landscape in Berlin's Neukölln neighborhood with the inscribed light of its past. Alfred Hrdlicka began (but never finished) a monument in Hamburg to counter—and thereby neutralize—an indestructible Nazi monument nearby. In a suburb of Hamburg, Jochen Gerz and Esther Shalev-Gerz have erected a black pillar against fascism and for peace designed to disappear altogether over time. The very heart of Berlin, former site of the gestapo headquarters, remains a great, gaping wound as politicians, artists, and various committees forever debate the most appropriate memorial for this site.[4]

Ethically certain of their duty to remember, but aesthetically skeptical of the assumptions underpinning traditional memorial forms, a new generation of contemporary artists and monument makers in Germany is probing the limits of both their artistic media and the very notion of a memorial. They are heirs to a double-edged postwar legacy: a deep distrust of monumental forms in light of their systematic exploitation by the Nazis and a profound desire to distinguish their generation from that of the killers through memory.[5] At home in an era of earthworks, conceptual and self-destructive art, these young artists explore both the necessity of memory and their incapacity to recall events they never experienced directly. To their minds, neither literal nor figurative references suggesting anything more than their own abstract link to the Holocaust will suffice. Instead of seeking to capture the memory of events, therefore, they

4. The long-burning debate surrounding projected memorials, to the *Gestapo-Gelände* in particular, continues to exemplify both the German memorial conundrum and the state's painstaking attempts to articulate it. For an excellent documentation of the process, see *Topographie des Terrors: Gestapo, SS und Reichssicherheitshauptamt auf dem "Prinz-Albrecht-Gelände,"* ed. Reinhard Rürup (Berlin, 1987). For a shorter account, see James E. Young, "The Topography of German Memory," *The Journal of Art* 1 (Mar. 1991): 30.

5. For an elaboration of this theme, see Matthias Winzen, "The Need for Public Representation and the Burden of the German Past," *Art Journal* 48 (Winter 1989): 309–14.

remember only their own relationship to events: the great gulf of *time* between themselves and the Holocaust.

For young German artists and sculptors like the Gerzes, Norbert Radermacher, and Horst Hoheisel, the possibility that memory of events so grave might be reduced to exhibitions of public craftsmanship or cheap pathos remains intolerable. They contemptuously reject the traditional forms and reasons for public memorial art, those spaces that either console viewers or redeem such tragic events, or indulge in a facile kind of *Wiedergutmachung* or purport to mend the memory of a murdered people. Instead of searing memory into public consciousness, they fear, conventional memorials seal memory off from awareness altogether. For these artists such an evasion would be the ultimate abuse of art, whose primary function, to their mind, is to jar viewers from complacency and to challenge and denaturalize the viewers' assumptions. In the following case studies of three contemporary counter-monuments, we explore the process whereby artists renegotiate the tenets of their memory-work, whereby monuments are born resisting the very possibility of their birth.

2. The Counter-Monument

To some extent, this new generation of artists in Germany may only be enacting a critique of "memory places" already formulated by cultural and art historians long skeptical of the memorial's traditional function. It is more than fifty years, for example, since Lewis Mumford pronounced the death of the monument in its hopeless incompatibility with his sense of modern architectural forms. "The notion of a modern monument is veritably a contradiction in terms," he wrote. "If it is a monument it is not modern, and if it is modern, it cannot be a monument." In Mumford's view, the monument defied the very essence of modern urban civilization: the capacity for renewal and rejuvenation. Where modern architecture invites the perpetuation of life itself, encourages renewal and change, and scorns the illusion of permanence, Mumford wrote, "stone gives a false sense of continuity, and a deceptive assurance of life."[6]

More recently, German historian Martin Broszat has suggested that in their references to the fascist era, monuments may not remember events so much as bury them altogether beneath layers of national myths and explanations. As cultural reifications, in this view, monuments reduce or, using Broszat's term, "coarsen" historical understanding as much as they generate it.[7] In another vein, art historian Rosalind Krauss finds that

6. Lewis Mumford, *The Culture of Cities* (New York, 1938), pp. 438, 435.

7. For the full, much more complex context of Broszat's remarks, see the exchange of letters between him and Saul Friedländer in Martin Broszat and Saul Friedländer, "Um die

the modernist period produces monuments unable to refer to anything beyond themselves as pure marker or base.[8] After Krauss we might ask, in fact, whether an abstract, self-referential monument can ever commemorate events outside of itself. Or must it motion endlessly to its own gesture to the past, a commemoration of its essence as dislocated sign, forever trying to remember events it never actually knew?

Still others have argued that rather than embodying memory, the monument displaces it altogether, supplanting a community's memory-work with its own material form. "The less memory is experienced from the inside," Pierre Nora warns, "the more it exists only through its exterior scaffolding and outward signs."[9] If the obverse of this is true as well, then perhaps the more memory comes to rest in its exteriorized forms, the less it is experienced internally. In this age of mass memory production and consumption, in fact, there seems to be an inverse proportion between the memorialization of the past and its contemplation and study. For once we assign monumental form to memory, we have to some degree divested ourselves of the obligation to remember. In shouldering the memory-work, monuments may relieve viewers of their memory-burden.

As Nora concludes here, "memory has been wholly absorbed by its meticulous reconstitution. Its new vocation is to record; delegating to the archive [*lieu de mémoire*] the responsibility of remembering, it sheds its signs upon depositing them there, as a snake sheds its skin" ("BMH," p. 13). As a result, the memorial operation remains self-contained and detached from our daily lives. Under the illusion that our memorial edifices will always be there to remind us, we take leave of them and return only at our convenience. To the extent that we encourage monuments to do our memory-work for us, we become that much more forgetful. In effect, the initial impulse to memorialize events like the Holocaust may actually spring from an opposite and equal desire to forget them.

In response to these seemingly generic liabilities in monuments, con-

'Historisierung des Nationalsozialismus': Ein Briefwechsel," *Vierteljahreshefte für Zeitgeschichte* 36 (Apr. 1988): 339–72; trans. under the title, "A Controversy about the Historicization of National Socialism," *Yad Vashem Studies*, no. 19 (1988): 1–47, and *New German Critique* 44 (Spring/Summer 1988): 85–126. The exchange was sparked by Friedländer's response to Broszat's "Plädoyer für eine Historisierung des Nationalsozialismus," *Merkur* 39 (May 1985): 373–85. Broszat's specific reference to monuments comes near the end of the first letter in his comments on "mythical memory," which he distinguishes from "scientific insight" (p. 90).

8. See Rosalind E. Krauss, *The Originality of the Avant-Garde and Other Modernist Myths* (Cambridge, Mass., 1984), p. 280.

9. Pierre Nora, "Between Memory and History: *Les Lieux de mémoire*," trans. Marc Roudebush, *Representations*, no. 26 (Spring 1989): 13; hereafter abbreviated "BMH"; "this text constitutes the theoretical introduction to a vast collaborative work on the national memory of France that I titled *Les Lieux de mémoire*" (p. 25).

ceptual artists Jochen and Esther Gerz have designed what they call a
Gegendenkmal—built at the city of Hamburg's invitation to create a
"Monument against Fascism, War and Violence—and for Peace and
Human Rights." The artists' first concern was how to commemorate such
worthy sentiments without ameliorating memory altogether. That is, how
would their monument emplace such memory without usurping the com-
munity's will to remember? Their second reservation was how to build an
antifascist monument without resorting to what they regarded as the fas-
cist tendencies in all monuments. "What we did not want," Jochen Gerz
declared, "was an enormous pedestal with something on it presuming to
tell people what they ought to think."[10] To their minds, the didactic logic
of monuments, their demagogical rigidity, recalled too closely traits they
associated with fascism itself. Their monument against fascism, therefore,
would amount to a monument against itself: against the traditionally
didactic function of monuments, against their tendency to displace the
past they would have us contemplate—and finally, against the authoritar-
ian propensity in all art that reduces viewers to passive spectators.

With these conditions in mind, the artists decided that theirs would
be a self-abnegating monument. So when the city of Hamburg offered
them a sun-dappled park setting, they rejected it in favor of what they
termed a "normal, uglyish place." Their counter-monument would not
be refuge in memory, tucked away from the hard edges of urban life, but
one more eyesore among others on a blighted cityscape. They chose the
commercial center of Harburg, a somewhat dingy suburb of Hamburg,
located across the river, thirty minutes from the city center, just beyond a
dioxin dump. It is populated with a mix of Turkish *Gastarbeiter* and Ger-
man blue-collar families. Set in a pedestrian shopping mall, their
counter-monument would rise sullenly amidst red brick and glass shop
windows: package-laden shoppers could like it or hate it, but they could
not avoid it.

Unveiled in Harburg in 1986, this twelve-meter high, one-meter
square pillar is made of hollow aluminum, plated with a thin layer of soft,
dark lead. A temporary inscription near its base reads—and thereby cre-
ates constituencies—in German, French, Russian, Hebrew, Arabic, Turk-
ish, and English:

We invite the citizens of Harburg and visitors to the town, to add
their names here to ours. In doing so, we commit ourselves to remain
vigilant. As more and more names cover this 12 meter tall lead col-
umn, it will gradually be lowered into the ground. One day, it will
have disappeared completely and the site of the Harburg monument

10. Quoted in Claude Gintz, "'L'Anti-Monument' de Jochen et Esther Gerz," *Galeries
Magazine* 19 (June–July 1987): 87.

A local woman makes her contribution to the Harburg monument. Photos: James E. Young.

Jochen Gerz and Esther Shalev-Gerz, *Harburg Monument against Fascism*, June 1989.

 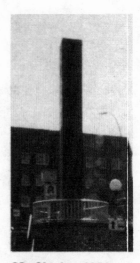

10. Oktober 1986 . **1. September 1987** **23. Oktober 1988**
Einweihung **1. Absenkung** **2. Absenkung**

The unveiling and first four sinkings of the *Harburg Monument against Fascism*. From the invitation to the ceremony commemorating the fifth sinking, courtesy Jochen Gerz and Esther Shalev-Gerz.

against fascism will be empty. In the end, it is only we ourselves who can rise up against injustice.

A steel-pointed stylus with which to score the soft lead is attached at each corner by a length of cable. As one-and-a-half-meter sections are covered with memorial graffiti, the monument is lowered into the ground, into a chamber as deep as the column is high. The more actively visitors participate, the faster they cover each section with their names, the sooner the monument will disappear. After several lowerings over the course of four or five years, nothing will be left but the top surface of the monument, which will be covered with a burial stone inscribed to "Harburg's Monument against Fascism." In effect, the vanishing monument will have returned the burden of memory to visitors: one day, the only thing left standing here will be the memory-tourists, forced to rise and to remember for themselves.

With audacious simplicity, the counter-monument thus flouts any

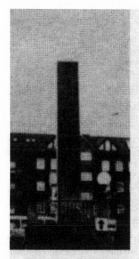 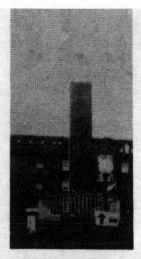

6. September 1989 22. Februar 1990 4. Dezember 1990
3. Absenkung 4. Absenkung 5. Absenkung

number of cherished memorial conventions: its aim is not to console but to provoke; not to remain fixed but to change; not to be everlasting but to disappear; not to be ignored by its passersby but to demand interaction; not to remain pristine but to invite its own violation and desecration; not to accept graciously the burden of memory but to throw it back at the town's feet. By defining itself in opposition to the traditional memorial's task, the counter-monument illustrates concisely the possibilities and limitations of all memorials everywhere. In this way, it functions as a valuable "counter-index" to the ways time, memory, and current history intersect at any memorial site.

In Germany today, not only does the monument vanish, but so too do the traditional notions of the monument's performance. How better to remember forever a vanished people than by the perpetually unfinished, ever-vanishing monument? As if in mocking homage to national forebears who had planned the Holocaust as a self-consuming set of events—that is, intended to destroy all traces of itself, all memory of its victims—the

Gerzes have designed a self-consuming memorial that leaves behind only the rememberer and the memory of a memorial. As the self-destroying sculpture of Jean Tinguely and others challenged the very notion of sculpture, the vanishing monument similarly challenges the idea of monumentality and its implied corollary, permanence.

Indeed, after nearly three decades of self-destroying sculpture, the advent of a self-consuming monument might have been expected. But while self-consuming sculpture and monuments share a few of the same aesthetic and political motivations, each also has its own reasons for vanishing. Artists like Tinguely created self-destroying sculpture in order to preempt the work's automatic commodification by a voracious art market. At the same time, and by extension, these artists hoped such works would thereby remain purely public and that by vanishing, would leave the public in a position to examine itself as part of the piece's performance. "The viewer, in effect, [becomes] the subject of the work," as Douglas Crimp has observed. Or, in Michael North's elaboration of this principle, "the public *becomes* the sculpture."[11]

The Gerzes' counter-monument takes this insight several steps further. "Art, in its conspicuousness, in its recognizability, is an indication of failure," Jochen Gerz has said. "If it were truly consumed, no longer visible or conspicuous, if there were only a few manifestations of art left, it would actually be where it belongs—that is, *within* the people for whom it was created."[12] The counter-monument is direct heir to Gerz's thesis on art and being, his ambivalence toward art's objecthood. For Gerz, it seems, once the art object stimulates in the viewer a particular complex of ideas, emotions, and responses that then come to exist in the viewer independently of further contact with the piece of art, it can wither away, its task accomplished. By extension, once the monument moves its viewers to memory, it also becomes unnecessary and so may disappear. As a result, Gerz suggests, "we will one day reach the point where anti-Fascist memorials will no longer be necessary, when vigilance will be kept alive by the invisible pictures of remembrance."[13] "Invisible pictures," in this case, would correspond to our internalized images of the memorial itself, now locked into the mind's eye as a source of perpetual memory. All that

11. Douglas Crimp, "Serra's Public Sculpture: Redefining Site Specificity," in *Richard Serra/Sculpture,* ed. Krauss (exhibition catalog, Museum of Modern Art, New York, 27 Feb.–13 May 1986), p. 43; Michael North, "The Public as Sculpture: From Heavenly City to Mass Ornament," *Critical Inquiry* 16 (Summer 1990): 861. As North shows, such an impulse has a long history in its own right. For further discussion of these dimensions of contemporary sculpture, see Henry M. Sayre, *The Object of Performance: The American Avant-Garde since 1970* (Chicago, 1989); Lucy R. Lippard, *Changing: Essays in Art Criticism* (New York, 1971), esp. pp. 261–64; and Crimp, "Serra's Public Sculpture."

12. Quoted in Doris von Drateln, "Jochen Gerz's Visual Poetry," trans. Ingeborg von Zitzewitz, *Contemporanea* 2 (Sept. 1989): 47.

13. Ibid.

remains, then, is the memory of the monument, an afterimage projected onto the landscape by the rememberer. The best monument, in Gerz's view, may be no monument at all, but only the memory of an absent monument.

The Gerzes are highly regarded in Europe as poets and photographers, and as conceptual and performance artists. In fact, much of their conceptual art conflates photographs and poetry, overlaying image with word. In their performances, they aspire simultaneously to be "the painter, medium, paintbrush, and not just witness to a work."[14] In their counter-monument, the artists have attempted a "performative piece" that initiates a dynamic relationship between artists, work, and viewer, in which none emerges singularly dominant. In its egalitarian conception, the counter-monument would not just commemorate the antifascist impulse but enact it, breaking down the hierarchical relationship between art object and its audience. By inviting its own violation, the monument humbles itself in the eyes of beholders accustomed to maintaining a respectful, decorous distance. It forces viewers to desanctify the memorial, demystify it, and become its equal. The counter-monument denaturalizes what the Gerzes feel is an artificial distance between artist and public generated by the holy glorification of art. Ultimately, such a monument undermines its own authority by inviting and then incorporating the *author*ity of passersby.

In fact, in this exchange between artist, art object, and viewer, the sense of a single authority, a single signatory, dissolves altogether: that the work was never really self-possessing and autonomous is now made palpable to viewers. The artist provides the screen, passersby add their names and graffiti to it, which causes the artist to sink the monument into the ground and open up space for a fresh exchange. It is a progressive relationship, which eventually consumes itself, leaving only the unobjectified memory of such an exchange. In its abstract form, this monument claims not to prescribe—the artists might say dictate—a specific object of memory. Rather, it more passively accommodates all memory and response, as the blank-sided obelisk always has. It remains the obligation of passersby to enter into the art: it makes artist-rememberers and self-memorializers out of every signatory. By inviting viewers to commemorate themselves, the counter-monument reminds them that to some extent all any monument can do is provide a trace of its makers, not of the memory itself.

The Gerzes' monument is intended to be a visual pun. As the monument would rise up symbolically against fascism before disappearing, it calls on us to rise up literally in its stead. It reminds us that all monuments can ever do is rise up symbolically against injustice, that the practical outcome of any artist's hard work is dissipated in its symbolic gesture. The Gerzes suggest here that it is precisely this impotence of the symbolic

14. Quoted in Gintz, "'L'Anti-Monument' de Jochen et Esther Gerz," p. 80.

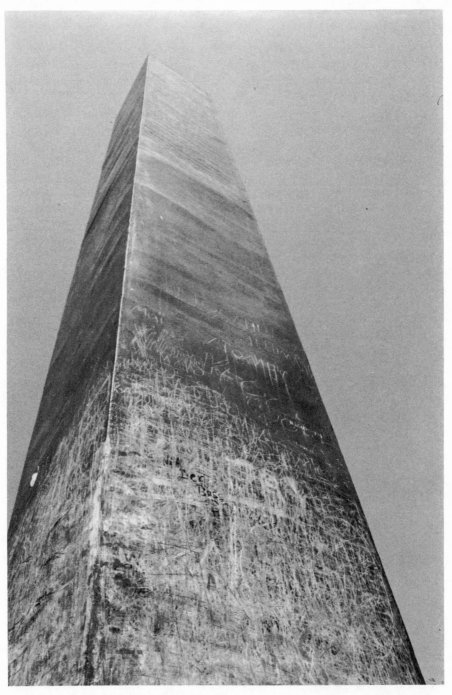

Harburg Monument against Fascism, viewed from its base, June 1989. Photo: James E. Young.

stand that they abhor in art, the invitation to vicarious resistance, the sub-limation of response in a fossilized object. In contrast, they hope that the counter-monument will incite viewers, move them beyond vicarious response to the actual, beyond symbolic gesture to action.

From the beginning, the artists had intended this monument to torment—not reassure—its neighbors. They have likened it, for example, to a great black knife in the back of Germany, slowly being plunged in, each thrust solemnly commemorated by the community, a self-mutilation, a kind of topographical hara-kiri.[15] The counter-monument objectifies for the artists not only the Germans' secret desire that all these monuments just hurry up and disappear but also the urge to strike back at such memory, to sever it from the national body like a wounded limb. In partic-ular, the Gerzes take mischievous, gleeful delight in the spectacle of a Ger-man city's ritual burial of an antifascist monument it just spent $144,000 to make—enough, in the words of Hamburg's disgruntled mayor, to repave ninety-seven yards of Autobahn. Indeed, the fanfare and celebra-tion of its 1986 unveiling are repeated in all subsequent lowerings, each attended by eager city politicians, invited dignitaries, and local media. That so many Germans would turn out in such good faith to cheer the destruction of a monument against fascism exemplifies, in the artists' eyes, the essential paradox in any people's attempt to commemorate its own misdeeds.

At every sinking, the artists attempt to divine a little more of the local reaction. "What kind of monument disappears?" some citizens demand to know. "Is it art when we write all over it?" ask teenagers. At one point, the Gerzes went from shop to shop to gather impressions, which varied from satisfaction at the attention it had generated in their commercial district to other, less encouraging responses. "They ought to blow it up," said one. Another chimed in, "It's not so bad as far as chimneys go, but there ought to be some smoke coming out of it."[16] The Gerzes found that even resent-ment is a form of memory.

In their original conception, the Gerzes had hoped for row upon row of neatly inscribed names, a visual echo of the war memorials of another age. This black column of self-inscribed names might thus remind all

15. The Gerzes made a public presentation on the *Gegendenkmal* at a conference on "Kunst und Holocaust" at the Evangelischen Akademie-Loccum, West Germany, 20 May 1989. Speaking in German to a German audience, Berlin-born Jochen Gerz was making an obvious, if ironic, allusion to the Nazis' own, notoriously literal-minded reference to being "stabbed in the back" by enemies internal, external, and imagined. Appropriating the Nazis' language in this way was clearly intended both as a provocation and as an ironic self-identification by the Gerzes as "enemies of the Reich." See *Kunst und Holocaust: Bildliche Zeugen von Ende der Westlichen Kultur,* ed. Detlef Hoffmann and Karl Ermert (Rehburg-Loccum, Germany, 1990).

16. Quoted in Michael Gibson, "Hamburg: Sinking Feelings," *ARTnews* 86 (Summer 1987): 106–7; hereafter abbreviated "H."

Harburg Monument against Fascism, details of graffiti. On the left, the names first inscribed on the monument, including the artists'. On the right, graffiti on the monument between the fourth and fifth sinkings. Photos: Jochen Gerz and Esther Shalev-Gerz.

visitors of their own mortality, not to mention the monument's. Execution did not follow design, however, and even the artists were taken aback by what they found after a couple of months: an illegible scribble of names scratched over names, all covered over in a spaghetti scrawl, what Jochen likened to a painting by Mark Tobey. People had come at night to scrape over all the names, even to pry the lead plating off its base. There were hearts with "Jürgen liebt Kirsten" written inside, stars of David, and funny faces daubed in paint and marker pen. Inevitably, swastikas also began to appear: how better to remember what happened than by the Nazis' own sign? After all, Jochen insists, "a swastika is also a signature." In fact, when city authorities warned of the possibility of vandalism, "why not give that phenomenon free rein, [the Gerzes] suggested, and allow the monument to document the social temperament in that way?" ("H," p. 106).

The town's citizens were not as philosophical, however, and began to condemn the monument as a trap for graffiti. It was almost as if the monument, covered over in this scrawl, taunted visitors in its ugliness. But what repels critics more is not clear. Is it the monument's unsightly form or the grotesque sentiments it captures and then reflects back to the community? As a social mirror, it becomes doubly troubling in that it reminds the community of what happened then and, even worse, how they now respond to the memory of this past. To those members of the community who deplore the ease with which this work is violated, the local newspaper answered succinctly: "The filth brings us closer to the truth than would any list of well-meaning signatures. The inscriptions, a conglomerate of approval, hatred, anger and stupidity, are like a fingerprint of our city applied to the column" (quoted in "H," p. 107). The counter-monument accomplishes what all monuments must: it reflects back to the people— and thus codifies—their own memorial projections and preoccupations.

Its irreverence notwithstanding, the memorial quality to most graffiti is legendary: we know Kilroy was here, that he existed, by the inscribed trace he left behind. As wall and subway graffiti came to be valued as aesthetic expressions of protest, however, they were also appropriated commercially by galleries and museums, which absorbed such graffiti as a way of naturalizing—hence neutralizing—it (how else does one violate a graffiti-covered wall? By cleaning it?). In its gestures to both graffiti artists and to the *Mauerkunst* of the Berlin Wall, the counter-monument points guiltily at its own official appropriation of guerrilla art, even as it redeems itself in its eventual self-destruction.

In addition to demonstrating the impulse toward self-memorialization and the violation of public space, some of these graffiti also betray the more repressed xenophobia of current visitors. Inscriptions like *"Ausländer raus"* echo an antipathy toward more recent national "guests," as well as the defilement of Jewish cemeteries and other memorials in Germany. By retaining these words, the counter-monument acknowledges that all monuments ultimately make such emendations part of their

Harburg Monument against Fascism, almost gone, August 1991. Photo: James E. Young.

memorial texts. That is, the monument records the response of today's visitors for the benefit of tomorrow's, thus reminding all of their shared responsibility in that the recorded responses of previous visitors at a memorial site become part of one's own memory.

Finally, part of the community's mixed reaction to the counter-monument may also have been its discomfort with this monument's very liveliness. Like other forms of art, the monument is most benign when static: there when you face it, gone when you turn your back. But when it begins to come to life, to grow, shrink, or change form, the monument may become threatening. No longer at the mercy of the viewer's will, it seems to have a will of its own, to beckon us at inopportune moments. Such monuments become a little like Frankenstein's monster, a golem out of the maker's control.

3. The Disruption of Public Space

Before the citizens of Hamburg bury their counter-monument for the last time, another conceptual memorial will be "unveiled" in the Neukölln district of Berlin—the former site of a forced labor camp and one of Sachsenhausen's satellite camps. Though Norbert Radermacher's memorial in Neukölln will bear little formal resemblance to the Gerzes' counter-monument, both its concept and spirit promise to make it a kindred soul. Like its Hamburg cousin, Radermacher's memorial at

Neukölln integrates written text and disappears. Unlike the permanently vanished column, however, Radermacher's memorial then reappears with the entry of every new passerby into its space.

In Radermacher's design, pedestrians strolling along the Sonnen-allee, next to the sports fields (former site of the *KZ-Aussenlager* [satellite concentration camp]), trip a light-beam trigger that in turn flicks on a high-intensity slide projection of a written text relating the historical details of this site's now-invisible past. From a slide projector mounted atop a five-meter-high pole, in the artist's words,

> the lettering from this text is beamed first onto the crowns of the trees, where one can see the text but cannot quite read it. Slowly, it moves down to the wire fence [surrounding the sports ground and perimeter of the former camp] until the words become more clear and legible. The text is then projected onto the sidewalk, where we can read it quite clearly. It remains for one minute before slowly fading out.[17]

In effect, by overlaying the nearby trees, houses, fence, and pavement in this way, the high-intensity beam literally bathes an otherwise forgetful site in the light of its own past—a spotlight from which neither the site nor pedestrians can hide.

As innovative as it is, no installation could also be truer to the artist's previous work. For years, Radermacher has made public spaces his primary canvas, creating installation texts precisely in the minimal disruption of public spaces. His aim has not been to remake these spaces, but to add to them in ways that cause the public to see and experience them anew. In the most unlikely settings he installs small, unexpected objects that disrupt the space on the one hand, but remain so unobtrusive as to be almost absorbed: a white, foot-high stone obelisk beneath an overpass in Berlin; a round, cakelike white stone under another bridge in Düsseldorf; small seashells affixed to the stone balustrade of a Parisian cathedral. A palm-sized, square mirror attached to a long brick wall reflects sky and trees in Paris; a small concrete gyrocompass lies on its side, lost amidst the cobble-stones of an immense square in Düsseldorf.[18] Each of these causes pedestrians to pause, if only momentarily, on realizing they have accidentally entered an artist's installation, a space they had previously regarded as banal. What is it? they ask. Who made it? And why is it here? Radermacher delights in such questions, of course, and knows that by their public

17. Norbert Radermacher, quoted in *Gedenkstätte KZ–Aussenlager Sonnenallee Berlin-Neukölln: Bericht der Vorprüfung* (Berlin, 1989), p. 20; my translation. I am indebted to Jochen Spielmann, coordinator of this competition, for so generously providing me with all of its documentation.

18. See Radermacher, *Stücke für Stadt,* catalog from the Künstlerhaus Bethanien (Berlin, 1985).

nature, these installations are irreproducible in the museum or gallery—thereby resisting commodification as well.

Like the Gerzes' monument, the memorial installation at Neukölln is meant to be ever-changing. According to Radermacher, the total message of his memorial text will never repeat itself: various times of the day, climate, seasons, and bystanders will ensure that no two showings are exactly alike. By day, the landscape will appear to be speckled with text, while by night distinct words will assume the very shapes of the objects over which they are draped. In a night rain, the droplet-filled air itself will become the medium for a message that cannot be washed away. Once the landscape has been overlaid with its memorial inscription, it retains an afterimage in visitors' minds—and is therefore never innocent of memory again.

In addition, the artist has invited schoolchildren to continue researching the history of the area before adding their own slide texts to his. By integrating the children's messages, the artist hopes to illustrate both the capacity in his memorial to absorb new meanings in new times and the essentially participatory nature of all memorials. In effect, Radermacher would remind us that all such sites depend for their memory on the passersby who initiate it—however involuntarily. He also suggests that the site alone cannot remember, that it is the projection of memory by visitors into a space that makes it a memorial. The site catches visitors unaware, but is no longer passive and intrudes itself into the pedestrians' thoughts. Of course, such memory can also be avoided by simply crossing the street or ducking under the light-beam trigger. But even this would be a memorial act of sorts, if only in opposition. For to avoid the memorial here, we would first have to conjure the memory to be avoided: that is, we would have to remember what it is we want to forget.

Until the installation of this mechanism sometime in 1992—a memory implant, as it were—there will be no sign that this site was ever anything other than what it appears to be: sports fields and an empty lot. The particular slice of history to be projected begins in 1941 when the German branch of the National Cash Register Company, an American firm, bought the property occupying 181–189 Sonnenallee as part of its wartime expansion. Having waxed and waned during the First World War, the depression, and the era of inflation, business at NCR began to boom in 1941 with the addition of its munitions plant at Neukölln. As part of its expansion, the company built a factory at one end of the site and barracks for slave labor at the other end, called NCR Colony, one of dozens of forced labor camps in Berlin alone.

Between 1942 and 1944, the number of foreign, mostly female slave laborers from Poland, the Soviet Union, and France fluctuated between 400 and 863. Then, in August 1944, the barracks were cleared for another kind of occupant: some 500 Jewish women from the Lodz ghetto. Having survived transports from the ghetto to Auschwitz during the early

summer of 1944, and then from Auschwitz to Sachsenhausen that fall, these women were shipped into Neukölln as slave laborers at NCR's munitions plant. From September 1944 to April 1945, the camp at Neukölln was thus turned into one of Sachsenhausen's many satellite camps. Bombings forced the women into shelters during much of the early spring in 1945, and, as the Red Army approached in April, the SS shipped these women back to Sachsenhausen, whence they were transported to Ravensbrück, the women's concentration camp. In the last days of the war, most of this group was taken by train to Sweden in Aktion Bernadotte, a rescue operation supervised by the Swedish Red Cross. The rest of the women escaped from a forced march to Lübeck, along with other survivors of Ravensbrück.

By May 1945 little remained of the *Lager* itself or the NCR factory next door, which had been dismantled by the Red Army and shipped back to the Soviet Union. Over the next few years, the cash register factory was rebuilt and, despite its low priority among American investors, flourished for awhile during the 1950s, when it exported its machines around the world. By the 1960s, however, bad management led to its closing; the factory was demolished and sports fields were put into its cleared space. The three-meter fence now surrounding the fields is said to be exactly as high as that once enclosing the forced labor and satellite camps here—the lone physical reference to the site's past.

Other than the projected text, Radermacher prefers to leave the site unaltered, a reminder of absence and the effacement of memory—and of the deliberate effort it takes to remember. Though the precise text to be projected has not been decided at this writing, early drafts included these details:

> On the site of the Sonnenallee 181–189, between fall 1942 and summer 1944, there was a *Lager* for forced labor. After that it was an *Aussenlager* for KZ-Sachsenhausen, in which 500 women were imprisoned, most of them Polish Jews. These women were forced to work in the National Cash Register Company factory when it was converted into a weapons production plant.[19]

The site-disruption, in this case, is the equivalent of a memorial inscription, reinvesting an otherwise unremarkable site with its altogether remarkable past. In fact, by leaving the site physically unaltered, the artist allows the site to retain a facade of innocence only so that he might betray more forcefully its actual historical past. Radermacher's memorial thus reminds us that the history of this site also includes its own forgetfulness, its own memory lapse.

19. Ibid., p. 7.

4. The Negative-Form Monument

When the city of Kassel invited artists to consider ways to rescue one of its destroyed historical monuments—the Aschrott-Brunnen—local artist Horst Hoheisel decided that neither a preservation of its remnants nor its mere reconstruction would do. For Hoheisel, even the fragment was a decorative lie, suggesting itself as the remnant of a destruction no one knew very much about. Its pure reconstruction would have been no less offensive: not only would self-congratulatory overtones of *Wieder-gutmachung* betray an irreparable violence, but the artist feared that a reconstructed fountain would only encourage the public to forget what had happened to the original.

In the best tradition of the counter-monument, therefore, Hoheisel proposed a "negative-form" monument to mark what had once been the Aschrott Fountain in Kassel's City Hall Square. Originally this had been a twelve-meter-high, neo-Gothic pyramid fountain, surrounded by a reflecting pool set in the main town square in 1908. It was designed by the City Hall architect, Karl Roth, and funded by a Jewish entrepreneur from Kassel, Sigmund Aschrott, whose name it bore. But as a gift from a Jew to the city, it was condemned by the Nazis as the "Jews' Fountain" and so demolished during the night of 8 April 1939 by Nazi activists, its pieces carted away by city work crews over the next few days. Within weeks, all but the sandstone base had been cleared away, leaving only a great, empty basin in the center of the square. Two years later, the first transport of 463 Kassel Jews departed from the Hauptbahnhof to Riga, followed in the next year by another 3,000, all murdered. In 1943, the city filled in the fountain's basin with soil and planted flowers; local burghers then dubbed it "Aschrott's Grave."

During the growing prosperity of the 1960s, the town turned Aschrott's Grave back into a fountain, *sans* pyramid. But by then only a few of the city's oldtimers could recall that its name had ever been Aschrott's anything. When asked what had happened to the original fountain, they replied that to their best recollection it had been destroyed by English bombers during the war. In response to this kind of fading memory, the "Society for the Rescue of Historical Monuments" (if not history itself) proposed in 1984 that some form of the fountain and its history be restored—and that it recall all the founders of the city, especially Sigmund Aschrott.

On being awarded the project, Hoheisel described both the concept and form underlying his negative-form monument:

> I have designed the new fountain as a mirror image of the old one, sunk beneath the old place, in order to rescue the history of this place as a wound and as an open question, to penetrate the consciousness of the Kassel citizens—so that such things never happen again.

Original Aschrott-Brunnen, Kassel, Germany, ca. 1930. Photo: Kassel Kulturamt.

Reflecting pool of the original Aschrott-Brunnen after "Aschrott's Grave" was turned back into a fountain, *sans* pyramid, Kassel, ca. 1966. Photo: Kassel Kulturamt.

That's why I rebuilt the fountain sculpture as a hollow concrete form after the old plans and for a few weeks displayed it as a resurrected shape at City Hall Square before sinking it, mirror-like, 12 meters deep into the ground water.

The pyramid will be turned into a funnel into whose darkness water runs down. From the "architektonischen Spielerei," as City Hall architect Karl Roth called his fountain, a hole emerges which deep down in the water creates an image reflecting back the entire shape of the fountain.[20]

How does one remember an absence? In this case, by reproducing it. Quite literally, the negative space of the absent monument will now constitute its phantom shape in the ground. The very absence of the monument will now be preserved in its precisely duplicated negative space. In this way, the monument's reconstruction remains as illusory as memory itself, a reflection on dark waters, a phantasmagoric play of light and image. Taken a step further, Hoheisel's inverted pyramid might also combine with the remembered shape of its predecessor to form the two interlocking triangles of the Jewish star—present only in the memory of its absence.[21]

20. Horst Hoheisel, "Rathaus-Platz-Wunde," in *Aschrott-Brunnen: Offene Wunde der Stadtgeschichte* (Kassel, 1989), p. [7]; my translation; hereafter abbreviated "RPW."

21. For this imaginative step I thank Gary Smith who suggested it to me in conversation.

gebaute Form 1908

Zerstörung 1939

verschwundene Form 1987

Grundwasser

4/B

Horst Hoheisel's conceptual sketch of his negative-form monument to the Aschrott-Brunnen. Photo: *Aschrott-Brunnen: Offene Wunde der Stadtgeschichte* (Kassel, 1989), p. [7].

Horst Hoheisel with his model of the negative-form monument to the Aschrott-Brunnen. Photo: James E. Young.

In his conceptual formulations, Hoheisel invokes the play of other, darker associations as well, linking the monument to both the town's Jewish past and a traditional anti-Semitic libel. "The tip of the sculpture points like a thorn down into the water," the artist writes. "Through coming into touch with the ground water, the history of the Aschrott Fountain continues not over but under the city" ("RPW," p. [7]). As an emblem of the Holocaust, the history of the Aschrott Fountain becomes the subterranean history of the city. In Hoheisel's figure, the groundwater of German history may well be poisoned—not by the Jews, but by the Germans themselves in their murder of the Jews. By sinking his inverted pyramid into the depths in this way, Hoheisel means to tap this very history. "From the depth of the place," he says, "I have attempted to bring the history of the Aschrott Fountain back up to the surface" ("RPW," p. [8]).

Of course, on a visit to City Hall Square in Kassel, none of this is immediately evident. During construction, before being lowered upside down into the ground, the starkly white negative-form sat upright in the square, a ghostly reminder of the original, now-absent monument. Where there had been an almost-forgotten fountain, there is now a bronze tablet with the fountain's image and an inscription detailing what had been there and why it was lost. On our approach, we detect the sound of water rushing into a great underground hollow, which grows louder and louder until we finally stand over the Aschrott-Brunnen. Only this sound suggests the depth of an otherwise invisible memorial, an inverted palimpsest

The negative-form monument to the Aschrott-Brunnen, phantomlike in its whiteness, shown here before being inverted and lowered into the ground. Photo: Horst Hoheisel.

that demands the visitor's reflection. Through an iron grate and thick glass windows we peer into the depths. "With the running water," Hoheisel suggests, "our thoughts can be drawn into the depths of history, and there perhaps we will encounter feelings of loss, of a disturbed place, of lost form." In fact, as the only standing figures on this flat square, our thoughts rooted in the rushing fountain beneath our feet, we realize that we have become the memorial. "The sunken fountain is not the memorial at all," Hoheisel says. "It is only history turned into a pedestal, an invitation to passersby who stand upon it to search for the memorial in their own heads. For only there is the memorial to be found" ("RPW," p. [8]). As have the Gerzes in Hamburg and Radermacher in Berlin, Hoheisel has left nothing but the visitors themselves standing in remembrance, left to look inward for memory.

5. Conclusion

On the surface, time and memory seem to operate to irreconcilably disparate ends: where time might be described, in Aristotle's terms, as that which "disperses subsistence,"[22] memory can be regarded as recollective in its work, an operation that concentrates the past in the figurative space of a present moment. The counter-monument would turn this over: it forces the memorial to disperse—not gather—memory, even as it gathers the literal effects of time in one place. In dissipating itself over time, the counter-monument would mimic time's own dispersion, become more like time than like memory. It would remind us that the very notion of linear time assumes memory of a past moment: time as the perpetually measured distance between this moment and the next, between this instant and a past remembered. In this sense, the counter-monument asks us to recognize that time and memory are interdependent, in dialectical flux.

The material of a conventional monument is normally chosen to withstand the physical ravages of time, the assumption being that its memory will remain as everlasting as its form. But as Mumford has already suggested, the actual consequence of a memorial's unyielding fixedness in space is also its death over time: a fixed image created in one time and carried over into a new time suddenly appears archaic, strange, or irrelevant altogether. For in its linear progression, time drags old meaning into new contexts, estranging a monument's memory from both past and present, holding past truths up to ridicule in present moments. Time mocks the rigidity of monuments, the presumptuous claim that in its materiality, a monument can be regarded as eternally true, a fixed star in the constellation of collective memory.

22. Aristotle, *Physics* 221b2, quoted in Edward S. Casey, *Remembering: A Phenomenological Study* (Bloomington, Ind., 1987), p. 181.

By formalizing its impermanence and even celebrating its changing form over time and in space, the counter-monument refutes this self-defeating premise of the traditional monument. It seeks to stimulate memory no less than the everlasting memorial, but by pointing explicitly at its own changing face, it re-marks also the inevitable—even essential—evolution of memory itself over time. In its conceptual self-destruction, the counter-monument refers not only to its own physical impermanence, but also to the contingency of all meaning and memory—especially that embodied in a form that insists on its eternal fixity. As such, the counter-monument suggests itself as a skeptical antidote to the illusion that the seeming permanence of stone somehow guarantees the permanence of a memorial idea attached to it.

By negating its form, however, the counter-monument need not so negate memory. And by challenging its premises for being, neither does it challenge the call for memory itself. Rather, it negates only the illusion of permanence traditionally fostered in the monument. For in calling attention to its own fleeting presence, the counter-monument mocks the traditional monument's certainty of history: it scorns what Nietzsche has called "monumental history," his epithet for the petrified versions of history that bury the living.[23] In effect, it might even be said that the counter-monument negates the very basis for this epithet's central trope: after the counter-monument, the "monumental" need no longer be conceived merely as a figure for the stone dead. By resisting its own reason for being, the counter-monument paradoxically reinvigorates the very idea of the monument itself.

If the place of memory is "created by a play of memory and history," as Nora believes ("BMH," p. 19), then time may be the crucible for this interaction. Memory is thus sustained, not denied, by a sense of human temporality, deriving its nourishment from the very changes over time that would otherwise mock the static, "everlasting" memorial. Nora is most succinct here:

> If we accept that the most fundamental purpose of the *lieu de mémoire* is to stop time, to block the work of forgetting, to establish a state of things, to immortalize death, to materialize the immaterial . . . all of this in order to capture a maximum of meaning in the fewest of signs, it is also clear that the *lieux de mémoire* only exist because of their capacity for metamorphosis, an endless recycling of their meaning and an unpredictable proliferation of their ramifications. ["BMH," p. 19]

23. Friedrich Nietzsche, *The Use and Abuse of History*, trans. Adrian Collins (New York, 1985), p. 17.

Even so, the precise beauty of the counter-monument may not lie merely in its capacity for change, nor in its capacity to challenge a society's reasons for either memory or its own configuration of memory. For in addition, the counter-monument seeks its fulfillment in—not at cross-purposes with—historical time. It recognizes and affirms that the life of memory exists primarily in historical time: in the activity that brings monuments into being, in the ongoing exchange between people and their historical markers, and finally, in the concrete actions we take in light of a memorialized past.

Peering down into the negative-form monument to the Aschrott-Brunnen, Kassel. Photo: Horst Hoheisel.

The Vietnam Veterans Memorial and the Washington Mall: Philosophical Thoughts on Political Iconography

Charles L. Griswold

Photographs by Stephen S. Griswold

My reflections on the Vietnam Veterans Memorial (VVM) were pro-
voked some time ago in a quite natural way, by a visit to the Memorial
itself. I happened upon it almost by accident, a fact that is due at least
in part to the design of the Memorial itself (see fig. 1). I found myself
reduced to awed silence, and I resolved to attend the dedication cere-
mony on 13 November, 1982. It was an extraordinary event, without
question the most moving public ceremony I have ever attended. But
my own experience of the Memorial on that and other occasions is far
from unique. It is almost commonplace among the many visitors to the
VVM—now the most visited of all the memorials in Washington—a
fact so striking as to have compelled journalists, art historians, and
architects to write countless articles about the monument. And
although philosophers traditionally have had little to say about architec-

A draft of this paper was presented on 27 March 1984 at the Iowa State Univer-
sity. A two-page article containing a few of the remarks made here about the VVM was
published by Public Research Syndicated on 11 May 1983. I would like to thank Profes-
sors Gina Crandell, Robert Ginsberg, William MacDonald, Joel Snyder, and David
Thompson for their helpful criticisms of the paper. I also acknowledge with gratitude
the encouragement and help I received in composing this piece from my colleague Dale
Sinos and from Francis V. O'Connor; their invaluable suggestions have contributed to
every page of this essay. My final words of thanks must go to Lisa Griswold, who so
patiently accompanied me on innumerable visits to Washington's memorials, and to
Stephen Griswold, whose photographs illustrate this essay.

FIG. 1.

ture in general or about that of memorials in particular, there is much in the VVM and its iconography worthy of philosophical reflection. Self-knowledge includes, I hazard to say, knowledge of ourselves as members of the larger social and political context, and so includes knowledge of that context.

Architecture need not memorialize or symbolize anything; or it may symbolize, but not in a memorializing way, let alone in a way that is tied to a *nation's* history. The structures on the Washington Mall belong to a particular species of recollective architecture, a species whose symbolic and normative content is prominent. After all, war memorials by their very nature recall struggles to the death over values. Still further, the architecture by which a people memorializes itself is a species of pedagogy. It therefore seeks to instruct posterity about

Charles L. Griswold, professor of philosophy at Boston University, is the author of *Self-Knowledge in Plato's "Phaedrus"* (1986) and has published widely in the areas of Greek philosophy, German Idealism, hermeneutics, and political philosophy. He is a recipient of numerous awards and fellowships. Currently he is completing a project which centers on Adam Smith's notion of the "self" and Smith's relationship to Stoicism and to the American Founding.

the past and, in so doing, necessarily reaches a decision about what is worth recovering. It would thus be a mistake to try to view such memorials merely "aesthetically," in abstraction from all judgments about the noble and the base. To reflect philosophically on specific monuments, as I propose to do here, necessarily requires something more than a simply technical discussion of the theory of architecture or of the history of a given species of architecture. We must also understand the monument's symbolism, social context, and the effects its architecture works on those who participate in it. That is, we must understand the political iconography which shapes and is shaped by the public structure in question. To do less than this—if I may state a complex argument in hopelessly few words—is to fall short of the demands of true objectivity, of an understanding of the whole which the object is. To understand the meaning of the VVM requires that we understand, among other things, what the memorial means *to* those who visit it. This is why my observations about the dedication of the VVM and about the Memorial's continuing power over people play an important role in this essay.

The VVM has been extremely controversial, though no more so than many other monuments in the same area (the Washington Monument being a case in point).[1] In spite of the controversy, no major memorial on the Washington Mall has been built in so short a time from the moment fund-raising began to the moment the last stone was in place—about three-and-a-half years for the VVM. I have no intention of arguing here for or against the war the VVM memorializes. But it is not possible to discuss the Memorial satisfactorily without understanding why it has stirred such discussion. The heart of the debate concerns the question of whether war memorials should take a stand for or against the cause over which the given war was waged—that is, it concerns the extent to which memorials should unite war and politics. None of the structures on the Mall can claim to unite war and politics as the Alamo and Gettysburg do, for no blood was actually spilt here in

1. The Continental Congress voted in 1783 to erect an equestrian statue of Washington near the place where the obelisk now stands. No statue was erected and in 1833 the Washington Monument Society was formed. Construction began in 1848, after years of debates and delays, and stopped partway through in 1854. In 1876 (after the Civil War) Congress appropriated the funds to proceed, and the bare obelisk was completed in late 1884 (the dedication ceremony took place on 21 February 1885). The original design for the monument was, however, never fulfilled. For an exhaustive account of the Washington Monument, see F. L. Harvey's *History of the Washington National Monument and Washington National Monument Society* (Washington, D.C., 1903). I note that in 1783 the House voted to commemorate Washington with a mausoleum shaped as a pyramid rather than with the equestrian statue, but the bill did not pass the Senate. In 1836 a public design competition was sponsored by the Society; the one criterion was that the design should "harmoniously blend durability, simplicity, and grandeur" (pp. 25–26).

pitiless battle. The Mall's land is not sanctified in that sense, nor indeed in the sense definitive of the monumental Arlington National Cemetery, which is connected to the Mall by the Arlington Memorial Bridge. No one is buried on the Mall itself.[2] The Mall's memorials connect (and occasionally separate) war and politics on a purely symbolic level and in a fascinating variety of ways. The VVM's stand on this issue is, as we shall see, singular and subtle.

I think it fruitful to approach the VVM in a somewhat roundabout way. I shall begin in section one with some general remarks about the Mall, of which the VVM is a part, and then in section two I will discuss several monuments in the immediate vicinity of the VVM. Two reasons recommend this approach. First, the geometry of the VVM clearly connects that memorial with two of the monuments on the Mall, those dedicated to Lincoln and Washington. Its presence in the Mall's Constitution Gardens in itself warns us against considering it in complete isolation from its context. Second, in order to understand just how radically different this memorial is, it is helpful to consider exactly what it is *not,* and this is effectively accomplished by contrasting it with the other memorials near it. With this preparation, I turn in section three to a consideration of the VVM itself, the heart of my reflections.

1

If we take the White House, Capitol, and the monuments to Lincoln and Jefferson as our reference points, the area thus defined is quadrilateral in shape or, more precisely, trapezoidal. At the west end of the area sits the Lincoln Memorial, and opposite it at the east end the Capitol. Bisecting the area vertically, we have the White House to the north and the Jefferson Memorial to the south. For the sake of convenience I shall extend the usual nomenclature and shall refer to this whole area as the "Mall." For all practical purposes, the center of the Mall is marked by the towering Washington Monument. The other four structures, marking the far reaches of the trapezoid both laterally and vertically, are like planets in orbit around this obelisk. All of this gives the Mall a formal unity. But the area derives its substantive unity not so much from its geometrical properties as from its purpose, memorializing. The Mall is *the* place where the nation conserves its past in this particular way, simultaneously recollecting it (albeit rather selec-

2. The one exception is James Smithson, who is buried in the Smithsonian Institution's "Castle." On the area denoted by the term "Washington Mall," see the beginning of section one below.

tively), honoring it, and practicing it (in the White House and Capitol). The presence of the many museums along the Mall emphasizes this fact; they adorn this monumental precinct with America's scientific and artistic heritage. The arts and sciences thus come into close proximity with the seat of government, as if to self-consciously proclaim their mutual influence. We are to infer that the history of American power is that of a cultured and progressive people.

On the Mall, then, matter is put to rhetorical use. It is made to educate and edify the citizens of the present as well as form those of the future by persuading them to live out the virtues of the past. It is memory in stone, earth, and water, a patrimony articulated by measured expanses and the interplay of symmetrically arranged symbols. The word *monument* derives from the Latin *monere,* which means not just "to remind" but also "to admonish," "warn," "advise," "instruct." It follows that the Mall says a great deal, in what it portrays and in what it omits to portray, about how Americans wish to think of themselves. In still another formulation: the Mall is a sort of political mandala expressing our communal aspirations toward wholeness.

The Mall in its present shape is a fairly recent creation.[3] The ability of a group to think of itself as a nation depends on a consensus existing among its citizens about what it means to be a unified whole. This consensus emerged only gradually in American history. The debate about how the united states ought to be united is coeval, of course, with the American Founding. The meaning of *E Pluribus Unum* (a phrase engraved on the spherical pedestal supporting the statue *Freedom* that caps the dome of the Capitol) has been hotly contested in the history of American political thought. The existence and character of the Mall demonstrate that the Federalists have very much won the battle. The fact that the Mall grew, so to speak, over a long stretch of time is not inconsistent with the following crucial point: Regardless of the intentions of the designers of the Mall and its monuments at various historical moments, the area possesses an extraordinary cohesiveness from the standpoint of its symbolism. It is as though an invisible hand has guided the many changes effected on the Mall, a communal logic imperceptible as a whole at any given time. The intricate ecology of symbolism that articulates the Mall's "substantive unity," as I called it above, is not contradicted by the fact that no one consciously designed the Mall with the totality of that symbolism in mind. The Mall pro-

3. The Jefferson Memorial was dedicated in 1943; the Grant and Lincoln Memorials in 1922. The Capitol took on something like its present appearance with the reconstructions in the 1850s and 1860s; and the entire Mall area was not fully landscaped, cleared of extraneous buildings, and the streets named after presidents, until after World War II.

vides us with a striking example of a whole that is, in good measure, self-organizing.[4]

Of course the city of Washington did not grow without *any* unified design. The land for the original ten-mile-square district, which George Washington did much to select, was authorized by Congress in 1790; the basic outlines of the city were set out in 1791 by Pierre-Charles L'Enfant, whom Washington chose for this task. The federal government moved to Washington from Philadelphia in 1800. The city has a rather Parisian scale to it or, more accurately, it possesses a distinctly Roman, and thus imperial, sense. The broad avenues up which the country's newly elected leader now travels like an emperor returning from a victorious war, the centrality of the obelisk (recall the many obelisks in Rome), the pervasiveness of the symbol of the eagle (even if it represents, in our case, a particular species of American eagle), the fasces on the front of the Lincoln Memorial (as well as on Lincoln's chair in the Memorial), a separate and palatial dwelling for the chief executive, as well as the physical separation of the Capitol into Senators' and Congressmen's wings (the "Senate" being of Roman origin)— all of these are reminders of Rome. Even the term *Capitol* derives from the Latin word (*Capitolium*) that referred to the temple of Jupiter

4. The notion of a "self-organizing whole" has not been terribly popular among philosophers, with weighty exceptions such as Aristotle and Hegel, thanks to the powerful attraction of the sort of unity a single *episteme* or *techne* promises. Consider Descartes' statement:

> One of the first of the considerations that occurred to me was that there is very often less perfection in works composed of several portions, and carried out by the hands of various masters, than in those on which one individual alone has worked. Thus we see that buildings planned and carried out by one architect alone are usually more beautiful and better proportioned than those which many have tried to put in order and improve, making use of old walls which were built with other ends in view. In the same way also, those ancient cities which, originally mere villages, have become in the process of time great towns, are usually badly constructed in comparison with those which are regularly laid out on a plain by a surveyor who is free to follow his own ideas. Even though, considering their buildings each one apart, there is often as much or more display of skill in the one case than in the other, the former have large buildings and small buildings indiscriminately placed together, thus rendering the streets crooked and irregular, so that it might be said that it was chance rather than the will of men guided by reason that led to such an arrangement. And if we consider that this happens despite the fact that from all time there have been certain officials who have had the special duty of looking after the buildings of private individuals in order that they may be public ornaments, we shall understand how difficult it is to bring about much that is satisfactory in operating only upon the works of others. [*Discourse on the Method of Rightly Conducting the Reason and Seeking for Truth in the Sciences,* trans. Elizabeth S. Haldane and G. R. T. Ross, *The Philosophical Works of Descartes,* 2 vols. (Cambridge, 1972), 1:87–88]

Descartes goes on to make the same point with respect to religion, laws, morals, science and the accumulation of knowledge, and finally his own search for "secure foundations."

in ancient Rome. Indeed, the domes of the Capitol, the Jefferson Memorial, the National Gallery of Art and National Museum of Natural History (both located on the Mall's Constitution Avenue), as well as the prominent rotunda in each, derive from the Pantheon.[5] And instead of the Colosseum down the street from the seat of government, Washington has its similarly placed Robert F. Kennedy Memorial Stadium.

In L'Enfant's design, the Capitol is close to the geographic center of the District of Columbia. The main avenues of the city meet at the Capitol, like spokes of a wheel at the hub. The Capitol, as the home of Congress, embodies the basic tenet of democracy, that the people ought to govern themselves. Thus the symbolic center of the district, and so of the nation, is the rule of the people. The foundation for this view is, in the tradition at the heart of American political theory, the doctrine of individual rights, that is, freedoms; and from this derives the doctrine that rule over the people is legitimized only by the voluntary consent of individuals. Correspondingly, the dome of the Capitol is capped by the huge statue (erected in 1863 during the Civil War) symbolizing freedom.[6] It is worth noting that this statue, as well as the Capitol, faces to the east. Traditionally, most great temples have faced the east, toward the rising sun, the source of dawn, light, renewal, hope, resurrection. In this way the sun illuminated the statue of the god within pagan temples. The Lincoln Memorial too faces east; as in the case of the Capitol, the directionality suggests hope for the "unity from out of many" that is life (as opposed to the dissolution that is death). I shall have more to say below about the directionality of the various memorials on the Mall.

But the center of the district, in another sense, is not the Capitol but the monument erected for the country's "father" and the district's eponym. The Washington Monument, as the center of the Mall, is in its own way also the symbolic center of Washington's city and so of the nation he did so much to found. It is not fanciful to detect, then, a certain tension between the center of the Mall and one of the "planets" at the east end of the trapezoid, a planet that nevertheless competes with its sun for the title of "center of the city." There is a tension, that is, between the founder and the system he founded, the rule of one man

5. For a thorough discussion of the Pantheon and later imitations (as well as earlier precedents) see William L. MacDonald, *The Pantheon: Design, Meaning, and Progeny* (Cambridge, Mass., 1976).

6. James M. Goode notes that the statue was originally crowned by a Liberty Cap worn in Rome by freed slaves, but that this "was changed after objections by then Secretary of War Jefferson Davis, who asserted that the headdress embodied a not-very-subtle Yankee protest against slavery" (*The Outdoor Sculpture of Washington, D.C.* [Washington, D.C., 1974], p. 60). The issue of individual freedom is very much at stake in the statue's symbolism.

and the rule of the people, the president and the Congress. Certainly the Washington Monument—an obelisk much taller than the obelisks of antiquity—is the visual center of the city; it can be seen from virtually every vantage point, particularly since local regulations severely limit the height of structures in the city. Since one can ascend to its peak, the Washington Monument is also a sort of observation tower from which everything in the city can be seen. In both of these ways the Monument is the center of things. Nevertheless, the Capitol usually serves as the city's signature, as it were; it is the localizing logo on everything from city billboards to commercial enterprises to local news programs. But the tension between these symbols is lessened by several peculiarities of the Washington Monument itself which I would now like to discuss in detail. The importance of the Washington Monument for my purposes is intensified by the fact that it is one of the two monuments to which the VVM points (see fig. 2). In keeping with my roundabout approach to the VVM, however, I shall also comment in the next section on several other relevant monuments and memorials.

2

The selection of the design for the Washington Memorial was hotly debated for quite some time. After all, just how should the nation's first commander-in-chief and president—in a real sense, its

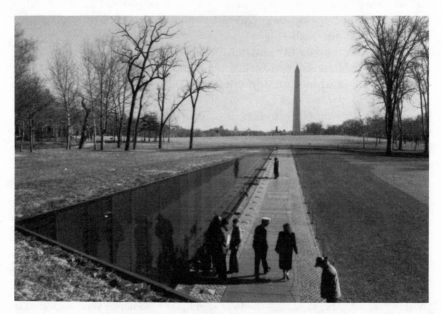

Fig. 2.

Founder—be remembered? The answer amounts to a philosophical position on the matter. Take, for example, the famous nonequestrian statue of Washington, now exiled to the Smithsonian's National Museum of American History—Horatio Greenough's 1840 rendition in the style of Antonio Canova's 1822 statue which was destroyed in a fire—in which Washington is portrayed bare-chested in a toga and sandals. This statue is an almost embarrassing allusion to Zeus, as well as to Washington's apotheosis after the manner of Roman emperors.[7] In any event, the original design of the Washington Monument called for a fantastically ornate base, and the 1879 redesign for an exterior so elaborate that the Monument would have been unrecognizable as an obelisk. Lack of funds prevented anything more than the bare obelisk from being erected. The absence of any vegetation around it emphasizes the simplicity of the Monument. It rises directly from the barely covered mound of earth.

Although the Washington Monument is a memorial to a man, there is no trace of him in the Monument. He is completely sublated in the symbol representing him. Hence it is different in kind from the Mall's other memorials to men. The Washington Monument is iconic only in a rather abstract sense, and in representing Washington it is not a means for a further symbol. By contrast, the Lincoln and Jefferson memorials are, as it were, houses for the statues residing within, and to that extent each is a means to a further end. The symbolism they possess independently of their function as beautiful houses is limited; they are not in themselves icons. In any event, no statue resides in the obelisk; hence the connection between it and Washington himself is not especially obvious.[8] The obelisk represents a ray of the sun, and the

7. See Garry Wills, "Washington's Citizen Virtue: Greenough and Houdon," *Critical Inquiry* 10 (Mar. 1984): 420–41. Wills remarks that "Greenough took for his model what the neoclassical period believed was the greatest statue ever created, by the greatest sculptor who ever lived—the Elean *Zeus* of Phidias" (p. 420). For a fascinating discussion of eighteenth-century portraiture of Washington, see Wendy Wick's *George Washington, an American Icon: The Eighteenth-Century Graphic Portraits* (Charlottesville, Va., 1982). The prints reproduced on pp. 139, 141, and 142, in which Washington's death is lamented, contain representations of obelisks. In her introduction to the volume, L. B. Miller points out how quickly and extensively Washington became a national icon. He was frequently compared to Roman heroes, "whom Washington himself so much admired" (p. xiv). Washington's honesty, simplicity, love of agrarian pursuits, prudence, restraint, reasonableness, lack of ambition, military abilities, and strength made him seem the perfect embodiment of Roman Republican virtues. I add that the fact that the memorial to Washington is Egyptian also reflects the fact that he was a Mason (the Masons were very much involved in the selection of the monument's design and in the dedication). Consider too the pyramid on the one dollar bill.

8. For an interesting distinction between three kinds of symbolism in architecture, namely, (1) that in which the structure's symbolism is not a means to anything else (as in obelisks), (2) that in which the outside structure is a means to a further symbol enclosed within (as in classical architecture), and (3) that in which the outside structure has its

sun-god is the source of life, warmth, light. The obelisk is a heliocentric monument. Thus, as I have already noted, the other monuments may be said to rotate around the Washington Monument like planets in its orbit. The VVM, by contrast, is a chthonic memorial. As a ray from the sun the obelisk both reaches upward to the sun and connects the sun with the earth. Washington is thus the enlightener, transmitter of life to humanity, a brilliant beam in an otherwise dark world. Looking at the monument one's eye is naturally drawn upward toward the bright divine orb of which the divine man is a part. The obelisk connotes immortality, which is an imitation of the eternity of the heavens. We cannot ignore, moreover, the blatantly phallic nature of this monument, a characteristic which heightens the contrast between it and the Capitol. The latter's dome is of an obviously female nature. The male/female contrast is to be found in other cities as well (for example, consider the contrast between the obelisk and dome in St. Peter's Square in Rome). Washington was a man of action rather than words; the Capitol is the home of endless talk, a trait traditionally, albeit tendentiously, associated with womanliness.

Obelisks originated in a civilization reputed even among the ancients to be very old, namely, that of Egypt. The founder of the New World republic is thus tied to the very origins of political life, a seeming paradox repeated elsewhere on the Mall: the American Revolution is conceived of as a turn backward as well as a turn forward, a return to origins as well as to the new. Of course, the intention was always to memorialize Washington in the way that would make the city named after him resemble the great capitals of Europe. No great city would be complete without its obelisk, as the treasures conveyed to Paris following Napoleon's looting of Egypt served to remind everyone. Thus the Washington Monument also expresses the belief that America is equal in its greatness to the old European nations. The American Founders, then, are not meant to be *radical* innovators. The architecturally represented origins of political life in the case of the Washington, Jefferson, and Lincoln memorials are, I add, all pagan.

Further, the Washington Monument has a characteristic that no other on the Mall possesses: it looks exactly the same from all angles. Correspondingly, it is not oriented toward any of the four points on the compass. For this reason as well the Washington Monument is divinely indifferent to the perspective of the beholder, like the unshadowed light itself. This indifference is emphasized by the fact that there is no writing on its sides, and so no sequence in which the

own inherent symbolism but is also a means (as in Romantic architecture), see Hegel's *Aesthetics,* trans. T. M. Knox (Oxford, 1974), vol. 2, pt. 3, sec. 1 ("Architecture").

eye must "read" the obelisk.[9] The Washington Monument can be seen as a whole all at once, from any side. Lincoln and Jefferson, by contrast, are surrounded by their own words, and their memorials have a front and back. The Washington Monument does not carve out a space particular to itself, a space into which the beholder is drawn and thus disconnected from the surroundings. It is not an absorbing monument in the way the VVM is. This helps to explain why, although people look and refer to this monument, they rarely sit and contemplate it and infrequently celebrate or demonstrate at its base. None of this contradicts the fact that the Washington Monument also serves as the center of the Mall, if not of the city. It is a space-defining, orienting structure even as (or perhaps because) it is indifferent to this or that perspective.

The other memorial to which the VVM points is dedicated to Lincoln (see fig. 3). The architecture of this monument is (except for the flat roof and the plan) mostly Greek. The monument itself serves in good part as a home for the statue that dwells within; its meaning thus conveys the classical pattern of a hero whose deeds have won him immortality and divinization. The singularly appropriate inscription behind Lincoln's statue reads "IN THIS TEMPLE AS IN THE HEARTS OF THE PEOPLE FOR WHOM HE SAVED THE UNION THE MEMORY OF ABRAHAM LINCOLN IS ENSHRINED FOREVER." Like Athena in the Parthenon on the Acropolis, Lincoln the savior and healer lives in his temple, a god awaiting offerings. Perhaps the two urns outside the temple are meant to contain eternal flames symbolizing the god's presence in his home. To reach the icon of Lincoln one must ascend a considerable number of (oversize) steps, as is appropriate when one approaches a hero-god. Similarly,

9. In his lengthy oration delivered during the formal ceremonies held at the Capitol in connection with the dedication of the Washington Monument, the Honorable Robert C. Winthrop took note of the absence of the customary writing on the side of the obelisk. He suggested that "no mystic figures or hieroglyphical signs" and "no such vainglorious words as 'Conqueror,' or 'Chastiser of Foreign Nations,' nor any such haughty assumption or heathen ascription as 'Child of the Sun'" are appropriate to the Washington Monument. Those who look at the memorial will be reminded of Washington's own "masterly words," the understanding of which "requires no learning of scholars, no lore of Egypt, nothing but love of our own land" (*The Dedication of the Washington National Monument with the Orations* [Washington, D.C., 1885], p. 61). Winthrop also suggests that the composition of a single massive structure out of many individual blocks (in contrast with the Egyptian obelisks which were monoliths) symbolizes "our cherished National motto, E PLURIBUS UNUM" (p. 52). Further, the memorial rises above the city as Washington "rose above sectional prejudices and party politics and personal interests." The memorial's height shows that Washington's name and example are more exalted than any other in American history, like a bright star and guiding light "for all men and for all ages" (pp. 53–54).

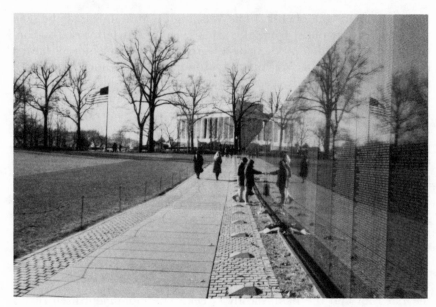

FIG. 3.

the statue to Jefferson occupies the heights at the summit of a series of steps. To get to the heart of the VVM, by contrast, one must descend, not ascend. The Doric columns of the Lincoln Memorial are tilted slightly inward, a fact that enhances one's impression of the building's monumental elevation. Inside, Lincoln is seated—almost wearily, it seems to me—like Zeus high on his throne, looking down on his relatively puny visitor. The visitor's sight, however, is drawn up no higher than the level Lincoln occupies, unless it be to read the inscription behind and slightly above him. In a Gothic cathedral, by contrast, the upward emphasis continues as far as the eye can see. Here, as at the Jefferson Memorial, the visitor's focus on the graven image of the hero-god contributes to the predominantly pagan effect of the monument, though there are also nonpagan overtones.

The air of dignified mourning conveyed even by the choice of vegetation surrounding the temple—cypresses are by tradition funereal trees—reminds us that Lincoln's mortal life was ended by assassination. The interior of the monument is open only from one side; hence there is a somber darkness inside. The adversity faced by Lincoln is evident not only from the quotations on the wall inside his temple (the Gettysburg Address and his Second Inaugural Address) but from Lincoln's face. It is the face of a just and compassionate judge who has seen much bitterness, a face hardened by war and difficult choices— and in particular by a war between brothers, the sort that is always full

of the greatest hate. Lincoln's face is etched with the lessons taught by destructive war; it is thus quite unlike that of Jefferson's statue.

Lincoln's temple also expresses the hope for the rebirth of peace among brothers which union would bring. Thus it is worth emphasizing that Lincoln faces east, as did the statues of the gods in their temples. At the same time, the bitter context from which Lincoln emerged is symbolized by the fact that his temple resides at the west end of the Mall. The sun sets in the west; it is the place where light is extinguished, where souls are taken upon dying. The sunset represents, furthermore, the struggle between light and darkness, good and evil.[10] This struggle provides the context for Lincoln's apotheosis; hence it is appropriate that he be the western god who looks east. As though looking back on this struggle, Lincoln gazes out of his temple and across the Mall into the impassive face of General Grant.

Lincoln's temple is, then, a monument to national unity achieved

10. I am indebted to the independent art historian Francis V. O'Connor for ideas concerning the symbolic content of the four directions. These ideas have proved valuable in interpreting the environmental iconography of the various public monuments discussed in this essay. Dr. O'Connor's theory of directional symbolism is developed in "An Iconographic Interpretation of Diego Rivera's *Detroit Industry* Murals in Terms of Their Orientation to the Cardinal Points of the Compass," published in the exhibition catalog *Diego Rivera: A Retrospective* (New York, 1986), pp. 215–29. The ancient and intimate connection between the founding of a town or city in accordance with a conception of the order of the universe is documented in Joseph Rykwert's *The Idea of a Town: The Anthropology of Urban Form in Rome, Italy, and the Ancient World* (Princeton, N.J., 1976). Rykwert comments:

> The rite of the founding of a town touches on one of the great commonplaces of religious experience. The construction of any human dwelling or communal building is in some sense always an *anamnesis*, the recalling of a divine 'instituting' of a centre of the world. That is why the place on which it is built cannot arbitrarily or even 'rationally' be chosen by the builders, it must be 'discovered' through the revelation of some divine agency. And once it has been discovered, the permanence of revelation in that place must be assured. The mythical hero or deity attains the centre of the universe or the top of the cosmic mountain by overcoming epic obstances. The ordinary mortal may find this place anagogically through the agency of ritual. In the case I am considering, through the ritual of orientation. [P. 90]

In the final paragraph of the book, Rykwert also notes that

> It is difficult to imagine a situation when the formal order of the universe could be reduced to a diagram of two intersecting co-ordinates in one plane. Yet this is exactly what did happen in antiquity: the Roman who walked along the *cardo* knew that his walk was the axis round which the sun turned, and that if he followed the *decumanus*, he was following the sun's course. The whole universe and its meaning could be spelt out of his civic institutions—so he was at home in it. We have lost all the beautiful certainty about the way the world works. [P. 202]

I am arguing that the organization of the heart of the city named after the quasi-mythical hero Washington exhibits a complex unity on the symbolic level, a unity tied to ancient perceptions of the cosmos' order. I do not, however, claim that this unity is the product of conscious design.

by the martyrdom of Lincoln himself. The overtones of Christ's dying
for the sins of man are unavoidable. Indeed, the principles praised by
Lincoln, above all that of universal equality, are not Greek but Chris-
tian. The Lincoln Memorial, precisely because of its somberness and its
emphasis on sacrifice as well as on the healing of dissolution, differs
radically from the monuments on the Mall to two of the nation's
Founders, Washington and Jefferson. Washington and Jefferson are not
healers so much as life-givers. By the time of Lincoln the age of the
Founders was over; their optimism had been severely tested by the
worst sort of internal conflict; costly reinstitution of the Founding had
become necessary. The Washington and Jefferson monuments repre-
sent the opening chapter in our history; the Lincoln monument per-
haps a middle chapter; and the Vietnam Veterans Memorial graphically
represents a very recent chapter of our past in a way that points to,
indeed cites, the two earlier ones. The great moral message of the
Lincoln Memorial—which is subdued in, if not lacking from, the Wash-
ington and Jefferson monuments—makes it the natural place for peo-
ple to proclaim and demonstrate their views. To be precise, it is not the
interior of this monument that is suited for the gathering of the people
(and in this it again differs from the Gothic cathedral) but its steps on
the exterior.

 Before passing on to the Jefferson Memorial, I note that the
Arlington Memorial Bridge (dedicated in 1932) extends from the
Lincoln Memorial southwest across the Potomac to General Lee's
house. Thus it symbolizes Lincoln's effort to save the union by reunit-
ing North and South. Lincoln, not Lee, is memorialized on the Mall,
showing which of them prevailed in their conflict (in the District of
Columbia as a whole, twenty-five statues remember Union officers but
only two memorialize Confederate officers).[11] That Lincoln should, as
it were, extend a bridge to his former enemy shows his "malice toward
none" and "charity for all."

 The Jefferson Memorial is the most delicate of the memorials on
the Mall. Its graceful architecture speaks not of war but of reason, not
of mourning but of life. To be sure, the circular design traditionally
connoted, among other things, a tomb; the Jefferson Memorial has
antecedents in Rome's Mausoleum of Augustus, that of Hadrian, and
the so-called Temple of Vesta by the Tiber. Still earlier antecedents are
the Greek *tholoi*.[12] Unlike the Lincoln Memorial, if the Jefferson

 11. See Goode, *Outdoor Sculpture*, p. 27.
 12. See MacDonald, who adds that "the idea of circularity in monumental architec-
ture descended chiefly from two sources, religious buildings and tombs. . . . The tradi-
tion of roundness was very strongly entrenched in funerary architecture" (*The Pantheon*,
pp. 44, 45).

Memorial suggests death, it does so in so delicate and allusive a way as to virtually dissolve any sense of loss the observer might otherwise feel. The music of the Memorial's proportions is pleasing to the eye and the mind. Again, the design is Roman; the dome resembles that of the Roman Pantheon, a building Jefferson admired very much (though the Memorial lacks the oculus, or round "eye," which opens the structure to the sky). The dome of the Pantheon symbolized the vault of the heavens. In this New World pantheon symbolized by the Jefferson Memorial, the gods are reason, the rights of man, and the freedom of the individual from political and religious tyranny.[13] I add that both the Lincoln and Jefferson memorials have a front and a back; hence neither is indifferent to perspective in the way that the Washington Monument is.

The contributions that Jefferson wished to have written on his epitaph were the authorship of the Declaration of Independence, the founding of the University of Virginia, and the Virginia Statute of Religious Freedom—Jefferson did not mention his two terms as president. The statue of Jefferson in the Memorial holds a scroll on which the Declaration is written. The Jefferson Memorial is clearly a hero-cult monument, but the demigod within is a cultural or intellectual hero, rather than a military or executive hero. Jefferson did not serve in the field of battle or command troops in a war, as Washington and Lincoln did. In this regard the memorial to Jefferson has something in common with another presidential memorial, the Kennedy Center (the city's cultural center). The statue of Jefferson is standing; unlike Lincoln, he has not been tired by the trials of civil

13. The adaptibility of a Roman design to Jefferson's New World is not as odd as it seems. Consider MacDonald's perceptive reflection that

> Symbolically and ideologically the Pantheon idea survived because it describes satisfactorily, in architectural form, something close to the core of human needs and aspirations. By abstracting the shape of the earth and the imagined form of the cosmos into a grand, immediately assimilated image, the architect of the Pantheon gave mankind a symbol that transcends religion, class, and political conviction. In contrast to Gothic architecture, for example, the Pantheon's religious associations are ambiguous, if they exist at all. Because it was not freighted with any sectarian or localized meaning, and because of the universality inherent in its forms, it was unendingly adaptable. It is one of the very few archetypal images in western architecture.

> The theme [of the Pantheon], of course, was unity—the unity of gods and state, of people and state, and the unity of the perpetual existence and function of the state with the never-ending revolutions of the planetary clockwork. The grid underfoot, in appearance like the Roman surveyor's plan for a town, appeared overhead in the coffering, up in the zone of the mysteries of the heavens. To unify unities is to produce the universal, and this is perhaps the Pantheon's ultimate meaning. [*The Pantheon*, pp. 132, 88]

One need only substitute "society" for "state" here to bring the point close to the Jeffersonian outlook.

war. The eyes look straight ahead (unlike those of Lincoln) with confidence, and one foot is slightly forward. The general impression given is that of gentle aggressiveness, purposive but controlled movement forward.

The dignity of civic virtue and intelligence—in short, the dignity of man as distinguished from the beasts—is clearly evident in this statue. Man can stand on his own two feet, guided by principles self-evident to reason and supported by the inherent orderliness of the natural world in which he exists. The light penetrates inside the Memorial from all sides, in contrast to the Lincoln Memorial. The rays of the sun symbolized by the obelisk are permitted to enter everywhere; Jefferson is open to the outside world and stays in touch with it. In this the Memorial is quite unlike the inside of a cathedral in which even the light is altered by stained glass windows, an invitation to forget the outside world so as to better remember incorporeal spirit within.[14] The Jefferson Memorial is not a temple.[15]

Jefferson wears a smile which resembles that of Mona Lisa—not the sort of expression a sunlike god or martyred savior would wear, but not a merely human grin either.[16] He is not smiling at any particular thing; rather, it is an expression that might accompany the activity of reflection and perhaps of listening. It is an almost philosophical smile. Correspondingly, Jefferson's statue faces north. The north is the region of darkness, a place of depth, mystery, questions, and all things interior. It represents the direction toward which the mind of the philosophical Jefferson would naturally be drawn. At the same time, Jefferson's belief that the mind can enlighten itself is reflected in the location of his memorial on the southern edge of the Mall. The south is the place of the sun, illumination, warmth, *physis*, the visible look (*eidos*, idea), the intelligible shape of things.

At Jefferson's feet are the capitals of two columns, one decorated with corn—the symbol of the New World—the other with the traditional design of Corinthian capitals. The vegetation outside includes the famous cherry trees, row after row of them—beautiful symbols of spring, of rebirth and natural order. This memorial is not a shrine in the sense that the Lincoln Memorial is, and it does not convey a clear moral principle as Lincoln's does. It is inspiring, but not moving in the way that Lincoln's memorial is. It recalls abstract principles and argu-

14. This contrast between classical and Gothic architecture is made by Hegel, *Aesthetics*, p. 686.

15. I note in passing that Jefferson designed his own grave marker, a six-foot-high obelisk placed on a three-foot-square base.

16. Consider, by contrast, Gilbert Stuart's famous "Atheneum" portrait of the unsmiling Washington (1796).

ments rather than bitter deeds or exhausting foundings. Perhaps this is the reason that the VVM does not point to it. It is as though the VVM asks whether America's involvement in Vietnam was true to Lincoln's justice and healing as well as to Washington's founding intentions, struggles against foreign tyrants, and military genius, rather than whether it was true to Jefferson's thoughts about higher education and the freedom of religion.

With the basic symbolism of the Mall in mind, we can prepare ourselves further for the VVM by looking very briefly at several war memorials in its immediate vicinity, beginning with those that are most unlike it and progressing to those more akin to it. The most obviously unlike the VVM is the Marine Corps Memorial, dedicated in 1954 and popularly called the Iwo Jima Memorial. It is a classic war memorial. The soldiers strain every muscle toward one end only, the raising of the flag. The monument shouts this imperative: Honor your country, act as nobly as these men have. It is modeled on a photograph of an event that occurred on 23 February 1945. The inscription on the side reads "IN HONOR AND MEMORY OF THE MEN OF THE UNITED STATES MARINE CORPS WHO HAVE GIVEN THEIR LIVES TO THEIR COUNTRY SINCE 10 NOVEMBER 1775." Vietnam too is listed on the monument's side. The focus is not so much on individuals but on one branch of the military—an obvious difference between it and the VVM. I note also that the VVM is explicitly dedicated not just to those who died but to all those who fought. The symbolism of the Marine Corps War Memorial is not abstract, as is that of the Washington Monument; its iconography is literal as well as unambiguous and immediately intelligible. In these respects it is also very unlike the VVM.

The memorial to the Seabees (just across Arlington Memorial Bridge, on the appropriately named Avenue of the Heroes section of Memorial Drive which leads to Arlington National Cemetery) proceeds along the same lines (see fig. 4). The Seabees are builders and rebuilders rather than destroyers, as is evident from the panels on the wall behind the statues. This memorial conveys a kind of giving warmth. The Seabee and the boy (who is clearly foreign) almost seem engaged in a gentle dance. The contrast between the boy's vulnerability and the soldier's tremendous strength heightens the goodness to which the soldier's great power has been turned. The Seabee's uncovered chest follows the pattern of what is called heroic nudity. Like the Iwo Jima Memorial, this monument focuses on those who fought in a particular branch of the service. In this sense both monuments are generic.

Across the street from this memorial is another, curiously called

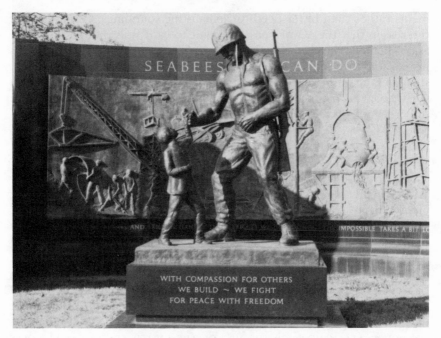

WITH COMPASSION FOR OTHERS
WE BUILD ~ WE FIGHT
FOR PEACE WITH FREEDOM

FIG. 4.

The Hiker, erected to commemorate our cause in the Spanish-American War and dedicated in 1965 (see fig. 5). The no-nonsense woodsman-turned-soldier is quaint to us, but the message is clear. A bronze plaque on the pedestal depicts a woman in supplicant pose before two American servicemen; she evidently represents the countries just "liberated" by them. American servicemen are the force of good.

The memorial to Ulysses S. Grant (dedicated in 1922) is far more ambiguous in its meaning, and so it bears a closer resemblance to the VVM than do any of the war memorials just discussed (see fig. 6). I would not go so far as to call it an antiwar monument; but it certainly neither glorifies war nor is heroic in any way. Grant looks distinctly ghostlike on top of his horse. The horse itself is not in heroic pose. Its tail is between its legs, indicating that the wind is coming from behind and so that it is stationary and not attacking. Grant is watching a battle plainly heard by the horse, a battle which Grant's side may or may not be winning. But there is no emotion on his face. Glory, the statue seems to say, is evanescent. The group of statues on his right depict Union troops on the attack (see fig. 7). Here again the accent is not on glory. The sculptor of this monument, Henry Merwin Shrady, went to extremes to ensure complete realism, and in this he suc-

FIG. 5.

ceeded. The tremendous tension and effort of the human figures' for-
ward movement says more about them as men than about the virtues
of their cause. In fact, one of them is about to be trampled to death
by the horses of his comrades, only one of whom notices the
immanent tragedy. To Grant's left is another group of statues, this
time artillerymen pulling a caisson through deep mud. It is hard to
say whether they are attacking or retreating; the emphasis is on the
severe strain of war.

The Grant Memorial as a whole does not convey a moral lesson,
and in this it resembles the VVM. One thinks, first, of all the death
and dying suffered in war. Perhaps this characteristic of the Grant
Memorial is due in part to the nature of the war it portrays. In a fight
against one's brothers it is more difficult to feel without ambiguity
that one is engaged in a battle between good and evil, a battle in
which there can be a clear-cut winner and loser. This is the only
memorial on the Mall explicitly showing battle scenes; on the whole
the Mall is very unwarlike. Appropriately enough, the Grant Memor-

FIG. 6.

ial sits on the western front of the Capitol and looks west, out across the Mall, in the direction of the Lincoln Memorial as well as Lee's house and the vast cemetery next to it. Recall that the west represents, via the sunset, the conflict between opposing forces—the battle which Grant, high upon his horse, studies. In the Mall complex the whole great oppositional struggle of war, and particularly of the Civil War, is oriented to the west. The presence of the facing Lincoln and Grant Memorials on the Mall, indeed on the same east–west axis, virtually establishes the Civil War as *the* critical event recollected on the Mall. The VVM too, let us note, sits at the western end of the Mall, and the war it recalls ignited much bitter dispute between Americans —bitterness second only, perhaps, to that which accompanied the Civil War.

The Second Division Memorial (1936) glorifies a division of the army but in a peculiarly symbolic way (see fig. 8). The whole syntax

of heroic images is compressed into a flaming sword of justice, held by a hand cut off from its body. This is an architectural version of synecdoche; the flaming sword in the sky stands for divine justice. The abstractness of this memorial distinguishes it from those we have examined but ties it to the VVM. The names of various places the division has fought are inscribed on the walls. The memorial is dedicated "to our dead," as in the case of the Iwo Jima Memorial.

The most thoroughly symbolic of all Washington's war memorials lies just across the Potomac alongside the George Washington Memorial Parkway. The Navy-Marine Memorial was dedicated in 1934 to those who perished at sea in the service of their country (see fig. 9). The seven delicately balanced gulls represent the souls of the dead. The symbolic representation of the disembodied soul as a bird is ancient and possesses a very rich history. There is no literal suggestion whatever in this war memorial as to its theme or purpose, and in this it is most like the VVM.

3

We are finally prepared to consider the Vietnam Veterans Memorial. The VVM initially seems extremely simple in its design, and in this as well as in its not being a means to a further symbol it

FIG. 7.

resembles the obelisk to which it points. Like that obelisk, it is not really beautiful in the way that the Jefferson Memorial is. The VVM basically consists of two walls of polished black granite meeting at a 125-degree, 12-minute angle and tapering off at each end. These tips point like arrowheads to the Washington and Lincoln monuments. The angle is not, then, just any angle. The monument is utterly symmetrical. Its two halves are, when considered in abstraction from the directions they point, identical except in the names inscribed and the dates of death. The wall supports nothing and is not supported by any other structure; there is no internal tension in the design. Since the wall's back is against the earth, the Memorial is in no way indifferent to the position of the beholder.

Most of the other memorials on the Mall are either classical in design or have classical antecedents. It is difficult to find any allusion in the VVM to a historical style except by visual incorporation of the two monuments to which it points. Furthermore, unlike all the other memorials discussed so far, the VVM is invisible from a distance, particularly as one approaches it from the north (the outlines of the Memorial are visible when one reaches the flagpole and statues located between it and the Lincoln Memorial to the southwest). It demands that you enter into its space or miss it altogether. When approaching the Memorial from the northeast, the first thing one sees is a stand

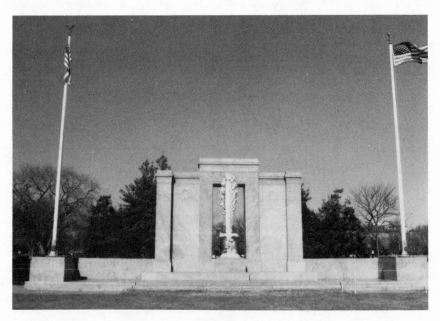

FIG. 8.

FIG. 9.

manned by Vietnam veterans soliciting support for the search for servicemen listed as missing in action. Another such stand presently exists on the southwestern approach to the monument. I mention this because it points to a fact which is not physically part of the architecture of this memorial but which is nevertheless revealing of it: it is a living monument in a way that is not true of the others I have discussed. It is almost impossible to visit this monument without encountering Vietnam veterans. And they generally are not just sitting and chatting but are usually involved very emotionally and publicly in the Memorial. I have seen many stand and weep there. The designer of the Memorial wanted it to serve as an occasion for therapeutic catharsis, and in this she has succeeded.[17] One can sit and have lunch at the Jefferson Memorial, fly a kite at the Washington Monument; one can smile at the

17. The designer is Maya Lin, who at the time was a twenty-one-year-old student at Yale University (the designer of the Grant Memorial too was young and unknown). Lin is quoted as saying that she intended the memorial "to bring out in people the realization of loss and a cathartic healing process" (*U.S. News and World Report* [21 Nov. 1983], p. 68). In her statement submitted as part of the design competition, Lin wrote, "Brought to a sharp awareness of such a loss, it is up to each individual to resolve or come to terms with this loss. For death is in the end a personal and private matter and the area contained within this memorial is a quiet place, meant for personal reflection and private reckoning" ("Design Competition: Winning Designer's Statement," reproduced by the Vietnam Veterans Memorial Fund, Inc.).

gentleness of the Seabees' Memorial; children can play on the nearby statue of Einstein;[18] but one cannot treat the VVM with informality or familiarity.

One must, then, come upon the VVM suddenly. It is quite possible to happen upon it almost by accident, as I did. Once there, however, one is led into it gently.[19] One sees a few names whose order is initially not clear; then more names; then many more. There are no steps at this memorial, making it easily accessible to handicapped veterans. One walks down an incline to its heart, which is precisely where the incline is reversed and climbs up again. The centralizing axis of the monument is horizontal (whereas that of the other memorials I have discussed, with the possible exception of the Grant Memorial, is vertical). The slowness of one's exposure to the Memorial is merciful, for initial surprise turns slowly, rather than all at once, to shock as one realizes what one is looking at: the fifty-eight thousand names of those Americans who died and are missing in action as a result of this war.

Since one walks down into the embrace of the memorial, it engulfs the visitor even though the open sky is always overhead and a large wide open space faces the monument. Yet one does not have the experience of descending into a tomb or grave; the VVM does not close the visitor in, not even in the way that the Lincoln Memorial may be said to do so. The walls of the mural-like monument face south—the direction of warmth and life—so as to catch the maximum sunlight. In the descent toward the center of the monument there may be a delicate allusion to the ancient *tholos* tomb (such as the "tomb of Agamemnon" at Mycenae), buried in the earth and approached by an angled, graded passage downward. Yet even if this allusion is present, it is not strong enough to give the VVM a tomblike feeling. I do not deny that the inscription of the names on the polished black granite closely resembles the gravestones in so many American cemeteries, a resemblance accentuated by the presence of flowers and small flags which visitors to the VVM frequently leave at its base; the VVM is to that extent a sort of national gravestone. But I do wish to emphasize that the VVM is not tomblike or

18. The memorial to Einstein is directly north of the VVM (indeed, the VVM almost points directly to it) just across the street and next to the National Academy of Sciences. On the border of the nation's memorials lies a reminder of the critical role of science in shaping our past. The connection between the Vietnam War and the products of science is especially intimate. And the nuclear weaponry that science and Einstein produced have, of course, huge consequences for the nation's future. Given Einstein's efforts to find a cure for the disease of war, his proximity to the Mall and its memorials is all the more symbolic.

19. Access to the monument is provided by a path running its length, the grassy area in front being roped off for now to preserve it from the crowds of people who continually visit the Memorial.

morose, and also that it possesses complex dimensions of meaning not exhibited by any ordinary gravestone. The suddenness of the visitor's entry into the Memorial's space, the demand that one give one's complete attention to it even while remaining in a completely natural setting (without even a roof overhead), the impossibility of avoiding it once there—all these effects would be lost if the Memorial stood on higher ground, in plain view from a distance.

The logical (and chronological) beginning of the monument is neither of the two tips at which one necessarily enters into its space, but rather the point at which the two walls intersect. Thus as one starts at the geographic beginning of the Memorial (either of the two tips), one is actually starting partway through the list of names. The rows of names begin at the intersection of the two walls, on the top of the right-hand wall, and follow each other with merciless continuity, panel by panel, to the eastern tip of that wall, which points to the Washington Monument. The sequence resumes at the western tip, which points to the Lincoln Memorial, and terminates at the bottom of the left-hand wall. Thus the list both ends and begins at the center of the monument. When one has read halfway through the list all the way to the eastern tip, one's eyes are naturally drawn to the Washington Monument. The visitor who continued to read the names in the proper sequence would be forced to turn and walk to the other end of the Memorial and so to see the Lincoln Memorial. One's reading of the VVM, in other words, is interrupted halfway through by the sight of the two other symbols. The monument thus invites one to pause midway and consider the significance of the names in the light of our memories of Washington and Lincoln. Moreover, in reading the names on the Memorial one is necessarily reading from west to east, from the direction of death to that of resurrection and new life. However, one is forced to double back toward the west in order to finish reading the catalog of names. The complexity of the monument's directionality is further illuminated by the following: although the face of the VVM is directed to the south, the Memorial also resembles the tip of an arrow which is pointing north, to the region of the dark and the mysterious. The VVM thus shares with the Jefferson Memorial a probing of reasons and fate, an effort to grasp in thought recalcitrant reality.

I cannot help but mention that the peculiar way in which the VVM begins and ends—with the names of the first and last Americans to die in Vietnam—reminds us of a rather sad fact about the Vietnam War. That conflict had neither an official start (in sharp contrast, for example, with President Roosevelt's statesmanlike appeal for a declaration of war on Japan) nor an official end (there were no real celebrations, no parades for the returning veterans, just silence). But the disturbing inarticulateness of the Vietnam War, which is in one sense embodied in

the organization of the VVM, is in another sense overcome by the VVM's intricate symbolism and, indeed, simply by the existence of the Memorial on the Mall. Its very presence there bespeaks national recognition of and respect for the veterans' service, and to that extent articulates a certain settling of accounts.

The list of names both ends and begins at the center of the monument, suggesting that the monument is both open and closed: open physically, at a very wide angle, like a weak *V* for "victory" (a *V* lying on its side, instead of with its arms pointing upwards); but closed in substance—the war is over. This simultaneous openness and closure becomes all the more interesting when we realize that the VVM iconically represents a book. The pages are covered with writing, and the book is open partway through. The closure just mentioned is the closure not of the book but of a chapter in it. The openness indicates that further chapters have yet to be written, and read. It is important that the back of the monument is to the earth, for the suggestion that the Vietnam War is a chapter in the book of American history, and that further chapters remain in the book, would be lost if the wall were above ground, backed by thin air. The wall lies against the earth, indeed against the hallowed earth at the core of the nation's capital. Our future lies there, in our nation's soil as it were. This is the soil of the Constitution Gardens, of the memorializing Mall, of the spiritual heart of the country. By inviting us to understand the Vietnam War in this context, the VVM accurately reflects the etymological meaning of *monument* I have already mentioned: the VVM asks us not just to remember that war, it admonishes us to write the next chapter thoughtfully and with reflection on the country's values, symbols of which are pointed to by the Memorial itself.

Two short inscriptions on the Memorial tell why these names are being memorialized. Both are written at the point where the two walls meet, one at the apex of the right-hand one, after the date "1959" (in which the first American was killed), and the other on the bottom of the left-hand one, after the date "1975" (when the last American was killed). The first of these inscriptions reads "IN HONOR OF THE MEN AND WOMEN OF THE ARMED FORCES OF THE UNITED STATES WHO SERVED IN THE VIET-NAM WAR. THE NAMES OF THOSE WHO GAVE THEIR LIVES AND OF THOSE WHO REMAIN MISSING ARE INSCRIBED IN THE ORDER THEY WERE TAKEN FROM US." The second reads "OUR NATION HONORS THE COURAGE, SACRIFICE AND DEVOTION TO DUTY AND COUNTRY OF ITS VIETNAM VETERANS. THIS MEMORIAL WAS BUILT WITH PRIVATE CONTRIBUTIONS FROM THE AMERICAN PEOPLE. NOVEMBER 11, 1982." I have already noted that the other war memorials we have looked at honor those who died, not all those who fought. The point is emphasized even by the monument's title: it is a memorial to the Vietnam *veterans*, not the Vietnam War. It honors everyone who fought there without qualification, thus suggesting that they had not previ-

ously been honored by the American people. The Memorial is a source of pride to Vietnam veterans, and this explains why it is a living memorial. Clearly the vets view it as *their* memorial, a way of proclaiming and redeeming the honor of *their* service to the country. It is as though just having fought in that war deserves praise, as though doing so was above and beyond the call of duty. Perhaps the war's eventual unpopularity, along with the ambiguity of its purposes and of the nation's commitment to fulfilling its stated aims, gives weight to this suggestion.

It should be obvious by now that there is nothing heroic about this memorial. It suggests honor without glory. The VVM is not inspiring in the usual way that memorials are. The focus throughout is on individuals, not on a flag (no flag was included in the original design, and the flagpole added subsequently in no way violates the VVM's space), or on a sword of divine justice, or on good deeds rendered to those we died to protect, or anything else of the sort.[20] Even the appearance of a mechanical and impersonal order is avoided. Such an order would have arisen if the names were alphabetized or divided into categories according to the branches of the armed forces (the monuments to the Second Division, Seabees, and Marines, by contrast, focus on one of the services). The chronology of this war is marked by the death of individuals. In this sense it is appropriate that the VVM sits at the west end of the Mall, given the symbolism of the four directions. And a visitor searching for a particular name is forced to read a number of other names, so paying attention once again to individuals.

It is true that the monument speaks first of all, but by no means

20. The seemingly neutral status of the Memorial was dictated by the criteria set down for the design competition. The criteria were that the monument (1) be reflective and contemplative in character, (2) be harmonious with its site and surroundings, (3) provide for the inscription of the names of the nearly 58,000 who gave their lives or remain missing, (4) make no political statement about the war, and (5) occupy up to two acres of land. Most objections to the VVM are thus objections to the criteria for the competition. I am suggesting that Lin's design fulfills these criteria in a way that responds to those objections. The design competition was open to all United States citizens over eighteen years of age. The jury of seven internationally known architects and one writer/design critic was selected by the Vietnam Veterans Memorial Fund. A total of 1,421 entries were submitted to the competition. They were judged anonymously (identified to the jurors only by number). After deliberating, the jury unanimously recommended Lin's design to the eight directors of the Vietnam Veterans Memorial Fund, who in turn accepted the nomination unanimously. The proposal then had to go through the lengthy federal approval process. After a rancorous and heated debate between supporters and opponents of the design, it was finally agreed to add a sculpture of three servicemen and a flagpole to the memorial site, so that the heroism of the veterans and the nobility of their cause might be more palpably, and traditionally, represented. These additions are now in place. I shall discuss them briefly below. The VVM was constructed entirely with private contributions.

exclusively, of loss and pain. As the Memorial's architect pointed out, it is physically a gash in the earth, a scar only partially healed by the trees and the grass and the polish.[21] The VVM is not a comforting memorial; it is perhaps because of this, rather than in spite of it, that it possesses remarkable therapeutic capacity. When people find on the VVM the name they've been looking for, they touch, even caress it, remembering. One sees this ritual repeated over and over. It is often followed by another, the tracing of the name on a piece of paper. The paper is then carefully folded up and taken home, and the marks of the dead left in stone thus become treasured signatures for the living.

Usually the names of individuals who die in a war are listed on a monument in their hometown. The VVM makes the loss of these individuals a matter of national concern. This has been one of the main causes for the controversy over the monument. Some persons (such as President Reagan's first Secretary of the Interior, James Watt) insisted that the cause for which these individuals died be praised. As a result of the pressure brought to bear, a realistic statue of three soldiers (two of them white, one black) sculpted by Frederick Hart, and a flagpole, have been added in the area between the VVM and the Lincoln Memorial (the dedication ceremony was held on Veterans Day, 13 November 1984). They are thus at some distance from the VVM and function as a kind of entrance device for those approaching from the southwest or as an exit device for those leaving in the same direction (see fig. 10). Neither addition in any way interferes with one's contemplation of the VVM except to the extent that one might catch a reflection of the flagpole in the surface of the Memorial. For all practical purposes, the visitor to the VVM must literally turn his back to these additions.

The soldiers seem to have just emerged from the trees and to be contemplating the names inscribed on the VVM. The look on their faces is not heroic; in this respect they recall the statuary of the Grant Memorial. Since the flagpole is itself some fifty feet in the direction of the Lincoln Memorial from the statue, the two additions do not, so far as I can tell, form a substantive unity. The inscription at the base of the flagpole reads "THIS FLAG REPRESENTS THE SERVICE RENDERED TO OUR COUNTRY BY THE VETERANS OF THE VIETNAM WAR. THE FLAG AFFIRMS THE PRINCIPLES OF FREEDOM FOR WHICH THEY FOUGHT AND THEIR PRIDE IN HAVING SERVED UNDER DIFFICULT CIRCUMSTANCES." Seals of the five armed services (Coast Guard, Army, Marine Corps, Navy, Air Force) also adorn the

21. Lin is quoted in R. Campbell's "An Emotive Place Apart" as saying that "I thought about what death is, what a loss is . . . a sharp pain that lessens with time, but can never quite heal over. A scar. The idea occurred to me there on the site. Take a knife and cut open the earth, and with time the grass would heal it. As if you cut open the rock and polished it" (*American Institute of Architects Journal* 72 [May 1983]: 151).

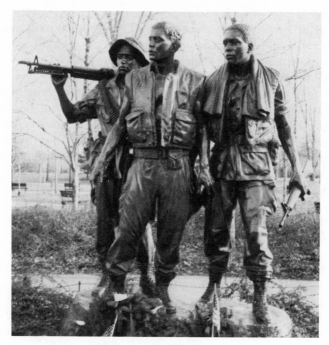

FIG. 10.

base. The statue and flagpole add a conventional, representational dimension to the nation's memorializing of the Vietnam veterans. Yet the physical and aesthetic distance between these two additions and the VVM is so great that there exists no tension between them. All three finally just seem to be separate memorials. Their presence on the same plot of land will eventually seem, I think, like faint echoes of the old and bitter debates about the Vietnam War, briefly reignited in the recent discussions about the political iconography suitable to memorializing it.

In any event, by emphasizing the sacrifice so many individuals have made, the VVM surely asks us to think about whether the sacrifice was worthwhile and whether it should be made again. The VVM is, in my opinion, fundamentally interrogative; it does *not* take a position as to the answers. It implies some terrible questions: Did these individuals die in vain? Was their death in keeping with our nation's best traditions as symbolized by the nearby monuments? For what and when should Americans die in war? That the person contemplating the monument is implicated in these questions is also emphasized by another crucial aspect of this memorial, namely, that the polished black granite functions as a mirror. This fact gives added depth to the monument and mitigates any sense of its being a tomb. In looking at the names one

cannot help seeing oneself looking at them. On a bright day one also sees the reflections of the Washington or Lincoln memorials along with one's own reflection. The dead and living thus meet, and the living are forced to ask whether those names should be on that wall, and whether others should die in similar causes. You are forced to wonder where you were then and what role you played in the war. Nineteen sixty-nine, perhaps one of your college years: as you studied books, these people were dying one after the other.

The VVM compels us to contemplate difficult questions with a clear awareness of the inevitable cost in human life. The Memorial does not claim that life is the most precious of all things, but it does force us to wonder when it is worth giving up. In looking at the polished walls of the VVM, the visitor is facing north. The viewer enters by reflection into the depth of the Memorial, beyond the southern sunlight which shines off the surface, into the northern region of dark mysteries and difficult questions. The Washington and Lincoln memorials are continually present as one enters that region; they help to give shape and direction to our questions.

The invitation to contemplate the Vietnam War and the whole issue of America's involvement in similar wars is accented in yet another way. Set directly in nature, the monument is undisturbed by the turbulence and constant fermentation of human affairs. The landscaped grounds in front of the Memorial function like the bowl of a theater in which one may sit and observe. The VVM is thus simultaneously an extraordinarily moving monument as well as one which demands the detachment of thought from emotions. The Memorial presents, in the context of the Mall's Constitution Gardens, the tremendous human cost of the Vietnam War, and on *that* basis asks us to think about whether such a war is just. The monument performs the valuable service of reminding us to question, without forcing any simple answers upon us.

The *interrogative* character of the Memorial requires that it not commit itself overtly to answering to these questions. Hence the seemingly apolitical nature of the monument and its separation of war and politics. Appropriately absent from the dedication of the Memorial were sectarian politics and politicians (with the exception of Senator John Warner, who was welcomed warmly thanks to his support of the VVM). The dedication was organized and run by the veterans themselves. The healing value of the dedication and the Memorial would have been compromised if either had become an official government event. The presence of the president, for example, would surely have stirred up bitter feelings for and against the war, and served as an occasion for the expression of a good deal of anger which many feel

toward the government for its conduct of the war and treatment of its veterans.

 I mention all this because it reminds us that a main purpose of the Memorial is therapeutic, a point absolutely essential for an adequate understanding of the VVM. This purpose was not explicitly called for in the design competition but is implied by one of the rules which guided it, namely, that the monument make no overt political statement. It was generally understood that what the nation needed was a monument that would heal the veterans as well as the rest of us, rather than exacerbate old wounds and reignite old passions. The interrogative character of the monument's architecture must be understood in the light of that purpose, and this purpose cannot be understood in abstraction from the severe conflicts of the times. In a way that is true of the Civil War but not of the two World Wars, the Vietnam War split the American people into warring factions united only by their hate for each other.

 But this does not mean that neutrality is the state of health that the VVM's therapy is ultimately intended to produce. For the Vietnam veterans, that state of health is, at the very least, the sense of wholeness made possible by a reaffirmation of the values for which the nation stands. That is, the monument's neutrality about the merits of the Vietnam War is intended to make possible proclamation of the honor of the veterans' service in Vietnam, and rejection of the suspicion that they did something shameful by answering their country's call. As part of one of the inscriptions on the VVM states, "Our nation honors the courage, sacrifice and devotion to duty and country of its Vietnam veterans." With this monument the veterans can reaffirm their pride in having served their country and so their pride in being Americans. Within that framework, furthermore, veterans and nonveterans alike are encouraged by the VVM to contemplate the difficult questions raised by America's involvement in the Vietnam War, and that too is a salutary effect of the monument. Thus at the VVM veterans can reconcile their doubts about the conduct and even the purposes of the war with their belief that their service was honorable, and nonveterans can retain the same doubts but also affirm the veterans' sacrifice. The VVM is not, then, therapeutic in a simply "psychological" way; its therapy depends on an understanding of certain overreaching values. Precisely that understanding was evidenced at the dedication of the Memorial, a day that was genuinely and openly patriotic, a day on which many veterans expressed their love of the United States. The striking and—given the long debates about the

Vietnam War—unexpected expressions of patriotism which one still witnesses at the VVM would not be possible if the monument were explicitly heroic or took a side in the arguments about the war.

That the author of the winning design of the VVM turned out to be a woman of Asian extraction too young to have experienced the Vietnam War herself looks like another instance of the unifying work of the "invisible hand" evident in the Mall as a whole. Even with respect to the designer of the VVM, the unexpected has conspired to reconcile the seeming contraries of east and west, male and female, youth and experience. Even here, the theme of healing is evident.

In sum, the monument has in fact accomplished the goal that those who have objected to it also praise: the goal of rekindling love of country and its ideals, as well as reconciliation with one's fellow citizens. In this crucial sense the VVM is not "neutral"—far from it. It neither separates war and politics completely nor proclaims a given political interpretation of the Vietnam War. This accomplishment of the Memorial tends to be missed by its critics. Differently put, the architecture of the VVM encourages us to question America's involvement in the Vietnam War *on the basis of* a firm sense of both the value of human life and the still higher value of the American principles so eloquently articulated by Washington and Lincoln, among others. This is the key to the Memorial's therapeutic potential. Because they have failed to understand this, critics of the VVM have held that the Memorial would quickly become a rallying place for all sorts of "anti-American" groups. This prophecy has not—and I think will not—come true. On the other hand, the VVM has not—and again I believe will not—become a rallying place for unreflective and unrestrained exhibitions of a country's self-love. For these reasons the VVM is a remarkably philosophical monument, quite in keeping with America's admirable tradition of reflective and interrogative patriotism. The VVM embodies the ability of Americans to confront the sorrow of so many lost lives in a war of ambiguous virtue without succumbing to the false muses of intoxicating propaganda and nihilism.

The patriotism expressed during the Memorial's dedication was informed by the healthy willingness to question the decisions of the politicians of the day about where and when Americans should die for their country. The monument's ability to engender declarations of patriotism is quite in keeping with such an interrogative character. If the Memorial momentarily separates war and politics, it is in order to give us a more secure foundation for understanding both.[22] The senti-

22. Thus my interpretation of the VVM differs from that of William Hubbard, "A Meaning for Monuments," *Public Interest* 74 (Winter 1984): 17–30. Hubbard does not take into account the therapeutic potential of this memorial. His criticism of the VVM culminates in the following:

ments of those who attended and addressed the Memorial's dedication were clear: America is worth dying for, but she must not fight a war when there is no popular consensus for doing so, and she must not fight without the intention to win decisively. Correspondingly, she must not fight under conditions where it is impossible to win.

But, as I have said, the overwhelming sentiment felt at the Memorial's dedication was patriotic, and so therapeutic. Even as the speakers expressed fears of entangling foreign alliances, most everyone seemed to feel that America is still like a ray of the sun in a somber world. In this way the ceremony and the Memorial once again served the cause of union. Complete strangers embraced each other. I repeatedly heard people saying "welcome home" to veterans, as though they had not been back all the while. I shall never forget the sight of Vietnam veterans who, though looking somewhat tired in their tattered combat fatigues, proclaimed by their very costume that they were proud to have accepted the call of their country. One veteran was dressed partly in combat fatigues and partly in the sort of leather attire favored by motorcycle gangs. His lined face and disheveled hair spoke of countless trials and difficulties undergone since returning home. He stood there silently during the dedication staring at the ground with one arm raised high, holding for all to see a miniature American flag. At the conclusion of the ceremony he joined in the refrain of "God Bless America." Those words swept boldly through the chill air, expressing the belief that, in spite of everything, America remains fundamentally good.

Little wonder, then, that the sheer emotional impact of the Vietnam Veterans Memorial satisfies us. Not having the idea that artworks can provide guidance in human dilemmas, we do not sense the absence of such guidance here. We take from the monument not a resolution of our conflicting emotions over the war, but an intensified, vivified version of those emotions. [P. 27]

Yet, as I have argued, the Memorial does not just demand emotion, it demands that emotion be checked by reflection guided by the symbolism of the VVM (symbolism partially sustained by the VVM's relationship to the rest of the Mall). The Memorial is interrogative in the way that Hubbard himself suggests all memorials should be (p. 28). His failure to consider the complex symbolism of the VVM leads him to erroneously assimilate the VVM to modernist architecture whose purpose is not to be *about* something in the world so much as to *be* a thing in the world (p. 26).

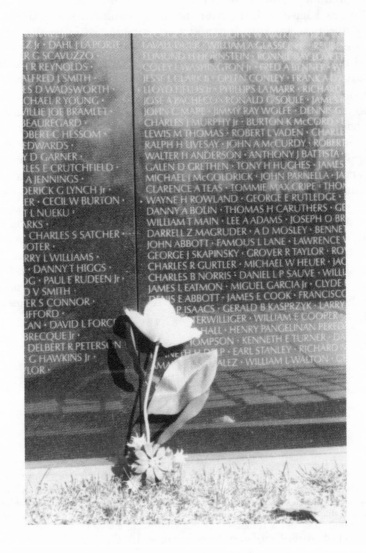

Law for Art's Sake in the Public Realm

Barbara Hoffman

A distinction must be made between the community acting as a public and as a crowd. Whenever a topic is beyond debate, the community no longer acts as a public.
—HAROLD D. LASSWELL, *Democracy through Public Opinion*

Beauty and the bureaucracy have as much trouble coupling as all the rest of us.
—LUCY R. LIPPARD, "Moving Targets, Moving Out"

Contemporary public art is still in the process of defining its artistic and legal identity. Indeed to juxtapose the terms *public* and *art* is a paradox. *Art* is often said to be the individual inquiry of the sculptor or painter, the epitome of self-expression and vision that may challenge conventional wisdom and values. The term *public* encompasses a reference to the community, the social order, self-negation: hence the paradox of linking the private and the public in a single concept. A goal of any general or jurisprudential theory concerning government sponsorship or ownership of art in the public context must reconcile, through state institutions and law, this tension between art's subjectivity with its potential for controversy and government's need to promote the public good.

This essay critically examines and discusses existing contemporary legal doctrine and its failure to accommodate or even adequately define the issues and competing values at stake in the public art context. Such failure may be attributed in part to the fact that neither legal theory nor

Critical Inquiry 17 (Spring 1991)

art policy have been inspired by the vision of or located in the broader context of a sociopolitical public realm.

The expression *public realm* is Hannah Arendt's.[1] It denotes that arena in which members of the public meet to accommodate competing values and expectations and hence in which all goals are open to discussion and modification. The notion of *public* I refer to is the one made current by American sociologists—particularly in the 1930s—who viewed the public as a form of social organization transcending particular communities and the restraints of existing norms to achieve corporate unity through critical interaction and public discourse; a public is constituted when persons have the ability to speak to each other across divergent cultural boundaries.[2]

The Dilemma of Contemporary Public Art

Before the modern period most public art commissions awarded by government in the United States could be labelled "public" in the sense that they served commemorative or functional purposes broadening the appeal of public policies and institutions. Art had a role in focusing, interpreting, and reinforcing accepted social, national, and civic values through comprehensible forms and symbols. The artist used the imagery, iconography, and formal structures that were part of the visual vocabulary of the society.

In the 1960s, federal, state, and municipal governments began to explore new ways to support art in public places for purely aesthetic reasons. They sought to install artwork that would both enhance public places and expand public awareness of contemporary artists. The bronze

1. See Hannah Arendt, *The Human Condition* (Chicago, 1958), esp. sec. 2, "The Public and the Private Realm." An important contemporary investigation of this concept is provided by Jürgen Habermas in *The Structural Transformation of the Public Sphere: An Inquiry Into a Category of Bourgeois Society,* trans. Thomas Burger and Frederick Lawrence (Cambridge, Mass., 1989).

2. See Robert C. Post, "The Constitutional Concept of Public Discourse: Outrageous Opinion, Democratic Deliberation, and *Hustler Magazine* v. *Fallwell,*" *Harvard Law Review* 103 (1990): 603–86; in particular, see Post's discussion of Carroll D. Clark, "The Concept of the Public," *The Southwestern Social Science Quarterly* 13 (Mar. 1933): 311–20.

Barbara Hoffman practices arts and entertainment law in New York and is counsel to the College Art Association. She is a former professor of constitutional law at the University of Puget Sound, and she has served as chair of the Public Art Committee of the Art Law Committee of the Association of the Bar of the City of New York, and president of the Washington Volunteer Lawyers for the Arts.

or stone commemorative work gave way to large scale abstract sculpture and earthworks.[3] The victory of abstraction meant that what was selected as public art was for the most part not public in the sense of shared aesthetic vocabulary, symbolism, or worldview between artists and their audiences.[4]

Commissioning or installing art in a public space has been from its inception a political act which involves a complex series of legal relationships often intertwined with a series of administrative, political, and funding considerations; the fact that a work of art is commissioned does not necessarily mean that it is for or of the public. In the absence of a political public, and with the collapse of the conception of a public realm defined by critical dialogue, government-sponsored art can only be understood by its audience as government-imposed art.[5]

The recent practice of and critical discourse about public art has struggled to deal with this, the central problem of public art, in order to legitimate and provide a rationale for public art programs. Almost every definition and concept pertaining to the field of public art has been scrutinized since the 1960s. Some public artists—Alice Adams, Siah Armajani, Donna Dennis, Nancy Holt, and Mary Miss—have adopted an approach based on collaboration with architects, landscape architects, and engineers, with a view to making the public space a work of art. Armajani has stated that "public art should not intimidate or assault or control the public. . . . The public artist is a citizen first. There is no room for self-expression."[6]

Some contemporary sculptors have tried to make sculpture public by taking the spatial experience of the audience as their subject. As Michael North recently observed, "if anything unifies the whole range of sculpture from minimalism to . . . political agitation . . . , it is the idea . . . that contemporary sculpture takes as its subject the 'public, conventional nature of what might be called cultural space.'"[7] For example, Richard Serra stated with respect to his *Tilted Arc:*

3. The Philadelphia Redevelopment Authority's guidelines for its Percent for Art programs state that "the Committee does not approve of a Commemorative Work of Art when it is simply illustrative or is a literal portrait of a historical figure" (sec. V, p. 26).

4. Jean-François Lyotard maintains that avant-garde art "manages to neglect utterly its 'cultural' responsibility for unifying taste and providing a sense of communal identity by means of visual symbols" (Lyotard, "Presenting the Unpresentable: The Sublime," trans. Lisa Liebmann, *Artforum* 20 [Apr. 1982]: 67).

5. See Martha Rosler's portion of "The Birth and Death of the Viewer: On the Public Function of Art," in *Discussions in Contemporary Culture* 1, ed. Hal Foster (Seattle, 1987): 9–15.

6. Siah Armajani, "The Artist as Citizen," in "Shaping the New Sculpture of the Street," *New York Times,* 22 Sept. 1985, p. E22.

7. Michael North, "The Public as Sculpture: From Heavenly City to Mass Ornament," *Critical Inquiry* 16 (Summer 1990): 861.

Tilted Arc was constructed so as to engage the public in dialogue that would perceptually and conceptually enhance its relation to the entire plaza.

The sculpture involves the viewer rationally and emotionally. A multitude of readings is possible. . . . The work, through its location, height, length, horizontality, and lean, grounds one into the physical condition of the place. The viewer becomes aware of himself, his environment, and his movement through the plaza.[8]

The controversial case of *Tilted Arc* reminds us that when the interests of the artist and those of a largely uninformed or hostile community collide—however self-evident the moral, social, and aesthetic issues involved may seem—in practical terms the burden of proof will always fall upon art's defenders. The refusal of the sculpture's passing audience to constitute itself as a public resulted in the government's decision, after three days of hearings and four years of acrimonious debate, to relocate *Tilted Arc*.[9] In his opinion that denied Serra's request to enjoin removal of the sculpture, Judge Pollack criticized Serra:

The sculpture as presently located has features of a purpresture. . . [:] "An inclosure by a private person of a part of that which belongs to, and ought to be free and open to the enjoyment of the public at large."[10]

Legal scholar Duncan Kennedy, in a 1979 law review article, described Blackstone's *Commentaries*—from which Judge Pollack's definition is taken—as an important eighteenth-century legal treatise, and as an attempt to "naturalize" purely social phenomena.[11] It appears a strange reference here, arguably reflecting the judge's perception that difficult art imposed on a reluctant public reflects a privatization of public space. That perception is a far cry from art historian Rosalind Krauss's, who sees Serra's work as exemplifying the phenomenology of Maurice Merleau-Ponty and *Tilted Arc* as "lived perspective."[12]

8. Richard Serra, testimony in *Public Art, Public Controversy: The "Tilted Arc" on Trial,* ed. Sherrill Jordan et al. (New York, 1987), p. 148.

9. The concept of critical interaction necessary to form a public requires that the participants value tolerance and heterogeneity and share standards of meaning. In contemporary cultural debates, what Herbert Gans has called a war of "taste cultures" has created only the illusion of a "public realm." Preconceived ideas with no likelihood of transformation through enlightened debate are brought fully formed to the public sphere.

10. *Richard Serra v. United States General Services Administration,* 667 F.Supp. 1042, 1056, n.7 (S.D.N.Y. 1987). For a discussion of the various claims, see my "Tilted Arc: The Legal Angle," in *Public Art, Public Controversy,* pp. 28–46.

11. See Duncan Kennedy, "The Structure of Blackstone's *Commentaries,*" 28 *Buffalo Law Review* 205, 211 (1979).

12. Rosalind E. Krauss, *Richard Serra / Sculpture,* ed. Laura Rosenstock (New York, 1986), p. 33.

It is clear then that in the face of such judicial attitude and community reaction, public art's defenders must find not only the reasons but the language to make such issues intelligible to those for whom art is at best a decorative amenity and at worst an authoritarian imposition.[13]

Important as it is in its own right, the *Titled Arc* debate calls forth many of the aesthetic, social, and legal questions evident in past and current controversies over what is appropriate public art. George Sugarman, Alexander Calder, Claes Oldenburg, and Mark di Suvero all have found their works attacked by a vocal segment of the general public when the abstract and nonreferential nature of their works proved to be a stumbling block. The tension between promoting art and responding to public responsibility is even sharper when tax dollars are used to finance projects that are perceived by representatives of an unidentified "public" as an artistic hoax, ideologically incorrect, obscene, or offensive to civilized society. Ironically, however, the artwork in these four instances became a civic icon in the city in which the work was permanently installed.

Not so fortunate was Alan Sonfist's *Time Landscape of St. Louis,* created from native vegetation as a civic monument to St. Louis's natural history. It was levelled by city bulldozers, barely seventeen months after its dedication by city officials, on order of Evelyn Rice, head of the parks department. St. Louis's first environmental sculpture was declared a public eyesore that attracted homeless people to hang their laundry in the trees. Explicitly ignored were the maintenance and deaccessioning procedures set forth but not made mandatory by the Regional Arts Commission.

In Washington State, the senate declared a mural painted by Michael Spafford entitled *The Twelve Labors of Hercules* to be pornographic and covered it in 1982 after receiving complaints that its suggestive nature caused children to giggle. Many legislators, presuming to reflect public resentment, saw sexual overtones in the depiction of Hercules slaughtering Hippolyta and found the scene of Hercules wrestling with death, represented by a skeleton, a depressing sort of theme, particularly in a state legislative chamber. Spafford selected the Hercules theme because of its referential and associational content: the capital, Olympia, in Spafford's opinion, is a place where both Hercules and legislators overcome great obstacles through compromise and effort.

Spafford and Alden Mason, whose work was also ordered removed, filed suit based on breach of contract, claiming that the site-specific nature of the murals prevented relocation. Both artists' contracts provided in pertinent part that "the agency agrees that it will not intentionally destroy, damage, alter, modify, or change the art work in any way whatsoever." Based on the contract, the court ruled that the state was entitled to

13. See Robert Storr, "'Tilted Arc': Enemy of the People?" *Art in America* 73 (Sept. 1985): 90–97.

remove or cover up but not alter or destroy the murals. (Spafford's work could not be removed without destruction; Mason's was placed in storage.) Judge Carroll offered a second reason for barring the murals' physical destruction: "publicly commissioned site-specific art is owned by the public and has rights independent of the artist. It has a right to be displayed in a way which promotes its aesthetic value. These are public rights enforceable in court."[14] In the fall of 1989, reacting to the censorship that many legislators saw inherent in Senator Jesse Helms's attack on federal arts support, the Washington State legislature ordered the Spafford murals uncovered. In September 1990, Judge Carroll ruled that the Mason murals could not be relocated to a university campus that had requested them because of Mason's objection to the site.

Since World War II, artists have frequently found themselves in conflict with political interests that claimed to be representative of a general American public sphere. During the 1940s and 1950s, political ideology dominated the controversy over the Rincon Annex Post Office murals created in San Francisco by Anton Refregier, winner of one of the last Works Progress Administration national competitions in 1941. The move to destroy the murals was sparked in 1946 by Congressman George A. Dondero who, targeting government-sponsored artworks,

> launched a campaign against all modern art as communistic "because it is distorted and ugly. Art which does not glorify our beautiful country in plain, simple terms that everyone can understand breeds dissatisfaction . . . it is therefore opposed to our government and those who create and promote it are our enemies.[15]

He was supported by Congressman Richard Nixon, who in 1949 "replied to a letter from an ex-American Legion Commissioner, agreeing that Refregier's murals should be removed, together with all other public art 'found to be inconsistent with American ideals and principles'" (*CPA*, p. 37). In 1953, a joint resolution was introduced to Congress by Congressman Hubert Scudder requesting the removal of the murals.

The mural controversy became a liberal cause célèbre. The American section of the International Association of Art Critics, one among Refregier's many supporters, accused the government of censorship:

> No law forbids an owner to destroy a work of art; but civilized thought has attached the name of vandalism to such acts of destruction. To remove a mural and painting because it expresses ideas

14. Oral decision in *Mason v. State of Washington*, No. 87-2-08597-0 (Wash. Sup. Ct., King County), 10 Oct. 1987.

15. Quoted in Elizabeth Ourusoff de Fernandez-Gimenez, "Anton Refregier," in *Controversial Public Art: From Rodin to di Suvero* (Milwaukee, 1983), p. 37; hereafter abbreviated *CPA*.

objectionable to some citizens is to destroy also the liberty of expression, the free market in ideas which is one of the foundations of a democratic society. It can only lead to the subjection of art to changing political doctrines. [*CPA*, pp. 38–39]

If modernist public art aroused controversy over its abstract, non-referential nature, recent public art has tended to arouse reactions by means of specific political references and direct affronts to traditional standards of decency and taste. These controversies have clear ideological implications involving national and racial pride, and homophobia. As Anthony Jones, president of the School of the Art Institute of Chicago, observed,

[most of] the art you have seen in the last twenty years . . . has been about abstraction, introspection, minimalism, theory, and non-figuration. . . . This is art work about *issues* via *images,* and members of the community (who mostly view art as something that stimulates or soothes but does not *assault*) are often horrified by this uncompromising confrontational aspect of the visual arts.[16]

Subject matter and its social implications rather than aesthetic idiom provoked the reaction to a historical mural painted by Edward A. Kane, Sr., in 1967 over the entrance to the city hall in Edwardsville, Illinois. In 1988 the black community objected to one figure in the mural described by the artist as "a Negro, a rope of bondage having been cut, symbolical of the slaves that were freed in Edwardsville by one of the early governors of Illinois." The city council, in response to intense community pressure, voted to let the Edwardsville Human Relations Commission change the mural, and a local artist was hired to transform the freed slave into a dignified figure holding farm implements. The director of Human Relations stated that "art doesn't have any more right to deeply offend people than people have to deeply offend people." The artist's son sought legal relief on the grounds that "'allowing any such alteration would constitute a deprivation of the right to artistic communication without governmental influence, interference, censorship, or suppression.'"[17]

A controversy of a similar nature evolved when Art Institute of Chicago student David Nelson's painting of Chicago's late mayor Harold Washington, portrayed in women's underwear, was displayed in a student exhibition in May 1988. The title of the work, *Mirth and Girth,* was also the name of a group of overweight gay men. Various police officers and aldermen of Chicago entered the exhibition and seized the painting; it was

16. Anthony Jones, "Stars and Bras: A Report from the Trenches," *Academe* 76 (July–Aug. 1990): 23.

17. Sylvia Hochfield, "The Moral Rights (and Wrongs) of Public Art," *ARTnews* 87 (May 1988): 143, 144.

later returned slashed. A year later, the Art Institute became the subject of another political and public outcry and a lawsuit as a result of Scott Tyler's *What Is the Proper Way to Display the American Flag?* As part of the work, viewers are invited to record their response to the title's question, but in order to do so they had to step on a flag lying on the floor. In response to fiscal censure by the legislature, Jones asked, "Is the legislature going to punish anyone who doesn't adhere to community standards of art as determined by politicians?"[18] The legal system proved a more sympathetic forum when a Cook County court held the flag-sculpture artistic and political expression protected by the First Amendment.

In January 1990 two paintings—one a nude self-portrait modelled after Botticelli's *Birth of Venus,* the other a partially clad pregnant woman, both by Frostburg State University graduate student Robyn Price—were removed from an exhibition at the university museum by the vice president of Student and Educational Affairs who "complained that their content could 'psychologically inhibit' off-campus visitors," especially given the "'number of religious people in [the] area who may have a sensitivity to nudity and to certain types of art.'"[19] The closing of the Robert Mapplethorpe exhibition The Perfect Moment at the Corcoran Gallery, the attacks on Andres Serrano's photograph *Piss Christ,* the trial of the Cincinnati Contemporary Art Museum and its director, Dennis Barrie, on pandering and obscenity charges for exhibiting The Perfect Moment, and the efforts to impose content-based restrictions on grants given by the National Endowment for the Arts (NEA), show the presence of a conservative segment of the American population led by religious right fundamentalists that is unwilling to constitute itself a "public" in support of artistic freedom when the images in question attack religious and sexual taboos even in spaces normally associated with a "public realm." These controversies show an increasing erosion of the boundary between the public and private spheres. At its outer reach, the political goal is to reprivatize many activities that are potentially or traditionally public, like government sponsorship of the arts. Such privatization renders art irrelevant or marginal to the social order and public debate.

At issue in all of these disputes is the conflict between the rights of the artist who creates the work, the rights and responsibilities of the governmental authority who commissions and/or funds the work, and the rights of the public for whose benefit it is presumably created. What limitations, if any, are imposed on government as an owner of property when that property is art? Does artistic freedom limit governmental property rights, or are such rights of artistic expression properly limited in the public con-

18. Quoted in Martha Gever, "Second City First in Censorship," *The Independent* (Oct. 1989): 8.
19. "Paintings Removed from University Exhibit in Maryland," Newsbriefs, *New Art Examiner* 17 (Mar. 1990): 11.

text? Does art that is publicly sponsored and displayed have the right to offend community values and contravene local standards of decency?

Tilted Arc: *The Appellate Court Decision*

In the remainder of this essay, I will use the appellate court decision in the *Tilted Arc* case as a specific focus of analysis and point of departure to discuss the contemporary legal response to these issues.[20] *Tilted Arc* may be viewed as the paradigmatic example of the failure of American public art policy. It also reveals the inadequacy of contemporary legal analysis with respect to constitutional and intellectual property doctrine as applied to artistic expression in the public context. The problem with the decision of the *Serra* court is not only that it failed to achieve a satisfactory reconciliation among the various competing interests by the sensitive balancing appropriate when significant First Amendment interests are implicated. It also failed to provide a framework for future analysis that could articulate the interests and values actually at stake. The court's opinion sheds little light on one of the central legal issues of the case: how strictly should a court scrutinize administrative actions for removing works of art that have been commissioned through due process and brought into existence through government-sponsored programs?

In fairness to the court, its decision was made against a matrix of exceedingly complex and essentially unsettled legal doctrines. The Supreme Court, unable to articulate any principled line between content regulation and censorship, has provided little guidance to lower courts. In part, the *Serra* court opinion reflects the congruence of the legal and sociopolitical spheres, for the law is not autonomous. To say that, however, is not to say that it was mandated by existing precedent, particularly where the issue is not relocation but destruction of a unique, site-specific work of art.

In 1979, Serra's sculpture was commissioned as part of the United States General Services Administration's (GSA) Art-in-Architecture Program as a permanently installed, site-specific sculpture on the Federal Plaza in lower Manhattan. Ten years later, it was removed to storage after a GSA-appointed panel of experts failed to find a suitable site for relocation. Serra's effort to enjoin removal of the sculpture through judicial intervention was ultimately unsuccessful. He alleged in federal district court that the GSA's decision to remove his sculpture violated his rights under the Free Speech Clause of the First Amendment, the Due Process Clause of the Fifth Amendment, federal trademark and copyright laws,

20. A specific discussion of the constitutional limits of content-based restrictions placed on publicly funded art is beyond the scope of this essay. There is no Supreme Court precedent directly bearing on funding of the arts in this context.

and state moral rights law. The linchpin for all Serra's claims was the existence of a cognizable legal relationship between the site and the artwork, which prevented its relocation or removal.

Judge Pollack dismissed for lack of subject matter jurisdiction Serra's claims based on breach of contract, federal trademark and copyright statute, and state law. He granted summary judgment (decision without trial) to the GSA on Serra's constitutional claims on the ground that the decision to relocate *Tilted Arc* was a content-neutral decision made to further the GSA's mission in administering and maintaining federal property, and that the hearing before the GSA provided all the process that was due.

Serra's appeal in 1988 presented the question of whether the removal and destruction of a government-owned artwork from federal property violates the free expression and due process rights of the artist. An eleventh-hour appeal in 1989 based on moral rights doctrine and U.S. adherence to the Berne Convention was subsequently abandoned, based on clear evidence in the Implementation Act itself that "the provisions of the Berne Convention . . . do not expand or reduce any right of an author of a work . . . to claim authorship of the work; or to object to any distortion, mutilation, or other modification . . . that would prejudice the author's honor or reputation."[21]

On appeal, Serra's lawyers argued that once a medium of expression—be it writing, film, theatre, painting, or sculpture—is publicly installed or displayed, First Amendment rights attach that prohibit the government from removing the expression on the basis of content. They relied on the Supreme Court decision in *Board of Education, Island Trees Union Free School Dist. v. Pico.* In *Pico,* a board of education ordered the removal from its high school libraries of nine books said to be "anti-American, anti-Christian, anti-Semitic and just plain filthy."[22] Students brought an action against the board alleging a violation of their First Amendment rights. Justice Brennan, writing for a plurality of the Supreme Court, affirmed the opinion of the Second Circuit Court of Appeals. In that decision, Judge Newman, in his concurring opinion viewed *Pico* as turning on the contested factual issue of whether the petitioners' removal decision was motivated by a justified desire to remove books containing vulgarities or an impermissible desire to suppress ideas. Justice Brennan stated that once a book is acquired and placed in a school library, removal on the basis of content violates the First Amendment. He drew a sharp distinction between acquisition and removal and ruled out the propriety of summary judgment in deciding the school board's motive for the removal.

21. Berne Convention Implementation Act of 1988, Public Law 100–568, 102 Stat. 2853–54.
22. *Board of Education, Island Trees Union Free School District No. 26 v. Pico,* 638 F.2d 404 (2nd Cir. 1980); affirmed 457 U.S. 853 (1982).

Writing for a distinguished three-judge panel of the Second Circuit, which included a former counsel to the Museum of Modern Art, Judge Newman affirmed the granting of summary judgment and held that Richard Serra's First Amendment rights were not infringed:

> While we agree that artwork, like other non-verbal forms of expression, may under some circumstances constitute speech for First Amendment purposes, . . . we believe that the First Amendment has only limited application in a case like the present one where the artistic expression belongs to the Government rather than a private individual. . . . In this case, the speaker is the United States Government. "Tilted Arc" is entirely owned by the Government and is displayed on Government property. Serra relinquished his own speech rights in the sculpture when he voluntarily sold it to GSA; if he wished to retain some degree of control as to the duration and location of the display of his work, he had the opportunity to bargain such rights in making the contract for sale of his work.[23]

Despite its conclusion that the government controlled the artwork, the court did consider the possibility that Serra retained some First Amendment interest in the continued display of *Tilted Arc,* although it failed to elaborate on the nature of such interest. Even assuming such interest, the court held that the GSA's action was properly analyzed as a permissible form of time, place, and manner restriction. Historically, time, place, and manner analysis concerned incidental restrictions on expressive activities resulting solely from content-neutral restrictions. Under recent decisions, restrictions are valid if they are content neutral, are "narrowly tailored to serve a significant governmental interest," and "leave open ample alternative channels for communication."[24] The court found that the government's content-neutral interest in an unobstructed

23. *Richard Serra* v. *United States General Services Administration,* 847 F.2d 1045, 1048, 1049 (2nd Cir. 1988); hereafter abbreviated *RS.*

24. *Clark* v. *Community for Creative Non-Violence,* 468 U.S. 288, 293 (1984). See also *United States* v. *O'Brien,* 391 U.S. 367 (1968). In *Clark,* the Court held that a ban on sleeping in Washington, D.C.'s Lafayette Park did not infringe on the First Amendment rights of demonstrators who sought to sleep in the park to protest the Reagan administration's policies and to portray the plight of the homeless. The opinion ignored the idea that the message was intertwined with the medium and attached no significance to the nexus between the message and the site. In *O'Brien,* the Court upheld criminal penalties for the destruction of draft registration cards because the law promoted an important interest unrelated to the suppression of expression. In *Ward* v. *Rock against Racism,* the Court dismissed a First Amendment challenge to a New York City regulation mandating the use of city-provided sound systems and technicians for concerts in Central Park. The Court upheld the regulation as a reasonable time, manner, and place restriction, stating that the narrow tailoring requirement did not include a "less restrictive" alternative analysis. Justice Marshall wrote in dissent that "the majority enshrines efficacy but sacrifices free speech" (105 L Ed 2d 661, 686 [1989]).

Federal Plaza could only be furthered by *Tilted Arc*'s removal and noted that alternative channels remained available for Serra's speech.

As if uneasy with its characterization of the government's interest in light of Serra's claim that removal was based on aesthetics, the court further elaborated on its view of content neutrality. It noted that the Supreme Court has approved the legitimacy of content-based regulation of aesthetics as a proper governmental objective and that several lower courts have held that the state may regulate the display and location of art based on its aesthetic qualities and suitability for the viewing public without running afoul of First Amendment concerns.[25] Only if Serra had presented "any facts to support a claim that Government officials acted in a 'narrowly partisan or political manner'" would the principles of *Pico* be implicated.

> In the absence of such facts, [Serra's] lawsuit is really an invitation to the courts to announce a new rule, without any basis in First Amendment law, that an artist retains a constitutional right to have permanently displayed at the intended site a work of art sold to a government agency. Neither the values of the First Amendment nor the cause of public art would be served by accepting that invitation. [*RS*, p. 1051]

The *Serra* court's decision reflects current judicial attitude towards First Amendment theory as applied to artistic expression. Unfortunately, the opinion provides no discussion of the values of the First Amendment or of the objectives of public art policy, nor does it explain why either is served by a rule that practically allows government to remove, relocate, or destroy works of art that offend a vocal segment of the community unless the government action is based on the artwork's political viewpoint narrowly defined.

The Scope of the First Amendment

The First Amendment to the United States Constitution provides that "Congress shall make no law . . . abridging the freedom of speech." Supreme Court justices and other constitutional theoreticians have propounded several theories on the scope of the First Amendment, varying with the time and the context in which the issue has arisen. The principle of free expression serves the political needs of a democracy and carries beyond the political realm to embrace the needs of individual self-fulfillment.

There traditionally has been a close link between First Amendment

25. See *Piarowski* v. *Illinois Community College District 515*, 759 F.2d 625 (7th Cir. 1985); cert. denied 474 U.S. 1007 (1985); and *Close* v. *Lederle*, 424 F.2d 988 (1st Cir. 1970); cert. denied 400 U.S. 903 (1970).

theory and the concept of the public. The Supreme Court has emphasized that the First Amendment "embraces at the least the liberty to discuss publicly and truthfully all matters of public concern" and has stated that expression on public issues has always rested at the highest level of the hierarchy of First Amendment values, reflecting "a profound national commitment to the principle that debate on public issues should be uninhibited, robust, and wide-open." "If there is a bedrock principle underlying the First Amendment," wrote Justice Brennan in *Texas* v. *Johnson*, "it is that the Government may not prohibit the expression of an idea simply because society finds the idea itself offensive or disagreeable."[26] Robert Post writes:

> Resting upon a deep respect for the "sharp differences" characteristic of American life, [First Amendment doctrine] is committed to "the right to differ as to things that touch the heart of the existing order." It thus creates "a cleared and safe space" within which can occur precisely that "uninhibited, robust, and wide-open" debate on public issues that one would expect to emerge when dominant cultural traditions are denied access to the force of law to silence the clash of divergent perspectives. . . . The first amendment embodies this conception of critical discourse by performing the wholly negative function of shielding speakers from the enforcement of community standards.[27]

The Supreme Court's vision of the First Amendment as creating a sphere of critical interaction essential to the formation of public opinion was first expressed in a series of decisions in the late 1930s and early 1940s. One of the earliest examples of a decision concerning the regulation of expression in public places is *Cantwell* v. *Connecticut*. In *Cantwell*, the Court, on First Amendment grounds, overturned a conviction of a Jehovah's Witness who had been convicted of the common law crime of inciting a breach of the peace because he played a record, offensive to some, on a public street. In reconciling the interest in allowing free expression of ideas in public places with the protection of the peace and the primary use of streets and parks, the Court perceived the interest of the First Amendment as overriding, stating that "these liberties are, in the long view, essential to enlightened opinion and right conduct on the part of citizens of a democracy."[28]

The *Serra* opinion also recognized that various forms of nonverbal expression have been extended First Amendment protection. Yet this has been one of the most vexing judicial issues and has yielded widely diver-

26. *Consolidated Edison Company* v. *Public Services Commission*, 447 U.S. 530, 534 (1980); *New York Times Co.* v. *Sullivan*, 376 U.S. 254, 270 (1964); *Texas* v. *Johnson* 109 S.Ct. 2533, 2544 (1989). See also *United States* v. *Eichman*, 110 S.Ct. 2404 (1990); and *West Virginia State Board of Education* v. *Barnette*, 319 U.S. 624 (1943).

27. Post, "The Constitutional Concept of Public Discourse," pp. 637–38.

28. *Cantwell* v. *Connecticut*, 310 U.S. 296, 310 (1940).

gent results. Nonverbal expression may be protected as "pure speech," "symbolic speech," or "symbolic conduct."[29] In an effort to prevent a limitless variety of conduct from being labeled "speech," in *Spence* v. *Washington* the Court explained its methodology for categorizing the acts as either protected expression or unprotected conduct.[30] The defendant had affixed a peace symbol to a flag he owned and displayed the flag out of his window. The Court focused not on the conduct/speech distinction but the intent of speech to convey a particularized message and the audience's understanding of the message; now, under *Spence*, context provides meaning to nonverbal expression. The Court has recently stated that it will scrutinize less strictly regulations that affect symbolic speech than those that affect pure speech,[31] and will review regulations when aspects of conduct make up part of the cognitive and emotive elements of expression with an even more deferential scrutiny than for pure speech or symbolic expression.[32]

No one seriously contests the proposition that an artist's work is sufficiently imbued with elements of communication to fall within the scope of the First Amendment. The protection of the First Amendment is not limited to ideas. The landmark case of *Cohen* v. *California* established that the First Amendment protects expression that appeals to the emotion as well as to the intellect. In holding constitutionally protected the right to wear a jacket bearing the words "Fuck the Draft" in a courthouse corridor—the dissenting justices saw this as conduct rather than speech—Justice Harlan invoked a broad view of the First Amendment to invalidate California's attempt to maintain a "suitable" level of discourse within the body politic:

> The constitutional right of free expression . . . is designed and intended to remove governmental restraints from the arena of public discussion. . . .
> For while the word . . . is more distasteful than most of its genre, it is nevertheless often true that one man's vulgarity is another's lyric. Indeed, we think it is largely because governmental officials cannot make principled distinctions in this area that the Constitution leaves matters of taste and style so largely to the individual.[33]

29. In *U.S. ex rel. Radich* v. *Criminal Court of the City of New York*, a case involving sculpturelike constructions, one of which was an erect penis wrapped in an American flag, the court relied on a symbolic speech analysis but stated that the case could easily have dealt with raising a pure speech issue (385 F.Supp. 165 [S.D.N.Y. 1974]).

30. *Spence* v. *Washington*, 418 U.S. 405 (1974).

31. *Texas* v. *Johnson*, p. 2533.

32. The fact that subjectivity is involved in determining whether a work in question is art, and the possibility that unlimited conduct might therefore claim entitlement as speech, may be a factor in judicial reluctance to accord works of art full First Amendment protection.

33. *Cohen* v. *California*, 403 U.S. 15, 24–25 (1971).

Cohen, together with *Cantwell* and its progeny, places the First Amendment squarely within the spirit of intellectual and artistic individualism, and supports those whose discourse in the public context would challenge community norms and whose creative process involves a willingness to view anew the human condition. More recently, in *Ward* v. *Rock against Racism,* Justice Kennedy recognized that

> music is one of the oldest forms of human expression. . . . Rulers have known its capacity to appeal to the intellect and to the emotions, and have censored musical compositions to serve the needs of the state. . . . The Constitution prohibits any like attempts in our own legal order. Music, as a form of expression and communication, is protected under the First Amendment.[34]

Nevertheless, the Supreme Court has carved out categories of speech characterized by unpleasant format or emotive qualities for less than full protection, thereby allowing majoritarian preferences to shape the protection given to minority forms of expression. If a work is sufficiently offensive within the definition of *Miller* v. *California,* it is deemed obscene and is not considered speech. Artistic expression has been afforded full protection only when the court perceives that the artist has an evident political message or has dealt with a matter of public concern. Artistic expression is seen as primarily derivative in nature and therefore marginal in value. This legal position reflects the status of the arts in American society, where art often tends to be perceived as mere entertainment and most Americans' contact with "culture" is film or television.[35] Art as the raison d'être of civilization and the embodiment of the true aspiration of the human spirit is simply not an American idea.

This hostility to according full protection to nonpolitical artistic expression is evident in the lower federal courts. In *Close* v. *Lederle,* the First Circuit Court of Appeals reversed a district court decision, thus permitting a state university to cancel an exhibition of Chuck Close's sexually explicit but not obscene paintings in a corridor in the student union, finding the artist's First Amendment interests "minimal" because the paintings lacked political expression. "One painting bore the title, 'I'm only 12 and already my mother's lover wants me.' Another, 'I am the only virgin in my school.'"[36] The district court had held that the university had no right to censor simply on the basis of offensiveness.

In *Piarowski,* Judge Posner of the Seventh Circuit permitted reloca-

34. *Ward,* p. 674.

35. In a recent survey by the Thomas Jefferson Center for Freedom of Expression, 62.9 percent of those questioned believed that freedom of expression under the Constitution should cover art; 84.1 percent of that group thought artistic freedom coextensive with that afforded the spoken word. See also *Miller* v. *California,* 413 U.S. 15 (1972).

36. *Close,* p. 990.

tion but not removal of an artist's stained-glass panels in a community college gallery exhibition to protect a hostile segment of the public from its imagery. Posner concluded that the artist intended no political statement, was not disparaging of women or blacks—the choice of glass color was only aesthetic—and contained no comment on race or sex relations, but was simply "art for art's sake." Part of Judge Posner's description of the work is as follows:

> In the third window another brown woman, also naked except for stockings and also seen from the rear, is crouching in a posture of veneration before a robed white male whose most prominent feature is a grotesquely outsized phallus (erect penis) that the woman is embracing.[37]

He concluded that an artist who was also a gallery administrator had no First Amendment right to exhibit sexually explicit, racially offensive artworks in the busiest corridor on the campus, an exhibition that some could construe as approved by college officials.[38]

Judge Posner, commenting on his decision in *Piarowski*, stated that a rule "that implies that the scope of First Amendment protection may be different for works of art than for political or scientific works, is not to everyone's taste." And in language reminiscent of the *Serra* court, he continued, "such a rule—a rule that gave privileged status to the *flaunting* of offensive art—might engender public hostility to art that would be out of all proportion to the benefits in artistic freedom gained."[39]

Why artistic expression should be relegated to a marginal status unless it presents an explicit political message is somewhat puzzling. Sheldon Nahmod "attributes the marginality of artistic expression in First Amendment theory both to an unconscious acceptance of Plato's fears regarding the influence of art on society, and to the unsettling, disruptive nature of artistic representation of the Kantian sublime":

> From the perspective of the sublime, then, conferring lower first amendment value on such expression is an attempt by the Supreme

37. *Piarowski*, p. 627.

38. *Sefick v. City of Chicago* (485 F. Supp. 644 [1979]) is the only case to date in which an artist has successfully prohibited the removal of his work. In that case the court invalidated on First Amendment grounds the revocation of a permit granted to John Sefick by the City of Chicago to display in the Richard J. Daley Civic Center artwork satirizing then-Mayor Bilandic that previously had not been viewed. The court noted that a governmental entity has no obligation to provide a forum, but once it does, constitutional mandates apply. The court found that the motivation for the revocation was political and based on content alone. In applying strict scrutiny, the court rejected the city's arguments that it needed to protect a captive audience and did not want to appear to sponsor specific views.

39. Richard A. Posner, "Art for Law's Sake," *American Scholar* 58 (Autumn 1989): 520.

Court, and by society through the legislative process, to *repress* such expression—the Freudian terminology is intentional and appropriate—because it is deeply subversive. Indeed, art manifesting the Kantian sublime is even more dangerous to society than is modernist art, because the sublime has the potential for undermining entirely the Enlightenment narrative of a rationally organized social order.[40]

It is difficult to draw a bright line between art that communicates political ideas and art that does not. There simply may be a distinction between art that does so explicitly and art that does so implicitly. Even the familiar proposition of First Amendment doctrine, that expression has special value in the context of dialogue, does not facilitate such a distinction. As *Close* and *Piarowski* show, the activity of categorizing artistic expression as nonpolitical or political is itself the product of value choices and a legitimization of the status quo. In addition, some forms of contemporary art rebel against traditional measures of artistic quality and seek to escape categorization, while formalism and abstract expressionism reject the Platonic ideal of art in order to find reality in what is perceptible to the senses and in art's physical properties. As a consequence, classification or evaluation for legal purposes may be extremely difficult. If the government has the right to define what counts as political speech and to define the manner of expressing that speech, the risk exists that requiring speech to conform to traditionally accepted forms will impose similar constraints on the substance of that speech.

For these reasons, artistic expression in the public context should be accorded full First Amendment protection. This is not to argue that the First Amendment creates an impenetrable shield protecting all creative works and processes merely because it is labeled Art; it is to state the proposition that creative works like *Tilted Arc* are entitled to the same careful analysis and protection that courts have traditionally reserved for other forms of speech. That analysis balances the interest in freedom of expression against asserted government interests with a heavy thumb on the side of the First Amendment. The court did not give Serra's First Amendment claim the "most exacting scrutiny" appropriate to cases where the First Amendment is at stake.

The Inadequacy of a Model Based on Governmental Ownership

To what extent if any should the fact that government owns an artwork affect the analysis and level of scrutiny applied to governmental actions in the public art context? The distinction between governmental

40. Sheldon H. Nahmod, "Artistic Expression and Aesthetic Theory: The Beautiful, the Sublime, and the First Amendment," *Wisconsin Law Review* (1987): 221, 251.

and private ownership is not without significance. Governmental owner-
ship may give rise to proprietary rights in commissioning works of art,
their display, and installation that afford it broader discretion in achieving
aesthetic goals and using content-based criteria than when it funds or reg-
ulates artistic expression. Nevertheless, a First Amendment model that
places a talismanic significance on government's legal title to artwork so as
to provide virtually no limitation on its actions in the context of relocation
or suppression is unsatisfactory for several reasons.

The view that governmental ownership of artwork transforms it into
a form of governmental speech so as to defeat a claim of censorship is
troublesome. This is not to say that government itself may not speak or
otherwise contribute to public debate.[41] To the contrary, government,
through its various officials and agencies, does speak on its own behalf;
however, to allocate to government rights equivalent to private First
Amendment rights in this context is inapposite. Not only does this call into
question the neutrality requested of government in the public realm,[42]
but it addresses a category of speech that is presumptively unprotected
under the First Amendment. As Judge Conner in the case of *David
Wojnarowicz* v. *American Family Association and Donald E. Wildmon*
observed, the First Amendment does not protect "the public display of an
altered artwork, falsely attributed to the original artist."[43] In that case, the
American Family Association argued that the New York State Artists'
Authorship Rights Act violated its First Amendment rights if applied to
prevent the publication of a pamphlet that intentionally displayed the art-
ist's altered work.

Title to the artwork should not be a dispositive criteria in consider-
ation of the public's *Pico* right. In *Pico,* Justice Brennan did not con-
sider government's ownership of the books when he balanced the
school's interest in the inculcation of values advanced in support of the
removal of the books against the school children's right to receive
information and ideas.

> Our precedents have focused "not only on the role of the First
> Amendment in fostering individual self expression but also on its role
> in affording the public access to discussion, debate, and the dissemi-
> nation of information and ideas." . . . "The State may not, consistent

41. The relationship between governmental funding and the doctrine of unconstitu-
tional conditions applied in the context of First Amendment rights is one of great uncer-
tainty. The Supreme Court in the future may be more reluctant to find forbidden the
suppression of dangerous ideas than presently permitted by Court decisions dealing with
governmental subsidy programs. See *New York* v. *Sullivan,* 889 F.2d 401 (2nd Cir. 1989);
cert. granted 29 May 1990 (58 U.S.L.W. 3749).

42. See Post, "The Constitutional Concept of Public Discourse."

43. *David Wojnarowicz* v. *American Family Association and Donald E. Wildmon,* 90 Civ.
3457 (S.D.N.Y. 1990); decision 9 Aug. 1990, p. 19.

with the spirit of the First Amendment, contract the spectrum of available knowledge." . . . More importantly, the right to receive ideas is a necessary predicate to the *recipient's meaningful* exercise of his own rights of speech, press, and political freedom.[44]

Having correctly concluded that public art involves a *Pico* interest, the *Serra* court's analysis accorded insufficient weight to such interest, which in this context may be called "the public access right." Even if the *Pico* standard of "partisan or political motive" arguably affords public school administrators discretion in removing books based on criteria of civility and taste in the context of the public school environment, to afford such deference to government bureaucrats or, worse, to politicians does not seem to further any identifiable goals of public art programs.

The court's view that destroying an artist's past work does not suppress speech if the artist can create new work does little to promote one objective of public art programs: the creation of a cultural legacy. Moreover, controversy is both an inevitable and acceptable part of public art, which may require time for its acceptance. As Judge Posner observed,

Artistic value is something an audience invests a work with, and as the tastes of audiences change, so do judgments of artistic value. . . . If we grant that art has value and add that the censorship of art has a dreadful historical record, we can derive, in order to guide judicial review of controversies over offensive art, a presumption in favor of letting the stuff be produced and exhibited to whoever is willing to pay the price of admission. . . . We can bolster the presumption in favor of a permissive judicial attitude toward offensive art by noting that the "test of time" that is the closest we seem able to get to an objective measure of artistic value presupposes, like natural selection in the theory of biological evolution (which the test of time resembles), the existence of variety, from which history makes its selections.[45]

The government is not simply another property owner. Transforming art into a commodity falsely simplifies the analysis and fails to recognize that the nature of governmental ownership or sponsorship of art in the public context places government in the hybrid role of a patron and sovereign that performs a social function. As such, its actions must promote the general welfare. American jurisprudence has often limited property rights in cases where public or social interests are involved; the maintenance and preservation of a work of art is invested with the public

44. *Pico,* 457 U.S. 853, 866-67 (1982), quoting *First National Bank of Boston* v. *Bellotti,* 435 U.S. 765, 783 (1978) and *Griswold* v. *Connecticut,* 381 U.S. 479, 482 (1965). See also *Lamont* v. *Postmaster General,* 381 U.S. 301 (1965).
45. Posner, "Art for Law's Sake," pp. 514, 518.

interest in culture and development of the arts. Nevertheless, the *Serra* court declined to redefine property rights in the absence of legislative mandate and declined the invitation to use the First Amendment as a substitute for Serra's moral right and copyright claims.[46] Such claims are in derogation of the concept of absolute property rights.[47]

Fortunately, judicial reluctance to recognize a difference between art and other property is contrary to an emerging legislative and bureaucratic trend. A new sensitivity to art and the artist is evident in recent governmental contracts, which no longer treat the artist as a general contractor subject to general governmental procurement regulations, and in ordinances that provide special treatment for disposition of surplus artworks in a city's collection, recognizing "that a work of art has a character that is distinguishable from other publicly owned supplies, material, and equipment."[48] Moral rights legislation (which I will discuss in a subsequent section) is another example of a new willingness to limit property rights to serve social and political values. A contrary tendency is evident in the Supreme Court's public forum analysis, which I will analyze in the next section, where government's rights as a property owner may be the principal criteria determining the outcome.

Public Art / Public Forum

Several concepts that have emerged in the judicial and scholarly analysis of the First Amendment were available to the *Serra* court as sites for critically interactive encounters among various interests: the concept of the public forum, the distinction between content-based restrictions and reasonable restrictions of time, place, and manner, the concept of the captive audience, and due process. Each concept has seen tortured doctrinal development and has often been manipulated in Supreme Court cases in a less-than-principled manner.

The Supreme Court first discussed time, place, and manner restrictions in a series of decisions in the late thirties and early forties. As origi-

46. *Crimi* v. *Rutgers Presbyterian Church* (194 Misc. 570, 89 N.Y.S.2d 813 [Sup. Ct. 1949]) was an early resolution of the property right/moral right issue. The *Serra* court, like that in *Crimi*, refused to read moral rights into American law, holding that an artist retained no interest in preventing the destruction of his work after it had been unconditionally sold.

47. Copyright is a property right that protects expression, not ideas, and allows the artist to prevent unauthorized copying of the work. In effect, federal copyright law gives the "author" the exclusive right to reproduce the work and prepare derivative works. There is a strong argument that if the artist retains copyright, any relocation of site-specific work would constitute a derivative work in violation of artist's retained right. See the Copyright Act of 1976, 17 U.S.C. §101.

48. City of Seattle, Ordinance 115337, 27 July 1990.

nally conceived, the concept was a way of preserving First Amendment rights and sensitively balanced governmental interests against restrictions on speech. Public forum analysis might well be called the territorial approach to First Amendment law. The doctrine recognizes that even protected speech is not equally permissible in all places and at all times. Nothing in the Constitution requires the government to freely grant access to all who wish to exercise their right to free speech on every type of government property, without regard to the nature of the property or to the disruption that might be caused by the speaker's activities.[49] Robert Post has described the doctrine as defining that space in which speech will be deemed constitutionally independent of the managerial authority of state institutions.[50] Its origin is found in Justice Roberts's plurality opinion in *Hague* v. *C.I.O.:*

> Wherever the title of streets and parks may rest, they have immemorially been held in trust for the use of the public and, time out of mind, have been used for purposes of assembly, communicating thoughts between citizens, and discussing public questions.[51]

The thrust of Justice Roberts' opinion in *Hague* is not that speech in streets and parks is especially important but rather that the government could not exercise proprietary control over such places. Serra argued that the Federal Plaza is a public forum. Under contemporary doctrine, the Court has held that a right of access to public property for the exercise of free speech rights depends on whether it is a public, limited public, or nonpublic forum. Content-based regulation of expression on government property that has been traditionally open to the public—like streets and parks—is subject to strict scrutiny and cannot be suppressed except to serve a compelling state interest in the least restrictive manner. Content-based regulation of expressive activity on property that the government has expressly dedicated to speech—a "designated" or limited public forum—is also examined under strict scrutiny.[52] For example, in *Southeastern Promotions, Ltd.* v. *Conrad,* the Supreme Court required the city of Chattanooga, Tennessee, to permit a performance of the rock musical "Hair" at its theatre on the ground that the theatre was "designed for and dedicated to expressive activities" notwithstanding the city's objections to the production's content.[53]

"Public property which is not by tradition or designation a forum for

49. See *Cornelius* v. *NAACP Legal Defense and Educational Fund,* 473 U.S. 788 (1985).

50. See Post, "Between Governance and Management: The History and Theory of the Public Forum," *UCLA Law Review* 34 (1987), esp. pp. 1784–1800.

51. *Hague* v. *Committee for Industrial Organization,* 307 U.S. 496 (1939).

52. See *Perry Education Association* v. *Perry Local Educators' Association,* 460 U.S. 37 (1983).

53. *Southeastern Promotions, Ltd.* v. *Conrad,* 420 U.S. 546 (1974).

public communication is governed by different standards." In a nonpublic forum, the government may limit access through criteria that focus on "subject matter and speaker identity" as long as the distinction is "reasonable in light of the purpose which the forum at issue serves."[54] The Court recently reaffirmed the validity of such forum restrictions stating that "'it need not be the most reasonable or the only reasonable limitation.'"[55] The desire to avoid controversy generally qualifies as a legitimate rational basis under nonpublic forum analysis. A federal district court has held that government funding of braille editions of magazines at the Library of Congress, even though a nonphysical medium, created a nonpublic forum for the communication of ideas. The government's elimination of access to such a forum was subject only to reasonable review unless, as in the case of the Library's failure to fund *Playboy,* it is "in reality a facade for viewpoint-based discrimination."[56]

The GSA argued that its decision to remove *Tilted Arc* does not implicate the First Amendment because the Federal Plaza is not a public forum. Today, when much of our open plaza space has been privatized by corporate America, plazas owned by the government are essential elements of the public realm and should be characterized as public forums. The Supreme Court, however, has rejected the idea that the definition of public forum depends on its functional significance as a channel of communication. In general it has held that a private owner of property such as a shopping center may forbid others to use the property for expressive activity even if that property has all the attributes of a company town,[57] and that buses and sidewalks adjacent to post offices are nonpublic forums. The current doctrine has been a serious obstacle to sensitive First Amendment analysis.

Regardless of whether a governmental art subsidy program may be characterized as a nonpublic forum, once a site-specific work of public art is installed, it may be properly analogized to either a traditional or limited-access public forum. This analogy is appropriate based on the nature of the property, which is held in trust for the use of the public and which is suited "for discussing public questions"; the government's hybrid role; and the existence of a public right of access based on the use of public funds. The contours of this forum may be defined by contractual or other narrowly drawn standards and guidelines. Then, governmental restrictions that suppress, relocate, or remove the art may be subjected to the "most exacting scrutiny" required by the First Amendment.

54. *Perry,* pp. 46, 49.

55. *United States* v. *Kokinda,* 58 U.S.L.W. 5013 (26 June 1990), quoting from *Cornelius,* p. 808.

56. *Cornelius,* quoted in *American Council of the Blind* v. *Boorstin,* 644 F.Supp. 811, 816 (D.D.C. 1986).

57. See *Lloyd Corp.* v. *Tanner,* 407 U.S. 551 (1972); *Lehman* v. *City of Shaker Heights,* 418 U.S. 298 (1974); and *U.S.* v. *Kokinda.*

Reasonable Time and Manner Versus Content

The *Serra* court implies but does not decide that the Federal Plaza is a public forum since even in a public forum a government may impose reasonable content-neutral time, place, and manner restrictions. In principle the standard of reasonableness is the same for both public forum and nonpublic forum cases. In practice, the cases suggest almost no review of governmental actions in the nonpublic forum as contrasted with the traditionally more sensitive ad hoc balancing of interests applied in the public forum.

The principle inquiry in determining content neutrality in time, place, or manner cases is whether the government has adopted a regulation of speech because of disagreement with the message it conveys. The First Amendment forbids government to regulate speech in ways that favor certain viewpoints or ideas at the expense of others.[58] The Supreme Court has made clear in another context that viewpoint regulation and content regulation are distinct concepts and both may be related to the suppression of expression, regardless of whether government action favors one side in a political controversy.[59] Content-based regulations receive strict scrutiny. A content-neutral regulation is one in which government does not aim at suppression of content but seeks a goal independent of communication with the indirect result that the message is in some way restricted. The traditional approach of the Court set forth a bright-line rule: any restriction on speech, the application of which turns on the content of speech, was content based. The Court currently applies a "secondary effects" analysis, which is a significant source of controversy in First Amendment methodology.[60] The Court has not adequately answered the questions implicated by governmental actions that blend consideration of speech content with time, place, and manner restrictions. These questions are of particular importance when the inseparable quality of the medium and the message may mean that there are no adequate alternative channels of communication.

The *Serra* court followed the framework of analysis adopted by the Supreme Court in *City Council of the City of Los Angeles* v. *Taxpayers for Vincent.* In *Vincent*, the Court upheld on aesthetic grounds an ordinance

58. See *Police Department of the City of Chicago* v. *Mosley,* 408 U.S. 92 (1972).

59. See *Boos* v. *Barry,* 485 U.S. 312 (1988), citing *Consolidated Edison,* p. 537.

60. In *City of Renton* v. *Playtime Theatres, Inc.* (475 U.S. 41 [1986]), the Supreme Court, in upholding a zoning ordinance aimed exclusively at adult theatres, adopted a test of "predominate" intent to determine whether a regulation was content neutral. If the predominate intent of a regulation is to prevent secondary effects of the expression, such as safety or terrorism, the regulation will only be subject to deferential review. The Court thus abandoned the two-track analysis it had previously applied, which looked to the language of a restriction to see if it was content based or content neutral, and focused on governmental motive.

prohibiting the posting of all signs on public property (applied particularly to political signs on utility poles). Justice Stevens stated that it is well settled that the state may legitimately exercise its police powers to advance aesthetic values, and that such regulation was not impermissibly content based so as to trigger strict scrutiny. Justice Stevens stated that

> the problem addressed by this ordinance—the visual assault on the citizens of Los Angeles presented by an accumulation of signs posted on public property—constitutes a significant substantive evil within the City's power to prohibit.[61]

The thrust of *Vincent* is that once the Court perceives content neutrality and that when adequate alternative channels of communication exist, it only asks with minimal review whether the action is reasonable. In *Vincent,* the Court concluded that the poles were not a public forum and that the medium of expression was not uniquely important to the speakers.

Justice Brennan, in his dissenting opinion in *Vincent,* correctly identified a more appropriate standard of review. He argued that "a total ban on an important medium of communication may be upheld only if the government proves that the ban (1) furthers a substantial government objective, and (2) constitutes the least speech-restrictive means of achieving the objective. . . . A court should require the government to provide tangible proof of the legitimacy and substantiality of its aesthetic objective."[62] Justice Brennan correctly noted that the inherent subjectivity of aesthetic judgments makes it all too easy for the government to fashion its justification in a manner that impairs the ability of a reviewing court to make the required inquiries.

Central to the Court's application of the *Vincent* model and its finding of content neutrality, significant government interest, and adequate alternative means is its view that the idea can be divorced from its manner of expression. This disregards the fact that for an artist the message is the medium; Serra's work means to expose and reflect its surroundings. As Marshall McLuhan observes, "the 'message' of any medium or technology is the change of scale or pace or pattern that it introduces into human affairs."[63]

Based on *Cohen,* a governmental interest in aesthetics cannot be regarded as sufficiently compelling to justify a restriction of speech based

61. *Members of the City Council of the City of Los Angeles* v. *Taxpayers for Vincent,* 466 U.S. 789, 807 (1983).

62. Ibid., pp. 824, 828. Justice Brennan cites *Schad* v. *Borough of Mount Ephraim* (452 U.S. 61 [1981]), which invalidated a zoning ordinance that excluded nude dancing from a commercial district.

63. Marshall McLuhan, *Understanding Media: The Extensions of Man* (New York, 1964), p. 24.

on an assertion that the content of the speech is in itself aesthetically displeasing. The Supreme Court has reaffirmed that a governmental justification that focuses on the emotive impact of speech and a listener's reaction to it is a content-based restriction and not a reasonable manner restriction.[64] The *Serra* court found a reasonable manner restriction in that there is a significant governmental interest in having the plaza unobstructed for public use. That finding is entirely unsupported by the record before it. The "sheer size of the sculpture" was a part of its message, a message selected for the site on the implicit promise of permanence by formal procedures utilizing professional art experts selected by the GSA. Moreover, there was no evidence that the sculpture prevented the social use of the plaza in any way. Serra was entitled to a trial on that issue. The court demonstrated an improper deference to the political aim of the GSA in allowing its taste claim to override Serra's artistic expression and the professional advice of its Art-in-Architecture Program's administrators and art experts.

Similarly, the court's finding of adequate alternative channels is flawed because of its perception that governmental regulation of the medium does not adversely affect the message even if, for example, relocation destroys *Tilted Arc* artistically. Such a view fails to recognize that a site-specific work represents a unique and important form of communication for the artist and that context is an essential element of its communicative appeal.[65]

An appropriate First Amendment theory for art in public places must consider whether time, place, and manner control of content is judged by less stringent standards than prohibition of content; whether control of content not aimed at viewpoint is judged by less stringent standards than regulation based on viewpoint; and how one is to determine whether control of content is aimed at viewpoint rather than form, subject matter, or something else.

Cases like *Piarowski* show the difficulty of the analysis. Judge Posner failed to articulate whether the university's relocation of the artwork is valid under the First Amendment as a reasonable regulation of time, place, or manner, or as a content-based restriction justified by its compelling need to protect the sensibilities of a "captive" audience. Or did the judge employ a significantly lower standard because he concluded that an art gallery is not a public forum?

The captive audience doctrine raises issues of time, place, and man-

64. See *Boos*, p. 321.

65. Dennis Barrie and 2 Live Crew were acquitted by juries despite similar judicial and legal efforts to take artwork out of context and thus deprive it of its value. The judge in Barrie's obscenity trial selected certain photographs rather than permitting the jury to consider the entire exhibition, while 2 Live Crew's rap lyrics were separated from the music. Ironically, the courtroom has become today's salon for discussing artistic expression.

ner, of privacy and property rights, and recognizes that free expression may conflict with other constitutional values. Public suppression of unpopular or offensive ideas has been on rare occasions permitted to protect the sensibilities of the captive or sensitive audience when "substantial privacy interests are being invaded in an essentially intolerable manner."[66] To its credit, the *Serra* court did not invoke the captive audience doctrine. As a general proposition, the captive audience rationale is an inappropriate justification for suppression of artistic expression in a university or open public space.

These doctrines properly applied to the medium of government-sponsored art in the public context suggest a rule that governments may not suppress artistic expression in the public context because of a mere desire to avoid the discomfort of hostility or unpleasantness that may accompany an unpopular viewpoint or form of expression. Such expression may only be restricted if it materially interferes with the normal function of the space in an unanticipated manner or when "substantial privacy interests are being invaded in an essentially intolerable manner."[67] There should be a presumption that work acquired with public funds is acquired for permanent public display, and in the case of site-specific works, permanent public display at the site for which it was created. Without a contractual provision or regulation permitting destruction of the work, it seems the government—which certainly could have included such a provision—should bear the burden of proving a significant, valid reason for removing the work.

Cases like *Serra, Piarowski,* and *Close* allow administrators substantial discretion concerning the display of works that have been selected for exhibition. Because such decisions are perceived as content-neutral or intended to protect the "sensibilities" of a passing audience, these decisions do not afford sufficient weight to the artist's interest in expression, particularly where the decision maker may not be the art professional or panel that originally commissioned the work. Moreover,

> as critics such as Douglas Crimp have pointed out, the way in which a museum chooses to place work within its space reveals an ideologically constructed hierarchy. In the case of this exhibition, the placement of those images only reaffirms the moral authority of conservative opponents to both a sexually diverse society and the ability of art to shape a pluralistic culture.[68]

66. *Cohen,* p. 21.

67. See also *Tinker* v. *Des Moines Independent Community School District,* 393 U.S. 503 (1969).

68. Connie Samaras, "Speakeasy," *New Art Examiner* 17 (Oct. 1989): 14. The exhibition Samaras refers to is Mapplethorpe's The Perfect Moment at the Museum of Contemporary Art in Chicago.

A Failure of Process

In a sense, the Serra case and other public art controversies can be viewed as having been caused by the failure of the selection process to incorporate various affected communities and to have procedures in place for the removal of art under certain circumstances. What is needed is a fair procedure for resolving controversial commissions, recognizing that such procedures might destroy public art programs. "As the artist Robert Murray put it, 'We cannot have public art by plebiscite.'"[69] Despite the risks involved, if situations similar to the case of *Tilted Arc* are to be avoided, standards and procedures for the selection and removal of public art must be developed. Of course, any discussion of such procedures raises historical concerns: will only "safe" art be chosen and retained as public art, and if so, who will make the decision as to what is "safe" art?

Both as a matter of public policy and because of the potential legal constraints imposed on public administrators by the Due Process Clause, the fair and efficient resolution of any conflict between an artist's right to retain publicly funded art in a particular location and the affected community's rights should not rest on ad hoc administrative decisions shaped by the pressures and biases of the moment. The protection afforded by the Due Process Clause is triggered when there is activity by government that constitutes more than a *de minimus* interference with a liberty (for example, freedom of speech) or property interest. The Supreme Court in 1972 defined a property interest to include a "legitimate claim of entitlement" in the case of *Board of Regents* v. *Roth*.[70] Since the late 1970s, the Supreme Court has, to a degree, narrowed the definition of liberty and property interests protected by the Due Process Clause by adopting a positivist approach. Under this approach, mere expectations, however reasonable and however demonstrably induced by government, do not amount to interest protected by due process unless they are grounded in explicit rules of state or federal law or express contractual provisions. "The essence of [procedural] due process is the requirement that 'a person in jeopardy of serious loss'"[71] of liberty or property interests from an erroneous decision be afforded "appropriate procedural safeguards against error."[72] At a minimum, due process implies notice and a meaningful opportunity to be heard. In addition, the Supreme Court traditionally has placed enormous weight on securing the neutrality of due process hearings. Thus, "the right to an impartial decision maker is required by due process in every case," and since "the appearance of evenhanded justice" is at the core of due process, the court will disqualify even decision makers

69. Calvin Tomkins, *"Tilted Arc," The New Yorker*, 20 May 1985, p. 98.
70. *Board of Regents of State Colleges* v. *Roth*, 408 U.S. 564 (1972).
71. *Matthews* v. *Eldridge*, 424 U.S. 319, 348 (1976).
72. *Vitek* v. *Jones*, 445 U.S. 480, 495 (1980).

who in fact "have no actual bias" if they might reasonably appear to be biased.[73]

The legal issue of whether the public—absent a contractual, legislative, or regulatory right—has a due process right, based on "ownership" of a public plaza, to participate in the selection of public art has been consistently overshadowed by practical considerations. Most recognize that the public's sense of "territoriality" must be respected.

As to the question of whether the government's action deprived Serra of a liberty or property interest, the court held that since Serra's sculpture was the property of the government, and injury to reputation without "an accompanying loss of government employment would not constitute a constitutionally cognizable deprivation of property or liberty," Serra had all the process he was due (*RS*, p. 1052).

The court did not apply the specific due process doctrine that has developed in the context of the deprivation of First Amendment liberty interest. It has been clearly established by previous cases that the government "may not empower its licensing officials to roam essentially at will, dispensing or withholding permission to speak, assemble, picket, or parade, according to their own opinions regarding the potential effect of the activity in question on the 'welfare,' 'decency,' or 'morals' of the community."[74] Although a public entity may be able to relocate artistic displays in accordance with narrowly drawn regulations enacted to further a substantial governmental interest, formal regulations or procedures are necessary to comply with the First Amendment to insure the integrity of public art programs.[75] For example, in *Pico* the fact that the school board had failed to adopt specific removal procedures and had ignored the advice of library experts, librarians, and teachers within the system was considered a significant criteria in the denial of summary judgment.

Legislative and Contractual Approaches

If current judicial doctrine has proved inadequate to achieve satisfactory resolution of these competing interests, legislative and bureaucratic developments have proved more positive. A moral rights consciousness is

73. *Morrissey* v. *Brewer*, 408 U.S. 471 (1972). Also, see sec. 8 of Laurence H. Tribe, *American Constitutional Law* (Mineola, N.Y., 1988).

74. *Shuttlesworth* v. *Birmingham*, 394 U.S. 147, 153 (1969). See also *David Avalaos* v. *General Services Administration*, No. 86-0043 (HLH) (S.D.Cal. 1987).

75. See *University of Utah Students against Apartheid* v. *Peterson*, 649 F.Supp. 1200 (D.Utah 1986). The university cited a number of reasons for ordering the removal of the shanties (which a group of students had built to protest South African apartheid) including liability insurance, risk of physical harm, and aesthetic concerns. The reasons, in the court's view, did not outweigh the student's speech interest but might form the basis for enacting reasonable and nondiscriminatory rules and regulations regarding time, place, and manner, which are not content related.

emerging in American law, which substantially adds to the legal framework of analysis for art in the public context. The concept of *droit moral* gives the artist certain nonpecuniary rights, among them the right to be credited as the creator of the work (right of attribution) and the right to prevent alterations of the work (right of integrity). In the last decade, eleven states have enacted legislation creating moral rights for artists. The scope and protection against prohibited conduct with regard to works of art varies in each state. The two basic models on which the various state statutes are drawn come from California and New York. The California model declares a public interest in preserving the integrity of artistic creations and prohibits the intentional alteration, mutilation, or destruction of a work of fine art of "recognized quality." The New York model, though it does not prohibit destruction of art, does prohibit the display or publication of, or making accessible to the public in any way an altered, defaced, mutilated, or modified work of fine art without the artist's consent if damage to the artist's reputation is likely to result. (New York law did not apply to *Tilted Arc* because of its location on federal property.)

This past October, Congress passed the Visual Artists Rights Act of 1990, which extends to visual artists certain rights governing the display and resale of their work. In introducing it, Senator Edward Kennedy stated that "artists in America, as in every other country and civilization, have been the recorders and preservers of the national spirit. The creative arts are an expression of the character of the country: they mirror its accomplishments, warn of its failings, and anticipate its future. . . . Visual artists create unique works. If those works are mutilated or destroyed, they are irreplaceable."[76] The act combines the New York and California models and provides for both the right of attribution and the right of integrity. It thus applies "to prevent any intentional distortion, mutilation, or other modification of [a] work which would be prejudicial to [the artist's] honor or reputation" and "to prevent any destruction of a work of recognized stature, and any intentional or grossly negligent destruction of that work" (*CR*, S 17916). The rights created by the act do not apply to a work for hire or other works not eligible for copyright protection. They exist for the author's lifetime and are eligible for the civil penalties and remedies available for copyright infringement. Rights can be waived in writing except for works of art attached to a building, which are deemed to be waived under certain circumstances. The act provides for preemption of state law with all legal or equitable rights that are "equivalent to" any of the rights conferred by it, but does not preempt any such rights that extend beyond the life of the artist. Because of the definition of fine art, the scope of protection, and the exceptions, the actual extent to which the act preempts state law is unclear. (For example, the act appears to preempt

76. *Congressional Record-Senate*, S 17574, 27 Oct. 1990; hereafter abbreviated *CR*. Enacted as Public Law 101–650 and signed by the president 1 Dec. 1990.

New York's protection of reproductions.) Also likely to provoke further debate and discussion is a provision that prohibits "a governmental entity to take any action or enforce restrictions prohibited by the First Amendment" (*CR*, S 17917).

Yet, as in the Serra controversy and even in Europe, the exact contours of an artist's right of integrity are not identified. What constitutes distortion, mutilation? What criteria should be used to measure threatened harm to honor or reputation? Moreover, to extend the concept of moral right beyond the work to the site is not without difficulty. Serra testified at the hearings that "'permanence is intrinsic to my site-specific work.'"[77] Does that mean that the right of integrity permits an artist to appropriate the site? Nor does the establishment of the legitimacy of a right of integrity in American law mean that the situations which abridge that right cannot be further defined by contract or legislation. For example, the provisions of the Visual Artists Rights Act balance the rights of artists and property owners where works of art are affixed to buildings. Under the act, any modification of a work of visual art that is the result of the public presentation—including lighting and placement of the work—does not constitute a mutilation or destruction unless it is caused by gross negligence.

The scope of the protection afforded site-specific art is unclear. What of works of art that are physically integrated to their site? Are collaborations defined as architecture, parks, or artwork? Significant is the fact that in October 1990, Congress amended the Copyright Act to include the Architectural Works Copyright Protection Act (section 701), which provides copyright protection for buildings and architectural plans and drawings. The work includes the overall form as well as the arrangement and composition of spaces and elements of designs, but does not include individual standard features. Nevertheless, section 120(a) provides that an owner may alter or destroy the work without the authorization of the owner of the copyright. An architect and an artist who collaborate may also be able to claim protection for the entire project as a joint work of visual art. The collaborations at New York's Battery Park, for example, have been defined as works of art. Until there are sufficient precedents, artists and governing bodies should attempt to arrive at fair contractual solutions that balance the previously identified needs of the government with the need to preserve artistic vision. For example, the Association of the Bar of the City of New York's Model Agreement specifically gives a commissioning body the right to destroy a commissioned work only under certain conditions, including the passage of time. Moreover, the Model Agreement stipulates that the commissioning body, in this case the City of New York,

> will not intentionally damage, alter, modify or change the Work without the prior written approval of the Artist.

77. Testimony quoted in *Public Art, Public Controversy*, p. 149.

The City shall notify the Artist of any proposed alteration of the Site that would affect the intended character and appearance of the Work and shall consult with the Artist in the planning and execution of any such alteration and shall make a reasonable effort to maintain the integrity of the Work.[78]

Tilted Arc has been a catalyst for discussion of public art selection and deaccession procedures. There is general agreement that the community in which the work of art is to be located should be involved in the overall process, but the problems of community definition and of involving that community in the selection process rather than in the commissioning process remain unresolved.

Deaccession discussions have highlighted the fact that it may be difficult to apply a museum's notion of "collection" to public art. Unlike museums, the public realm has no storage place. Criteria must be developed to help us edit our cultural past without sacrificing the confidence or creative potential of those who are integral to it. One way might be to require periodic review—in accordance with agreed-upon procedures—after several years to see whether the work of art has passed the "test of time." The review process should balance artists' rights with the equally important right of an informed public to reject that form of expression through critical dialogue.

The Model Agreement recommends that municipalities engaged in public art programs adopt deaccessioning policies and procedures. The King County (Washington) Arts Commission, for example, adopted such a policy in 1979. Among its objectives was "to insure that the deaccessioning of works of art is governed by careful procedure" and "to insulate the deaccessioning process from fluctuation in taste both on the part of the King County Arts Commission and on the part of the public."[79] The policy states that deaccessioning is to be a seldom-used procedure and in no event would any work of art be deaccessioned within five years of acquisition. (A National Endowment for the Arts task force recently proposed a ten-year waiting period.)

Conclusion

The current discussion and debate over public art is a surrogate for the debate over the direction of culture and values in America. Govern-

78. Association of the Bar of the City of New York, Committee on Art Law, "Commissioning a Work of Public Art: An Annotated Model Agreement," secs. 7.4(a) and (b) (New York, 1985), p. 33. The Model Agreement is also published in *Going Public*, ed. Pam Korza (Amherst, Mass., 1987).

79. King County (Wash.) Art Commission, policy on acquisition and deaccessioning (1979).

ment's involvement in the arts is complex. It must offer a sense of freedom to artists to provide society with the capacity to grow and expand its horizons beyond the conventional. As its original authorizing language provided, the NEA is directed to fund projects "which have substantial artistic and cultural significance, giving emphasis to American creativity and cultural diversity and the maintenance and encouragement of professional excellence."[80]

Such goals may often find themselves in conflict with government's goals of promoting cultural stability, harmony, and the social ties that bind society together. To fund only the beautiful, the nonpolitical, or noncontroversial is to deprive society of the impetus for its cultural development and assures a mediocre collection of ornamental objects in public places. There is much to suggest that there is a disturbing trend to fund only art that reaffirms recognized and generally held values of American life.[81] Apart from the unresolved question of the constitutionality of such practices, their wisdom, as a matter of policy, is sharply in question. William Diamond, who became the GSA regional administrator after the *Serra* decision, laid down ground rules that works must not be pornographic or overtly political and that they should promote solidarity. The reauthorization of the NEA enacted in 1990 adds as a condition of funding that the chairman ensure that all applications meet a general standard of decency.[82]

Art sponsored or owned by the government in the public context has the potential to become a critical element in the establishment of a public realm with artists acting as the "priests of our democracy," fostering

80. National Endowment for the Arts, 20 U.S.C. §954 (c) (1).

81. This trend is not only evident with respect to the arts. Recently the Supreme Court has held that the standard articulated in *Tinker* for determining when a school may punish student expression need not be the standard for determining when it may lend its name and resources to the dissemination of expression (*Hazelwood School District* v. *Kuhlmeier*, 484 U.S. 260 [1989]). It has also begun to articulate a perception of education that, rather than emphasizing independence and diversity, concentrates on instilling students with a sense of the boundaries of socially appropriate behavior. See *Bethel School District* v. *Fraser,* 106 S.Ct. 3159, 3164 (1986).

82. In November 1990, John Frohnmayer, the chairman of the NEA, rejected the recommendations of both a peer panel and the NEA advisory council and denied a grant to conceptual artist and sculptor Mel Chin. Chin's project, called *Revival Field,* is a "sculptural earthwork that uses special plants to soak pollutants from the earth. In a process called 'green remediation,' the plants are then incinerated and the metals in their systems recycled." The project is a collaboration with a research agronomist in the U.S. Department of Agriculture. The chairman's reason for the rejection, that he "'was not persuaded . . . that the artistic aims' of the project 'were sufficient to merit arts endowment funding,'" shows an extraordinarily narrow view of public art, one which is particularly inappropriate in Chin's category of funding (Susan Chadwick, "NEA Chairman Vetoes Grant for Ex-Houston Artist," *Houston Post,* 24 Nov. 1990, p. A1). Fortunately, on 2 Feb. 1991, Frohnmayer announced that he had "changed his mind and will approve [the] $10,000 grant" for Chin's project (Barbara Gamarekian, "Frohnmayer Approves Environmental Project," *New York Times,* 4 Feb. 1991, p. B2).

"open-mindedness and critical inquiry."[83] The public artist today engages issues of history, site, politics, class, and environment. These multiple visions may help to transform communities as they find common grounds based not on the symbolic icons of abstract justice represented in monuments of the past, but on substantive principles of justice and tolerance for diversity. Policies should facilitate the formation of a "public" through education and procedures so that public art can once again recapture its power to convey public meaning to diverse communities in the "public realm."[84] The successful creation of public art depends on the quality of the art, sensitivity to its social context, an appropriate relation to its site, and a selection and commissioning process that permits community members to have faith in its integrity, encouraging dialogue with the artist but not dilution of artistic vision.

In this article, I have suggested a legal framework for public art, inspired by the First Amendment, that may provide sites for the critical interactions necessary to the formation of a public realm. This framework may facilitate diverse approaches to public art and enable public art programs to help shape and transform political and social life as well as beautify the environment. While legal doctrine in this area must invariably turn on the specific facts involved, the framework I have suggested, at least in the context of governmental ownership or sponsorship of art in spaces open to the public, rejects a property rights model as a significant analytical tool for accommodating the interests of artist, government, and community. To rely on the notion of ownership and its concomitant rights to relocate, remove, and destroy provides insufficient protection to freedom of artistic expression and the preservation of our cultural heritage. A

The NEA also has announced a funding program called "Art in the Marketplace," which gives a grant to the Rouse Company, one of the nation's leading real estate development and ownership organizations. Chairman Frohnmayer's insight in announcing the program that "the shopping center of today reflects the fairs and marketplaces of renaissance times" is certainly laudable. But the fact that the Supreme Court has not accorded to such sites public forum status for First Amendment access, and the fact that Rouse's primary goal is to rent space, causes concern that artists with views antithetical to those of corporate America will not receive sponsorship, and also that corporate control of our culture will be expanded—this time into federal arts funding (National Endowment for the Arts press release, "Rouse Company, Arts Endowment Announce Joint Funding and Winners of Arts Program," 5 Nov. 1990).

83. Justice Frankfurter: "To regard teachers . . . as the priests of our democracy is therefore not to indulge in hyperbole" (*Wieman* v. *Updegraff*, 344 U.S. 183, 196 [1952]).

84. This vision is embodied in In Public: Seattle 1991. Artists from around the world will bring to Seattle an exchange of information and ideas addressing these issues and conditions that shape the life of the city. Artists will be able to choose their sites, from community centers and libraries to television, radio, and newspapers. In redefining traditional public art venues, In Public will engage new audiences in the artists' public voice.

model based on nuisance theory, which arguably inspired Judge Pollack,[85] also fails to provide sufficient protection. The determination of the existence of a nuisance is entirely contextual and balances the reasonableness of the defendant's use of his property against the gravity of the harm to the complainant. The incorporation of the nuisance methodology and its weighing of various factors in order to reinvigorate a review of the "reasonableness" of time, place, and manner restrictions may be appealing. Yet if the question of what is harmful or beneficial is rooted solely in how a community establishes its values and not in how art is defined, nuisance theory then ignores the more complicated task of addressing the paradox inherent in public art—the sensitive balance between artistic expression and community values.

The Supreme Court's reluctance to expand public forum doctrine in its application of a deferential standard of review—except in cases where art has expressed an overtly political message—and its willingness to uphold a ban on an entire medium of expression as a reasonable time, place, and manner of restrictions suggest that the courts have delegated to the legislature and the bureaucracy the task of developing law for art's sake in the public realm. As Judge Carroll stated in his *Mason* decision:

> It troubles me as a judge and as a citizen to listen to the treatment of these artists by the state. [No one] in this court could come away without respect for them. In the future, the state owes it to the public to be more organized, and clearer, and more sensitive in acquiring its art works.

The adoption of a uniform national standard of federal protection for the moral rights of visual artists based on the recognition that works of visual art communicate an aspect of an artist's personality, namely creative vision, and that compels an owner to recognize that ownership of art is different than ownership of other property, is an incremental step forward in the development of this framework. Ironically, the ambivalence of attitude expressed in the law—protection of the artist's personality versus the public interest in preserving artwork—mirrors the ambivalence in public art policy. Future policy will develop contracts and procedures that are sensitive to artistic vision and to the need to preserve a cultural heritage. It will involve the selection of artists who, while representing myriad voices and visions, share the recognition that to make public art is to enter into dialogue with diverse communities, each of which views public art, as does the artist, as a quest for and mirror of a public self-identity.

85. Justice Sutherland, in the first case to uphold the legislative power to enact zoning regulations, wrote that "a nuisance may be merely a right thing in the wrong place,—like a pig in the parlor instead of the barnyard" (*Village of Euclid* v. *Ambler Realty Company,* 272 U.S. 365, 388 [1926]).

Through the Back Door: Alternative Approaches to Public Art

Virginia Maksymowicz

The artist without an audience would be a contradiction in terms. The type of audience an artist seeks relates to his or her aspirations—for the artist and for the objects he or she creates. Some direct their efforts towards other artists; some address collectors. Still others believe they have something to say to a wider, public audience. How to address that wider audience—an audience that may or may not know anything about art (or even care to know anything)—is an issue for artists who want to work in the public sphere. Does the intended audience alter the form and content of an artist's work? Is there a difference between "private" and "public" art?

Arlene Raven pulled together in *Art in the Public Interest* (1989) a collection of essays by artists, historians, and critics—Linda Burnham and Steven Durland of *High Performance,* Moira Roth, Donald Kuspit, Robert Storr, and others—that attempts to tackle such questions. Four years earlier in an issue of *Art&Artists,* I too struggled with the definition of *public art.* Using a time-honored tactic, I quoted the *American Heritage Dictionary*'s description of *public:* "1. of, concerning, or affecting the community or the people; 2. maintained for or used by the people or community; 3. participated in or attended by the people or community; 4. connected with or acting on behalf of the people, community or government, rather than private matters or interests; 5. open to the knowledge or judgment of all." I went on to conclude that "if the term 'public' is applied to art . . .

it should consequently imply a kind of artmaking that involves or responds
to community concerns and interests."[1]

Perhaps this should be obvious—as obvious as the observation that
(as the opening line of Raven's book puts it), "public art isn't a hero on a
horse anymore."[2] But most discussions of public art, whether in academic
or more general circles, still center around large sculptures placed in
urban plazas; big steel constructions like Richard Serra's *Tilted Arc* have
become the archetypal image.[3]

Sculptor Scott Burton addressed this limiting view of public art in
1983 when he wrote that "public art has descended from, but must not be
confused with, large-scale outdoor sculpture, site-specific sculpture and
architectural or environmental sculpture."[4] Two years earlier, curator
John Beardsley emphasized an interpretation of public art that addresses
societal concerns: "art in public places must be differentiated from public
art," he observed. "An artwork can become significant to its public
through the incorporation of content relevant to the local audience."[5]

Burton's caveat and Beardsley's careful distinction point toward
another kind of public art—one that directly engages people who do not
regularly visit galleries and museums with the sociopolitical issues that
affect their communities. During the last decade, artists throughout the
United States have produced significant works in this genre: in the

1. Virginia Maksymowicz, "Let's Define Public Art," *Art&Artists* 14 (May/June 1985):
8.

2. Arlene Raven, introduction, *Art in the Public Interest,* ed. Raven (Ann Arbor, Mich.,
1989), p. 1.

3. Sculptor Stephen Luecking described the public art stereotype this way: "A foreman
at a Chicago sandblasting firm, speaking on his role in the making of public sculpture, sum-
marizes: 'They weld 'em up. We blast 'em and prime 'em. Then they paint 'em and stick
'em on a plaza somewhere'" (Stephen Luecking, "What's Public about Public Sculpture?"
New Art Examiner 12 [Nov. 1984]: 39).

4. Scott Burton, untitled contribution to a symposium on "Site: The Meaning of Place
in Art and Architecture," *Design Quarterly,* no. 122 (1983): 10; also quoted by Raven in *Art
in the Public Interest,* p. 15.

5. John Beardsley, "Personal Sensibilities in Public Places," *Artforum* 19 (Summer
1981): 43, 44.

Virginia Maksymowicz is a mixed-media artist who lives and makes
art in New York and Philadelphia. She has exhibited her work at the
Franklin Furnace, the Alternative Museum, and the Grey Art Gallery in
New York City, and in other galleries and museums around the country. A
recipient of a National Endowment for the Arts Fellowship in 1984, she is
currently lecturing on the topic "Public Art: The Artist and the Commu-
nity" under a grant from the New York State Council for the Humanities.
She is also a coeditor of "Art and Society," a monthly feature in *The Witness
Magazine.*

neighborhood-based art projects of the late seventies funded by the Comprehensive Employment and Training Act (CETA), in the development of artists' coalitions mobilized around specific social and political issues (that have brought artworks to window spaces, churches and union halls, street corners, and even the steps of the Capitol), and in single-artist collaborations with local communities.

Few critics other than Raven (and in some respects Lucy Lippard and Suzi Gablik), however, would place this kind of work within the public art domain.[6] Most of it is neither permanent nor monumental. Much of it gets labelled pejoratively as "political" art. But for many artists who are seriously concerned about engaging audiences other than the usual gallery-going crowd, the conscious decision has been made to adopt alternative approaches to communicating their ideas. To this end, their art might take the form of posters, street signs, billboards, bus advertisements, or even fake newspapers surreptitiously placed in vending machines. Despite the "political" nature of this work and the less-than-fine-art appearance that the use of nontraditional media gives it, I would contend—especially given the etymological root of the word *political* in the Latin and Greek words for *citizen*, a member of the "public"—that it may well be the most authentic type of public art.

Arlene Raven credits the Foundation for the Community of Artists (or FCA, which published *Art&Artists*) with helping to lay the ground for this new kind of public art. From 1978 to 1980, along with the Cultural Council Foundation, it acted as one of the sponsors of the CETA Artist Project, the largest government-funded artist employment program since the Works Progress Administration's in the 1930s. Over seven hundred artists in New York City and thousands more across the United States gave free performances, poetry readings, and concerts, taught classes, and produced "public" artworks. But, as opposed to many state- and city-run percent-for-the-arts programs or the federal General Services Administration Art-in-Architecture Program, these artworks were usually created in close communication and (in the best cases) collaboration with grassroots community groups. The community group would request an artist

6. Lucy R. Lippard's editorial involvement with *Upfront* (a magazine published during the 1980s by Political Art Documentation and Distribution [PAD/D]) and her books *Overlay: Contemporary Art and the Art of Prehistory* (New York, 1983), *Get the Message? A Decade of Art for Social Change* (New York, 1984), and *Mixed Blessings: New Art in a Multicultural America* (New York, 1990), all certainly (and eloquently) present an argument for an art that is community-based in form and in content. The same holds true for Suzi Gablik's *Has Modernism Failed?* (New York, 1984) and *The Reenchantment of Art* (New York, 1991). Raven, though, has put particular emphasis on considering this kind of art within the public art context.

Melissa Feldman is another arts writer who has tried to define public art in more inclusive terms. In the mid-1980s her short-lived publication *Stroll: The Magazine of Outdoor Art and Street Culture* featured art as diverse as Siah Armajani's architectural sculptures, Merle Laderman Ukeles's performance pieces with the New York City Department of Sanitation, and punk street fashions in Manhattan.

and negotiate a fit between the artist's skills and its constituency's needs. More often than not a new way to communicate was forged between artists, who previously might have had little opportunity to work outside their studios, and nonartists, who very likely had never had contact with artists in any capacity before.

Programs like the CETA Artist Project, organizations like the FCA, and issue-oriented groups like the Art Workers Coalition (that produced the well-known anti–Vietnam War poster of the My Lai massacre) were artist-conceived, artist-founded, and artist-administrated. According to Raven, it was this "tenuous network" developed in the 1970s that formed "the immediate historical context for the complex and ambitious projects that would be undertaken in the 1980s."[7]

Artists Working with Nonartists

Much like the CETA artists in the seventies, individual artists in the last decade have emerged to work closely communities of nonartists. For example, painter Judy Baca, working in Los Angeles, orchestrated the creation of *The Great Wall of Los Angeles,* a nearly mile-long mural along the walls of the Tujunga Wash of the Los Angeles River. It chronicles the history of the area from prehistoric times to the present. Under the direction of Baca and a group of fine artists, the painting was executed by a cross section of the city's ethnic and economic groups. Judy Chicago and Suzanne Lacy are feminist artists who have dedicated much of their careers to working in collaboration with other women. Chicago's *Dinner Party* and *Birth Project* could not have come about without the many hours of detailed craftwork on the part of hundreds of participants, artists and nonartists alike. Lacy has produced large-scale, tableaulike performances also involving casts of hundreds. Her *Whisper, the Waves, the Wind* revolved around the experiences of 150 older women as they gathered on a beach in La Jolla, California. *The Crystal Quilt,* performed in a glass-ceilinged atrium in a downtown Minneapolis office building in 1987, choreographed 430 women with their stories of living and growing old.

Artist and teacher Tim Rollins collaborates with reading-disabled kids in the Bronx. The work resulting from this sometimes controversial project has been exhibited around the world. Two other South Bronx artists, John Ahearn and Rigoberto Torres, have made cast-from-life sculptures of local community members; the casts have found their way onto the walls of public buildings, and into the homes of neighborhood residents, as well as into commercial art galleries. In Washington, D.C., photographer Jim Hubbard began the Shoot Back project, which gives homeless children cameras and film and teaches them to document their

7. Raven, introduction, *Art in the Public Interest,* p. 18.

own lives, in the way they (rather than the news media) see themselves. Their efforts have been published in book form and exhibited in a range of community and art spaces. Hubbard is now getting photographers around the country involved in setting up similar projects in their own cities. In New York City, artists Annie Q. and John-Ed Croft founded an organization called The Struggle for the Freedom to Create. At one time homeless themselves, these two artists have worked with other homeless people and squatters to produce art shows, postcards, and a newsletter of illustrations, poetry, and even a guide to soup kitchens.

There are also artists who have worked with existing community organizations. Peter Cohen designed a powerful poster for New York City's Coalition for the Homeless with an image of the face of Jesus Christ accompanied by the question, "How can you worship a homeless man on Sunday and ignore one on Monday?" John Baldessari worked with the Committee in Solidarity with the People of El Salvador (CISPES) to produce a graphic subway and bus poster. Some have worked anonymously with community groups, contributing their expertise towards publicizing neighborhood issues, such as the artist who painted miles of purple footprints and stencilled wildlife on New York City sidewalks in a futile attempt to save Adam Purple's neighborhood "Garden of Eden" from being razed by the city's housing authority.

Performance artist John Malpede is perhaps the ultimate example of an artist integrally connected with his direct audience. During the 1980s Malpede participated in Creative Time's Art on the Beach project, a series of summer exhibitions in New York City held outdoors on a landfill in lower Manhattan near the financial district. The usual format was to assemble a team made up of a visual artist, an architect, and a performer. In an interview I did with him in 1988, Malpede said:

> The people I [was] working with decided that since this was the world's most expensive piece of real estate, we'd do something about homelessness. It turned out I was in Los Angeles when I had to get my end of the performance together—right before the Olympics, when there were a lot of police sweeps and harassment of homeless people to get them away from the tourist areas near Skid Row. So I started going to government hearings and I just sort of fell into the center of the activism around that issue. . . . I kept coming back for more because it was really interesting, being with such diverse people.[8]

Malpede moved to Los Angeles and started volunteering at the Inner City Law Center, a free law clinic on Skid Row. His performance troupe—

8. John Malpede, from an interview conducted by the author in the fall of 1988 in New York City. Excerpts from this interview appear in "The Los Angeles Poverty Department," *Art&Artists* 17 (Dec.-Jan. 1988–89): 8.

the Los Angeles Poverty Department (LAPD)—grew organically out of his interactions with the center's clients. The group is a mixture of black, white, and Latino men and women ranging in age from twenty to sixty. Linda Burnham, in an article in *High Performance* magazine, described them as "an intimate conglomeration of inner-city denizens—artists, drifters, singers, actors, writers, lovers, and fighters well acquainted with life on the street."[9] The collaborative relationship eventually became so close that Malpede and the group began living together. The work of the LAPD derives its communicative power from its connection to what Malpede terms "the real deal," that is, the unsanitized truth about life on the streets, and the way these artists are able to weave that truth into the fabric of their performance. Their plays have been presented in both art and nonart venues around the world.

Affecting the Community

Similar to organizations like CISPES and the Coalition for the Homeless, groups of artists have formed around issues that affect them as members of local, national, and international communities. Using their visual skills, these artists have tried to engage a public audience in discussions of gentrification, homelessness, AIDS, the nuclear arms buildup, the U.S. government's role in Central America and South Africa, and racism here at home. In one instance, confronted with the dilemma of being caught between encroaching developers and long-time residents who viewed artists as the precursors of gentrification, a group of artists calling themselves Not for Sale produced a series of posters that were displayed on impromptu "art gallery" walls on the outsides of boarded-up buildings on the Lower East Side of New York City. With gallery names like "Guggenheim Downtown" and "The Leona Helmsley Gallery," these sets of artworks posed important questions as to the nature of gentrification and what residents could do to protect their neighborhood. In a project related in both form and content, the Storefront for Art and Architecture in New York City sponsored a street stencil series. Artists spray-painted statements about homelessness in gutters, on sidewalks, in doorways— unexpected sites for art, perhaps, but places that some city residents may have had to call home.

Other examples include Gran Fury, a group that started out as the artist contingent of ACT-UP (AIDS Coalition to Unleash Power), which was responsible for designing the "Silence=Death" logo. They have mounted window displays and used advertising media in order to keep the AIDS epidemic in public focus. The NAMES Project—although con-

9. Linda Burnham, introduction to an interview with Malpede, *High Performance*, no. 43 (Fall 1988): 22.

ceived by one man, Cleve Jones—has evolved into a true coalition of artists and nonartists who have vowed to continue to document each death from the disease and to use the quilt as a public memorial. Artists for Nuclear Disarmament produced artworks and held exhibits in public places such as New York City's *10 on Eighth,* a group of ten display windows on the side of a parking garage on Eighth Avenue in Manhattan. Along with PAD/D, Artists' Call against U.S. Intervention in Central America not only produced artworks and exhibits, but contributed visually to mass demonstrations against government policies; their "Uncle Sam PacMan" skit was presented in Washington, D.C., on the steps of the Capitol. Art against Apartheid presented exhibits at churches such as Abyssinian Baptist in Harlem, at union halls, and at community centers like the Bronx River Art Gallery. Members lectured at colleges and to community groups around the U.S. and Canada and discussed their efforts on a number of New York City radio stations.

Using Commercial Spaces

Throughout the country, artists concerned with public issues have often used window displays and other spaces usually reserved for commercial promotion for exhibiting their work. In addition to *Windows on White, Broadway Windows, 10 on Eighth,* and exhibits at the Grey Art Gallery, New York City's examples include *Let the Record Show . . . ,* a display about the politics of AIDS mounted by Gran Fury in the window of the New Museum on lower Broadway. Beverly Naidus transformed the window of the Franklin Furnace into a simulated job agency in a work titled *Apply Within.* Her mimicry questioned the bait-and-switch tactics of nearby downtown employment centers that promised high pay for minimal skills. I showed my own installation about work and unemployment, *The Bottom Line,* in Public Image Gallery's storefront window on Manhattan's Lower East Side. In Chicago, Anita David used a soaped-up shop window for a "drawing" about racism, and Robert Peters commandeered an entire corner store for a "hard-sell" installation about the pursuit of money. And in a slightly different fashion, the City without Walls gallery in Newark, New Jersey, has used an actual store space in a shopping mall to mount exhibits about important social issues. *Uhruru,* the Gallery's 1988 show about apartheid, drew and audience that seldom frequented art galleries.

Using the Media

Finally, there are those who have broadcast their artworks as publicly as possible: through print and electronic media. Perhaps one of the largest audiences ever made available to artists came through the Public Art

Fund's decade-long project Messages to the Public, wherein visual artists
were given time on the giant Spectacolor screen in Times Square. Each
month a different artist produced a thirty-second sequence of images
(animated, in color, and sandwiched between standard commercials)
that was broadcast fifty times a day and viewed daily by an estimated 1.5
million people, including businessmen, panhandlers, tourists, prosti-
tutes, runaway children, drug dealers, working people, newly arrived
immigrants, and the homeless—a full cross section of urban society.
Martha Rosler's 1989 contribution showed deteriorating public hous-
ing and dollar signs and drew connections between federal budget cuts
and real estate speculation. She concluded with the statement, "Hous-
ing is a Human Right." In August 1988, Ericka Beckman juxtaposed
images of tanks and tractors in an attempt to raise questions about the
farm crisis. Both Judite Dos Santos and Marina Gutiérrez focused on
U.S. military policies around the globe. Unfortunately, the Spectacolor
board no longer exists.

Artists in this country and abroad have also put their images on bill-
boards. Among those dealing with environmental issues were the Sisters
of Survival, who produced an anti-nuclear power billboard in Los Ange-
les. Kathy Constantinides, Carol Jacobsen, and Marilyn Zimmerman did a
billboard in Detroit linking safe sex to safe waste disposal (protesting the
opposition to a garbage-to-steam plant located in the heart of Detroit).
Craig Freeman, while still a graduate art student at University of Colo-
rado, Boulder, mounted a series of billboards exposing radiation dangers
at the Rocky Flats nuclear weapons production facility. Barbara Kruger
confronted current politics with her "We Don't Need Another Hero" bill-
board, and Les Levine's enigmatic billboards about the violence in North-
ern Ireland provoked their share of controversy.

As part of the Center for Exploration and Perceptual Art's (CEPA)
Gallery-in-Transit Program, Blaise Tobia's photo series, *Surveillance*,
which juxtaposed dated and timed infrared photographs of satellite
receivers with selected off-air images from the Iran-Contra hearings, trav-
elled around Buffalo for a month on a city bus. In several cities across the
country, bus and subway commuters could have seen Gran Fury's poster
stating that "Kissing doesn't cause AIDS; greed and indifference do." A
collective of artists in San Diego (made up at various times of Liz Sisco,
David Avalos, Louis Hock, Debra Small, and Scott Kessler) have repeat-
edly caused controversy by their use of transit posters, bus benches, and
billboards to make art about local political issues: the debate about naming
the city's convention center after Martin Luther King, Jr.; the plight of the
undocumented workers who form the basis of southern California's econ-
omy; and repeated incidences of police brutality. In addition to reaching
those who directly see the images via paid-for advertising spaces, the
group has been able to reach an even wider audience through the news
media's coverage of the controversies.

In a guerrilla mode, California artist Robbie Conal arranged to have his political posters that juxtapose grotesque portraits of people in the news with sarcastic texts—such as the words "False Profit" under the grinning visages of Jim and Tammy Bakker—pasted up around many U.S. cities. A group of photographers, in a similar spirit, entered boarded-up, landmark buildings in Detroit to photograph the rotting interiors; the building owners had been receiving tax breaks on the properties in exchange for their preservation, but in fact had only maintained the facades. They followed up their spy work by posting photo blowups of these interiors on the outsides of the buildings, stencilled over with the words, "Demolished by Neglect." Although the illegality of the act was denounced by a number of politicians and the local arts council, Detroit's city council finally found in the artists' favor and reprimanded the landlords. Groups of graphic artists in Houston and New York, in conjunction with CISPES, designed bogus newspaper front pages that blared, "U.S. at War in El Salvador," and wrapped them in the dead of night around the real papers in vending machines.

An even more heroic gesture was made during the Gulf War when two artist-made billboards were surreptitiously posted overnight on a dual commercial billboard space at a major intersection in downtown Manhattan. One was by a New Jersey group called Artfux, the other by painter Ron English; both decried the nature of the war (English's billboard overlayed an image of Picasso's *Guernica* with the words, "New World Order").

Finally, there are artists using a medium that is both highly visible and highly subtle: traffic control signs. Ilona Granet (who actually worked with New York City's Department of Transportation) produced a series of signs that showed the silhouette of a man restraining a dog or wolf from lunging at a female passerby, and warning in English and Spanish, "Control Your Animal Instincts." Gran Fury questioned the city's supposed housing shortage by installing official-looking signs that stated, "NYC owns 30,000 empty apts and has 30,000 homeless people; NYC's cost effective solution: Let them die in the streets."

The kind of art I have described has little in common with either heroes on horses or *Tilted Arc*. It does not consist of memorials to the past; instead it seeks to integrate itself into everyday life. It is not a set of statements that are essentially personal; it is an art that struggles to be intelligible to nonartists on multiple levels. It takes seriously the concepts of audience and communication.

When such considerations are sidestepped, public art ceases to be public.

In 1985, during the height of the *Tilted Arc* controversy, I testified at the governmental hearings held in response to a petition calling for its

removal. I spoke not against Richard Serra or the artwork, but against a process that had systematically shut out the workers at Federal Plaza—the primary audience for this sculpture. The issue, as it seemed then and as it still seems now, was not whether the piece was good art or bad art (although most of the debate became polarized in this way) but rather an arrogance on the part of art professionals and government bureaucrats that led to a shutdown in communication. Disdain for the concerns of the people who were to live permanently with the sculpture was not only evident in the selection of the art, but in the hearings as well, where testifying office workers were often jeered by *Tilted Arc*'s defenders. Rather than stimulating real dialogue, Serra's sculpture resulted in an obstinate standoff between artists and the nonart public. Whether or not it was good art, it had been put in the wrong place—or at least put there in the wrong way. In terms of artist-community relationships, *Tilted Arc* was an absolute fiasco.

Of course, it is virtually impossible for any art—public or otherwise—universally to be liked. (Remember that even the *Pietà* lost a nose to an angry viewer.) Some of the artwork discussed here as attempting to respond to community interests has met at times with forceful opposition. The two anti–Gulf War billboards were quickly covered with "Support the Troops" posters, and one of Ilona Granet's street signs was torn down by construction workers as soon as she had finished installing it; the air was let out of her car's tires as well. But it is also true that the billboards, which lived a second life in the form of documentary photographs, found favor in a variety of nonart publications (including religious ones) that shared the artists' sentiments. And most of Granet's street signs remained undisturbed. In a way, the very things that seem to exclude this type of artwork from being considered within the context of public art— its impermanence and its other-than-fine-art construction—are the same traits that throw open the interaction between artist, audience, and artwork. Unhappy viewers tend to be less unhappy about an image they consider disturbing if they know it will eventually go away. One man can unbolt a street sign; the removal of *Tilted Arc* required a crew of crane operators.

I am arguing neither for the destruction of artworks nor against permanent forms of public art. Besides the issue of artist-audience communication, permanent works face a unique set of problems that could result in a potential nightmare involving government bureaucracy, budget overruns, union negotiations, and dealing with special interest groups. Artists who try to navigate this labyrinth will most likely find themselves devoting more time to diplomacy than to aesthetics. But those who persevere in this balancing act without losing sight of their audiences can achieve astounding results, as evidenced by artists such as Maya Lin, Athena Tacha, and Siah Armajani.

Perhaps these alternative approaches to public art can offer a more

direct way for artists to communicate with a popular audience. Most nonartists are not the philistines so often referred to during the *Tilted Arc* hearings. Many of the CETA artists worked amicably with their assigned community groups and the resulting artworks are still appreciated. The people with whom John Malpede, Judy Chicago, and Suzanne Lacy work certainly comprehend the nature of the art they are making. Detroit's city council easily recognized the real issues involved in the "Demolished by Neglect" project. I personally have been able to get career secretaries from Wall Street to enjoy rather unconventional sculpture-and-text installations because the art touched on subjects important to them. With exhibit titles like "Power/Money" and "Insider Information," they had little trouble relating to artistic content that was readily understandable in the context of their day-to-day lives.

The late Scott Burton, quoted earlier in this article, was one of the most eloquent spokespersons for a truly public art. "Art has become a cult," he said. "It is a private language that is learned by art lovers. The important thing is to make art that is intelligible to a non-art audience." Sculptor and architect Siah Armajani phrased it even more concisely: "If public art is beyond comprehension, then it's not part of life!"[10]

10. Both Burton and Armajani are quoted in Douglas C. McGill, "Sculpture Goes Public: A Hybrid Art Engages Architecture and the Eye," *New York Times Magazine,* 27 Apr. 1986, p. 45.

Public Space in a Private Time

Vito Acconci

1

It used to be, you could walk down the streets of a city and always know what time it was. There was a clock in every store; all you had to do was look through the store window as you passed by. The business day came and went with its own time clock; after hours, if the store was dark, the street lights let you still see inside—you had the time not just for business but for pleasure. But then times changed, and time went away. Well, it didn't go *away* exactly, but it certainly did go *out:* time went out like a virus and spread through all those bodies walking the streets. Time aimed straight not for the heart but for the arm. It fit around the wrist in the form of a watch: the quartz watch that was no trouble to make and no worry to wear, the cheap wristwatch you could buy for two or three dollars off-the-shelf and on-the-street. The wristwatch was no longer an expensive graduation present, no longer a reward for a lifetime of service to the corporation. Time came cheap now; you picked up a watch like a pack of matches as you walked down Canal Street. Watches were instant fashion, you chose one to suit your every mood. Take one with a built-in calculator, one that ran on a few drops of water, one whose hands were entangled in a spider's web. There was no need anymore for time to be installed on the street, in a bank, or a liquor store—no need for time to be set in place, to be in the place where you happened by, when all the while you were on your own time, you wore time on your sleeve, you had time (almost) in the palm of your

Critical Inquiry 16 (Summer 1990)

hand. Public time was dead; there wasn't time anymore for public space; public space was the next to go.

2

Public space is an old habit. The words *public space* are deceptive; when I hear the words, when I say the words, I'm forced to have an image of a physical place I can point to and be in. I should be thinking only of a condition; but, instead, I imagine an architectural type, and I think of a piazza, or a town square, or a city commons. Public space, I assume, without thinking about it, is a place where the public gathers. The public gathers in two kinds of spaces. The first is a space that *is* public, a place where the public gathers because it has a right to the place; the second is a space that is *made* public, a place where the public gathers precisely because it doesn't have the right—a place made public by force.

3

In the space that *is* public, the public whose space this is has agreed to be a public; these are people "in the form of the city," they are public when they act "in the name of the city." They "own" the city only in quotes. The establishment of certain space in the city as "public" is a reminder, a warning, that the rest of the city isn't public. New York doesn't belong to us, and neither does Paris, and neither does Des Moines. Setting up a public space means setting *aside* a public space. Public space is a place in the middle of the city but isolated from the city. Public space is the piazza, an open space separated from the closure of alleys and dead ends; public space is the piazza, a space in the light, away from the plots and conspiracies in dark smokey rooms.

Vito Acconci's latest show, entitled "Public Places," was held in 1988 at the Museum of Modern Art, New York. He is currently at work on a park in Detroit, a pedestrian mall in Baltimore, and a housing project in Regensburg, Germany.

Proposal for city hall complex, Las Vegas
1989
Mirrored stainless steel, aluminum space-frame and trusses, concrete,
water
120′ × 120′ × 60′

The front of the city hall building is a side-to-side convex curve. Most of the facade is a blank wall surfaced with travertine marble. In front of this fortresslike wall is a reflecting pool, which resembles a moat.

The proposal attaches to the front of the building a mirrored cross, a giant Greek cross made of mirrors. The cross peels away from the building: the arms of the cross curve out, away from the curve of the building, and down, as does the top of the cross.

Where the cross peels away, the panels of marble are removed from the wall; what remains are signs of removal—rough concrete, patches of adhesive. From the removal-area behind the arms of the cross, water drips down the wall of the building and into the reflecting pool.

Where the cross peels away, searchlights are tucked away in the space-frame of the cross, and they shine at night off to each side and up into the sky.

Just as the cross curves away from the building, the plaza in front of the pool curves away from itself. A strip of the plaza, the width of the cross, slips away from the sidewalk and toward the building, down into the ground and into the water. The slippage moves whatever is on the surface—a tree, a bench, a patch of grass. As the path goes down into the water, the side walls are waterfalls formed from the reflecting pool above.

The pathway leads you to the cross as if toward an entrance to the building. This entrance is a fake one: it doesn't open into the building. Instead, it opens the building up to the outside; it brings onto the building images of the city and its people, reflected as if in a funhouse.

4

The space that is *made* public began as its own opposite. This was a space that was never meant to be public at all: a royal space, or a presidential space, or a corporate space. This private and privileged space had inherent in it, from its beginning, the seeds of public space: the fact of its existence provoked desire, its privacy functioned as a taunt to the public that felt left out. Once that space has been taken over by force and made public, it has inherent in it, in turn, the seeds of private place, the seeds of a redefined and reinhabited privacy: the public that takes it over is working its way up to the royalty or the presidency or the corporate office. Private space becomes public when the public wants it; public space becomes private when the public that has it won't give it up.

5

The making of a public space demands a belief in God, or at least in *a* god. That god is either a target or an instrument that aims at the target. God-as-target is the institution that the public dreams of, the institution that—now that dreams have become a reality and are just out of reach—the public is attempting to storm. In this scenario, the current inhabitants of the institution are questionable, but the institution itself is never questioned; it can't be questioned; if it were, there'd be no reason to try and take it over. God-as-instrument, on the other hand, comes in two varieties. Either it is the public itself, more specifically, the *idea* of a public that acts as a belief system, a "body politic" that subsumes and glorifies the particular bodies that make it up, no matter how misshapen those bodies might be; or it's one person who has been picked out of the crowd, or who picks him- or herself out. In the latter scenario, the public doesn't know what it wants; in fact, it *shouldn't* know what it wants. The public exists as raw material; it exists only so that it can be mesmerized by a solo voice, only so that it can follow a leader.

6

An open public space, like the piazza, is a vast multidirectional space. People are dots sprinkled across the floor; one dot slides into another and slips past another to continue on its own. A number of dots queue up to form a dotted line of tourists who follow a flag and criss-cross another dotted line of tourists. Here and there, as if scattered through a sea, dots merge together into islands. It's every person for him- or herself here, every group for itself, and the tower above all. The space is public, but the people in it don't function as *a* public. In order for public space to be a gathering place, where all the people are gathered together as a public, it needs a gathering *point*. To be seen and read as a public, to act and/or be used as a public, the dots have to form a circle, as if *around* a point; or they have to form a line, as if *toward* a point; or they have to blend together so that they form a point themselves, which blots and spreads out to cover the piazza floor.

7

One diagram of the piazza might show dots scattered and separate from one another at varying distances; a second diagram might show these dots condensed into areas. The first diagram analyzes public space as a park or a suburb; the second analyzes public space as a city street or as the city itself. In the first diagram, the dots are too far apart from each other to mix: people are solitary and spend only passing moments together. All you can do in a space like this is sit down, lose yourself in a book, satisfy yourself with lunch, drift into dirty thoughts about other people walking by. In the second diagram, the dots are pushed so close to each other they can't be seen as dots anymore, and the space itself can't be seen for all the dots: the dots have filled the open space and closed it until it's about to burst; it can no longer function as a container, it has to become something else. This type of public space is, potentially, a politically active space. But it becomes that only when the dots within are brought together by, and put at the service of, an external point: that point might enter the space and dwell in the mind, in the form of a shared idea, or it might enter the space in the flesh, in the form of a leader. To become a political arena, the piazza—the model of an open public space—gives up any claims of being a democratic space: it resigns itself and becomes an authoritarian space.

Proposal for Revelle Plaza, University of California, San Diego
1988
Steel, grass, water, flagpoles
152′ × 148′ × 48′

The existent plaza is like a conventional college quadrangle but so vast that it can function only as a place to walk through—the buildings are too far apart to suggest a place to gather in.

The proposal deals with an area of grass off to the side of the central concrete walkway. This area of grass is on two levels, one plane about three feet higher than the other.

The ground is made to burst in or burst out, the ground is made to implode or explode. On the lower level the grass spirals up out of the ground; on the upper level the grass spirals down into the ground. You can walk up as if on a little mountain, you can walk down as if into a tunnel. The spiral ends in a pool of water fed by a timed fountain. (The spurts of water are all the same height so that the fountain from the lowest spiral is barely seen above ground while the fountain from the highest spiral rises above the site.) The water spurts for a few seconds here, then way over on the other side for a few seconds there.

The way the site is now, there's a flagpole, bearing an American flag, in the middle. The proposal calls for additional flagpoles: these are of different heights; they are not perpendicular to the ground but diagonal—it's as if they're rising up from or sinking into the ground. The flags are red, the flags are metal, the metal clanks in the wind. (The flags function as a kind of rallying cry, as if calling people to storm a hill or to come together underground.)

8

The piazza remains democratic when people break up into clusters. Groups of people form territories, as if over a vast plain. The cluster is small enough that it doesn't need a leader: each person in the cluster has the chance to talk for him- or herself, without asking for it, without needing to be granted the privilege of talking. Each cluster acts as if (at least for the moment) the rest of the space isn't there; each cluster acts as if it doesn't need the rest of the space. In fact, it doesn't *want* the rest of the space; the cluster-space exists as democratic only as long as it keeps the rest of the space out. The more people break in, and make the cluster bulge, the more the cluster dissolves into individual parts that would spread out indefinitely until one person either from within or without reshapes them into something bigger than a cluster, something that needs—and that is an—organization.

9

To keep itself intact, the cluster moves indoors where it has walls to preserve it. People gather together as small groups in bars, and in cafes, and in nightclubs. A person might come here specifically for a service that, as a by-product, inserts that person into a group of people seeking the same service; or the person might come here primarily to be part of a group, the service being only a decoy, an excuse for companionship. Whatever the intention, in order to achieve that goal these people have come to this particular place and no other. The individual goal is subsumed into what's called "a sense of place." When "place" is embodied concretely enough to be "sensed," it has been distinguished from the places surrounding it. Either it is a "historical place," a preservation or re-creation of the place as it once was, as if in a time capsule; or it is a "virtual place," the importation of another place far away from this one in space or time that you visit as if in a space capsule, or a time machine. The implication of a "historical place" is that there's no space without time—a place has no life until time has gone by. The implication of a "virtual place" is that there's no time without space—the past or the future can't be prelived or relived without a place to live it in. In either case, you're not where you are, you only desire to be somewhere else; place is linked either with memory or with imagination. Going to a "historical" cluster-place is the equivalent of going home, except that this is the home not only of the family but of the tribe; "historical place" turns the private time of the family into the public time of the tribe. Coming to a "virtual" cluster-place is the equivalent of going on vacation, except that you never have to leave your own backyard; "virtual place" transports the public space of the foreign into the private space

of the home. A "historical place" puts the place into the flow of history, but a history that's stopped at a certain point in time; time has gone by, but it can't go on. A "virtual place" puts the place into the field of geography, but a fragment of geography that's cut off from its neighbors; you're in place, but you can't go from place to place. This is not history but myth, not geography but only a travelogue, not science fiction but romance: the laboratory invention of the perfect environment, which can't be spoiled by further time and by other places encroaching on it.

10

In these indoor cluster-places, you get what you pay for. You pay to belong to the community, and the class, that is accustomed to use the place. You pay for the fabrication of a past or of a future, for the idea that this is how the place should be and not merely how it is. You pay, too, for the proximity of other bodies; you pay for the right to "test the waters," to try your hand at this sea of bodies that swarm through the place. The bodies are packed close together so that, at least in theory, at least in the mind and in the libido, you can have your pick; here you're the king of the mountain, you can't be shot down, you will make a conquest. In a bar you're allowed to make conversation, whereas on the street you're expected to pretend that you walk alone. You're obligated to just walk on by. You have to pay for the chance that you might get lucky; you pay in order to enter another body or consume another body.

11

The indoor cluster-place has embedded, within its own category, the principle of its own negation. The prototype of the self-destructive cluster-place is the rock music club. These are places with names, like The Knitting Factory, that flaunt the subversion of places that once had a history of their own; places with names, like Deviate, that encourage the perversion of inhabitants who once had a philosophy of their own. Like other indoor cluster-places, these clubs are privately owned; but the owners of these places betray their own masochism or display their own arrogance. They risk losing all they have—either they feel guilty for having it and want to give it up or they want to beat the devil and look death and destruction straight in the eye. The club has, as its end, the playing of music that draws people into the club and keeps them there as paying customers; but the end of the music itself—if it isn't stopped too soon, before it's too late—is to be so loud and so strong that the walls shatter: the goal of the music is, literally, to bring the

house down. On the one hand, these places deny privacy and ownership by admitting, within their own walls, the instruments of their own destruction, the instruments of revolution; on the other hand, these places appropriate destruction in order to extend ownership and privacy. They have their own insurance policy: if the place is destroyed, just build a bigger and better one—they domesticate revolution.

12

Sooner or later you have to leave the cluster-place; the bar closes; you've had one more for your baby, and one more for the road. You take this literally—either you go on home, or you walk around, through the city. But the choice of inside or outside, of private or public, is outdated now. In an electronic age, you have all the information of the city—the information of one city after another, of one city piled upon another city—at your fingertips, on a computer terminal, in the privacy of your own home. You never have to get up out of your seat, you never have to leave home. The information is in your head and on your mind; you leave your home computer not for the mind but for the body, not for the head but for the genitals. You go out to shake your body loose, you go out to shake rattle and roll. The public space of the city is the presence of other bodies: public space is an analogue for sex—either it's a composite of objects of the desire for sex, or it's a composite of images that substitute for sex. Public space contradicts its name and functions as the domestication of sex: you escape into public space when sex at home, within closed walls and where there's nothing else to do, becomes closed up in itself and festers and becomes a monster, out of control. Or else public space lives up to its name and functions to bring sex out into the open: you liberate yourself into public space when sex at home closes you up inside a relationship and "sex" becomes reduced to a subcategory of "relationship." Public space is the refusal of monogamous relationships and the acceptance of sex that has no bonds and knows no bounds.

13

Time is fast, and space is slow. Space is an attempt to place time and understand time; space is a need to have something to see and solid ground to stand on; space is a desire to follow the course of events and to believe in cause and effect. The electronic age obliterates space and overlaps places. You travel by airplane: you're in one place, then it's all white outside the window, and then—zap!—you're in another place, with nothing in between. You're switching channels on a TV set,

rewinding and fast-forwarding a videotape, instead of watching a movie from beginning to end. The electronic age establishes the primacy of time. The video game versus the pinball machine. The push-button phone versus the rotary phone. The digital watch versus a clock whose hands travel around a field in which each individual second has a place. In a fast time, public space—in the form of an actual place with boundaries—is a slowing-down process, an attempt to stop time and go back in history and revert to an earlier age. The plaza, bounded by buildings and owned by a corporation, is a nostalgia for nineteenth-century nationalism.

14

Public space, in an electronic age, is space on the run. Public space is not space *in* the city but the city itself. Not nodes but circulation routes; not buildings and plazas but roads and bridges. Public space is leaving home and giving up all the comforts of the cluster-places that substitute for the home. Space on the run is life on the loose. There's no time to talk; there's no need for talk, since you have all the information you need on the radio you carry with you. There's no need for a person-to-person relationship, since you already have multiple relationships with voices on your radio, with images of persons in store windows and on billboards. There's no time to stop and have a relationship, which would be a denial of all those other bodies you're side-by-side with on the street, one different body after another, one body replacing another. There's no time and no need and no way to have "deep sex": in a plague year, in a time of AIDS, bodies mix while dressed in condoms and armored with vaginal shields—the body takes its own housing with it wherever it goes, it doesn't come out of its shell. The electronic age and the age of AIDS become intermixed in an age of virus, whether that virus is information or disease. Each person becomes too infected, either with information or with disease, to be with another. You come to visit, not to stay.

Project for Cervantes Convention Center, St. Louis
Steel, mirror, neon
1004' × 64' × 48' (Each panel 18' square)

The truss at the top of the building functions as the support for other trusses: triangular trusses jut out and up and down and to one side or the other, like cranes at a work-site, like limbs of the building.

Each pair of trusses holds a mirrored stainless steel panel, like a billboard, which rotates on the trusses as if on a spit. As the panel slowly rotates, it reflects first sky, then building, then street, then people, then sky again

On each mirrored panel is inscribed a phrase from the Pledge of Allegiance. The letters are cut out of the panel, the background made visible through the mirror. The letters are lined with white neon, the words are made readable at night. Some of the letters are lined also with an additional neon tube, either red or blue, which flashes on and off. One word pulls out of the basic phrase, a different word flashes at different times. One word calls the other word into question: you can't read one word without seeing another word rip it apart from within: you start to think harder, maybe, about the meaning of the words: as the panel rotates, now you see the words, now you don't, now you see the words upside down

Out of I PLEDGE ALLEGIANCE flashes LED or EDGE or PEG LEG

Out of TO THE FLAG flashes TOT or LAG

Out of OF THE UNITED STATES flashes NITE or STAT or TAT

Out of OF AMERICA flashes O or ME

Out of AND TO THE REPUBLIC flashes REP or PUB or RELIC

Out of FOR WHICH IT STANDS flashes OR or HIC or AND

Out of ONE NATION flashes TIN or TON

Out of UNDER GOD flashes GO or OD

Out of INDIVISIBLE flashes VISIBLE or INVISIBLE

Out of WITH LIBERTY flashes WIT or LIT or LIE

Out of AND JUSTICE flashes JUST or TIC or SIC

Out of FOR ALL flashes FALL

15

The electronic age redefines *public* as a composite of privates. When you're in a plane, and you look out the window and you're in the clouds and you have no clue as to what your route is, you might be anywhere you want to be, anywhere in the world. The image you have of where you are is different from the world in the dreams of the person sitting next to you. Except that it doesn't matter what either of you might think, what either of you might want; you're not going anywhere but here, where the plane has been programmed to land, where the pilot has taken you. You're in the position of a child: "This is your captain speaking. . . ." The electronic age—by turning concrete space into abstract space, by turning space into time—takes control out of your hands and puts it in the will of another, whether that other is called God or Magic or The Corporation or The Government. A single person has access to all the information of the city and becomes, him- or herself, a self-sufficient city. That self-contained entity is easier to contain now from the outside, easier to control, since it has no need and no desire to join with any other self-contained and self-sufficient entities in resistance. Each of these self-enclosed entities, by the way, might be wearing one of those cheap wristwatches that started off this essay, pages ago. The watch that used to be "Made in the U.S.A." is now "Made in Korea," or "Made in Taiwan." Electronics, by making information accessible and exchangeable, and by making the products of information repeatable and cheap, forces the breakup of national boundaries. One nation is connected to another, one nation goes through another. But older structures, economic and military, retain their power in the organization of electronics. One nation is connected to another either as dominant or submissive; one nation goes through another either as invader or as parasite. We in the United States don't have to go to South Korea anymore; we can have South Korea come to us. South Korea comes cheap; we can take it with us wherever we go. We have it up our sleeve like a wristwatch.

16

The collision of electronics and bodies will subvert the organization of information and of cities. Each bit of information is controlled, but the mix of information is accidental and can't be organized. The propaganda from one station, on a radio that's carried in the street, weaves in and out of the propaganda from another station, and

another. One product on a shelf, in a rack, bulges against another and pushes that one into another, etc. One billboard image peels away only to reveal behind it another image, which comes into collusion then with the unpeeled part of the upper image. One neon message is lost in the stars of other neon. One home computer can plant a bug in the programs of other computers. Public space is the air space between bodies and information and other bodies; public space is a mix of electric current and sexual magnetism. So much information fills the air, and so many things and so many bodies, that you can trust and love any one of them only "for the time being." There's no danger of being a true believer, no danger of being a husband or a wife—you're playing the electronic field, you're on the move and on the make.

17

The building of spaces in the city has already been assigned to established disciplines: the vertical is allotted to architecture, the horizontal to landscape architecture, and the network of lines between and through them to engineering. The city has all the design it needs. For another category—"public art"—to have a function in the design of city spaces, "art" has to be brought back to one of its root meanings: "cunning." Public art has to squeeze in and fit under and fall over what already exists in the city. Its mode of behavior is to perform operations —what appear to be unnecessary operations—on the built environment: it adds to the vertical, subtracts from the horizontal, multiplies and divides the network of in-between lines. These operations are superfluous; they replicate what's already there and make it proliferate like a disease. The function of public art is to de-design. It builds up, like a wart, on a building: there might be a capsule, say, that attaches itself like a leech to an empty wall, where it provides housing for people who wouldn't have access inside the building. Or public art digs out, like a wound, from the floor of a plaza or the ground of a park: at your feet, say, there might be a burrow or a foxhole or a lair, which could be used for a quick fuck or for a conspiracy. Or, instead of spaces that people have to stop at and slip into, public art furnishes spaces that house people as they keep moving: it might be in the form of vehicles, or it might be clothing, that takes as its model the T-shirt that invites you to read text at the same time as it dares you to stare at the breasts behind it. The end is public, but the means of public art might be private. The end is people, but the means might be individual persons. The end is space, but the means might be fragments and bits.

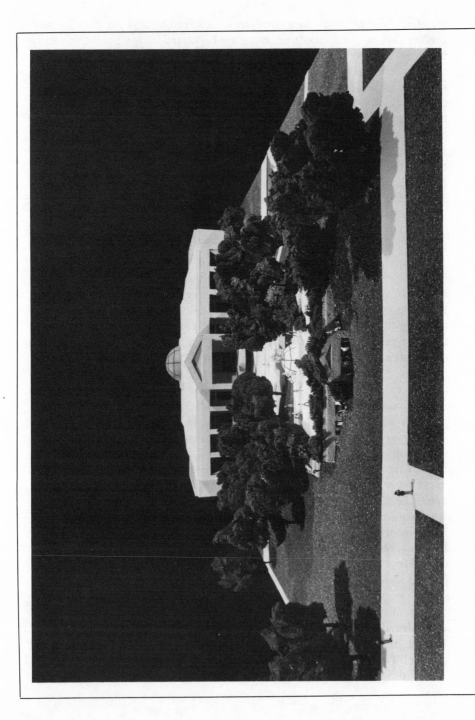

Proposal for the Supreme Court lawn, Carson City
1989
Concrete, metal, glass, plantings, water
128' × 64' × 10'

The Supreme Court building is a classical court building: columns and a portico in front, a dome on top. The proposal is for the lawn in front of the Supreme Court building.

On the lawn, between the walkways, another building is submerged in the ground. It is a replica of the Supreme Court building, half the size of the original. You can walk on the grass and onto the roof of the building; the lawn slopes down toward the portico so that the front of the building is partly visible, the roof here elevated off the ground.

The trees and shrubbery of the lawn continue onto the roof of this other building, around the edge (the trees and shrubbery form, as a by-product, a railing). Below the roof, behind the columns, fountains rise to different heights and shoot up against the ceiling and up through the dome and the open shaft at the side of the roof.

This other Supreme Court building functions as a person-made landscape: you can use the roof as a kind of park; you can walk around the roof and step up and sit on different levels of the roof.

This other Supreme Court building might be an older court that by now is sinking down into the ground (it's overgrown with shrubbery, the building has sprung a leak). Or it might be a newer court, an alternative court, that is starting to rise up out of the ground (it pushes up the landscape with it as it ascends, the water springing up shoots up the building with it).

18

The built environment is built because it's been allowed to be built. It's been allowed to be built because it stands for and reflects an institution or a dominant culture. The budget for architecture is a hundred times the budget for public art because a building provides jobs and products and services that augment the finances of a city. Public art comes in through the back door like a second-class citizen. Instead of bemoaning this, public art can use this marginal position to its advantage: public art can present itself as the voice of marginal cultures, as the minority report, as the opposition party. Public art exists to thicken the plot.

19

The model for a new public art is pop music. Music is time and not space; music has no place, so it doesn't have to keep its place, it fills the air and doesn't take up space. Its mode of existence is to be in the middle of things; you can do other things while you're in the middle of it. You're not in front of it, and you don't go around it, or through it; the music goes through you, and stays inside you. It's a song you can't get out of your head. But there are so many voices, too many songs to keep in your head at once. You walk down the street and hear one song from the soundbox you carry with you, another song blaring out of an audio speaker in front of a store, one more through an open bedroom window, yet another coming off the radio in a car that speeds by another car with still one more, and then another, as the driver changes stations. This mix of musics produces a mix of cultures; of course pop music exploits minority cultures, but at the same time it "discovers" and uncovers them so that they become born again to sneak into and under the dominant culture. The music of the seventies was punk; the music of the eighties was rap. Each of these types is music that says: you can do it, too. You don't need a professional recording studio; anybody can do it, in the garage and in the house. The message of punk was: do what you can do and do it over and over until everybody else is driven crazy. The message of rap is: if something has been done better by somebody else, who had the means to do it, then steal it, and remix it; tape is cheap and airspace is free. The message of punk and rap together is: actions speak louder only because of words, so speak up and talk fast and keep your hands free and your eyes wide open and your ear to the ground and be quick on your feet and rock a body but don't forget to rock a culture, too.

20

Beware of the Walkman.

The Dream

Agnes Denes

All my philosophical concepts seem to culminate and come to life in my environmental/sculptural works. They are meant to begin their existence in the world when completed as works of art, and come to full realization as they grow and evolve with the changing needs and perspectives of mankind.

The issues touched on in my work range between individual creation and social consciousness. We have entered an age of alienation brought on by specialization, a by-product of the Information Age. This is an age of complexity, when knowledge and ideas are coming in faster than can be assimilated, while disciplines become progressively alienated from each other through specialization. The hard-won knowledge accumulates undigested, blocking meaningful communication. Clearly defined direction for mankind is lacking. The turn of the century and the next millennium will usher in a troubled environment and a troubled psyche.

Making art today is synonymous with assuming responsibility for our fellow man. I am concerned with the fact that we have taken evolution into our own hands. We are the first species that has the ability to consciously alter its evolution, modify itself at will, even put an end to its existence. We have gotten hold of our destiny and our impact on earth is astounding. Because of our tremendous success we are overrunning the planet, squandering its resources. We are young as a species, even younger as a civilization, and like reckless children initiate processes we cannot control. We tend to overproduce, overuse, and quickly tire of things. We also overreact, panic, and self-correct in hindsight.

Critical Inquiry 16 (Summer 1990)

The pluralistic nature of things creates too many variables, confusing the goals to be achieved. Sustained interest and effective action are diminished with the alienation of the individual who feels little potential to interact or identify effectively with society as a whole. Overview for mankind is lacking and as the momentum increases human values tend to decline.

In the meantime, for the first time in human history, the whole earth is becoming one interdependent society with our interests, needs, and problems intertwined and interfering. The threads of existence have become so tightly interwoven that one pull in any direction can distort the whole fabric, affecting millions of threads. A new type of analytical attitude is called for, a clear overview, or a summing up.

I believe that the new role of the artist is to create an art that is more than decoration, commodity, or political tool. It is an art that questions the status quo and the direction life has taken, the endless contradictions we accept and approve of. It elicits and initiates thinking processes. My concern is with the creation of a language of perception that allows the flow of information among alien systems and disciplines, eliminating the boundaries of art in order to make new associations and valid analogies possible. My ideas are unorthodox compared to those usually dealt with in the art arena. I incorporate science and philosophy into my work and allow the concept to dictate the mode of realization. The materials I work with are as diverse as the concepts that dictate them. By allowing this flow of information to infiltrate the art arena, art can rise above being just another self-styled, elitist system busy with its own functions. Art is a specialization that need not feed upon itself. It is capable of imbibing key elements from other systems and unifying them into a unique, coherent vision. Art need not be restricted by the limitations inherent in the other systems or disciplines.

An art dealing with these issues has the power to make statements with universal validity and thus benefit mankind. When the creative mind is aimed at global communication and concerns, the door is open to a new form of art that goes beyond the self and the ego without being selfless. This art must assume the difficult task of maintaining a delicate balance between thinking globally and acting individualis-

Agnes Denes has had over 250 solo and group exhibitions on four continents since 1965. In 1989, she received her fourth National Endowment Individual Artist Fellowship. She has published four books, including *The Book of Dust—The Beginning and the End of Time and Thereafter* (1986). A major retrospective of the artist's work is at the Herbert F. Johnson Museum, Cornell University, Ithaca, New York, accompanied by a monograph.

Flying Pyramid for the Twenty-Second Century II. Proposal for Miami airport, Florida. Self-seeding perennial wildflowers and green shrubs. 787′ × 537′. © 1987 by Agnes Denes.

Flying Pyramid for the Twenty-Second Century. Proposal for Miami airport, Florida. Coral rock and water feature. 57″ × 34½″. Pencil study. © 1984 by Agnes Denes.

tically. For the ego must remain intact in order for the self to act fearlessly, with certainty and confidence, yet one must be able to relinquish the ego in order to think universally.

In this sense I see the importance of art emerging beyond a personal style, trend, or region, pointing to new ways of seeing and knowing that enhance perception and awareness and forming new insights and new methods of reasoning. This is the essence I often refer to in my writings, the sum of an analytical process that has the potential to reach beyond itself and become the thermometer or gauge of its time—the summing up needed for the missing overview.

I created my first environmental work in 1968 with these concerns in mind, and I have been developing these concepts ever since.

Art in public spaces has the potential to play an important role in our society. It can offer meaningful collaboration and the integration of disciplines. It can bring people together in meaningful and provocative ways while it can enhance and unite environments. These valuable opportunities are often overlooked in the mad rush of its exploitation. Public art has become the newest game, a new phase in our overproduction and somewhat indiscriminate cluttering of our environments. In the light of our tendencies toward quick consumption, depletion, and reaching saturation points, especially when the results are not exactly satisfactory, public art may become extinct before we have had a chance to see its best examples.

Many recent complaints focus on assertive ego art, which may be strong but obstructs common ground, or on art that lacks merit, which may be weak but gains the consensus of votes needed for commissioning. If the meaning and ultimate goals of public art were better understood, these problems would not arise. Perhaps we ought to question whether public values are different from private ones and examine the kind of quality possible in public art under present conditions and practices. Should public art be judged differently since it is a blend of design, landscaping, architecture, and urban planning, in addition to being art? Who is at fault when something does not reach its highest potential? Without pointing fingers, we must reach for a clear assessment of issues and ask for new directions.

Today it is nearly impossible for art to avoid being commercialized. It is either a collectible object in the marketplace, or it must conform to demands to be functional, cost-effective, and unobjectionable when it enters the public domain. The entire process must be reexamined when quantitative issues become the criteria for the commissioning process at the sacrifice of qualitative concerns. When well-meaning but often incompatible groups of people come together from diverse backgrounds with varying degrees of expertise and commitment, perhaps with conflicting goals and totally different results in mind, what is possible gives way to what is at hand. This does not happen all the time,

because some very good work is being done, but it happens often enough.

The players in this game or drama are the art advisory committees, jurors, coordinators, city officials, art consultants, developers, corporations, architects, designers, contractors, and, bringing up the rear, the communities and the artists. Their aims and sensibilities could not be further apart. Having deadlines, budget constraints, politics, and each other to deal with, compromise is inevitable. Once this process begins, there is no turning back. How can meaningful art get produced under these conditions? How many of these works done today will pass the test of time and the changing needs of people and the environment? How much will it cost to remove the ones no one wants? Hence the importance of selecting works with a strong vision. They never become obsolete.

Public art, like any other art, must have an immediate and a lasting effect. The difference is that public art invades areas where people live and work as opposed to museums or galleries where they go by choice. This alone ought to create a responsibility to the public whose common ground is thereby invaded. And this is where the dream comes in (or disappears). It is difficult to visualize a dream collectively, especially with strange bedfellows. And we know what happens when ideas are forced into a mold. Public art is important for our communities and for artistic expression, but it will fail if we cannot come to terms with its complexities and potentials. It is essential that art remain free to renew itself through the assessment of a world whose issues it reflects and analyzes. Art in the public domain loses its preciousness, but it gains in strength by becoming a social phenomenon, sharing itself with others willingly and effectively. The artists' vocabulary is limited only by the depth and clarity of their vision and their ability to create true syntheses well expressed. This art sees reality but never gives up the dream.

Map Projections: The Snail. Proposal for environmental work. Paving stones and plantings. 80' × 120'. © 1987 by Agnes Denes.

Snail Pyramid. Study for environmental work. Ink on mylar. 40" × 59". © 1988 by Agnes Denes.

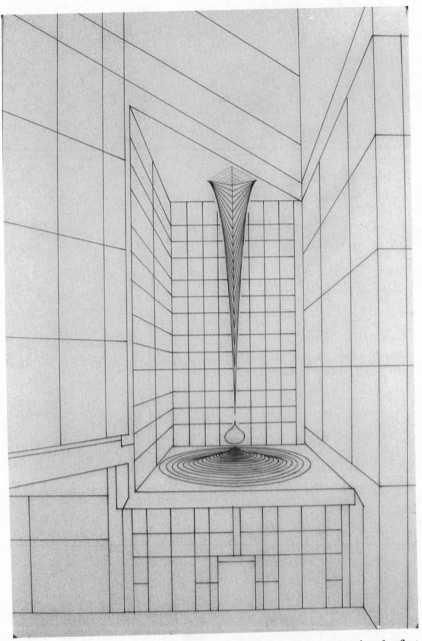

Teardrop—Monument to Being Earthbound with Upside-down Logic (teardrop free-float-
ing). Finalist's drawing for University City Science Center, Philadelphia, Pennsylvania.
42′ × 24′ × 24′. © 1988 by Agnes Denes.

Teardrop—Monument to Being Earthbound

The sculpture consists of a circular base and a teardrop-shaped top, which levitates above the center of the base, held afloat on an elastic cushion of magnetic flux. The top is gently and mysteriously moved about by air currents but held in place by superconductive elements. When lit, the teardrop resembles the flame of a candle.

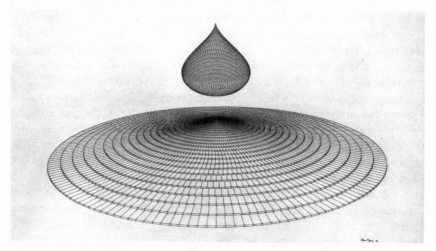

Teardrop—Monument to Being Earthbound (teardrop free-floating). Ink on mylar. 46″ × 80″. © 1984 by Agnes Denes.

Wheatfield—A Confrontation

The Philosophy

My decision to plant a wheatfield in Manhattan instead of doing just another public sculpture grew out of a long-standing concern and need to call attention to our misplaced priorities and deteriorating human values.

Manhattan is the richest, most professional, most congested, and, without a doubt, the most fascinating island in the world. To attempt to plant, sustain, and harvest two acres of wheat here, wasting valuable precious real estate, obstructing the machinery by going against the system, was an effrontery that made it the powerful paradox I had sought for the calling to account.

It was insane. It was impossible. But it would call people's attention to having to rethink their priorities and realize that unless human values were reassessed, the precious quality of life, even life itself, was perhaps in danger. Placing it at the foot of the World Trade Center, a block from Wall Street, facing the Statue of Liberty, was to be a careful reminder of what this land had stood for and hopefully still does.

My work usually reaches beyond the boundaries of the art arena to deal with controversial global issues, questioning the status quo and the endless contradictions we seem to accept into our lives. Namely, our ability to see so much and understand so little; to have achieved technological miracles while remaining emotionally unstable; our great advances, desirable, even necessary, for survival that have interfered with evolution and the world's ecosystems; alienation in togetherness; illusions of freedom and the inescapability of the system, or, for that matter, the individual human dilemma, struggle and pride versus the whole human predicament.

Wheatfield was a symbol, a universal concept. It represented food, energy, commerce, world trade, economics. It referred to mismanagement and world hunger. It was an intrusion into the Citadel, a confrontation of High Civilization. Then again, it was also Shangri-la, a small paradise, one's childhood, a hot summer afternoon in the country, peace. Forgotten values, simple pleasures.

The idea of a wheatfield is quite simple. One penetrates the soil, places one's seed of concept, and allows it to grow, expand, and bear fruit. That is what creation and life is all about. It's all so simple, yet we tend to forget basic processes. What was different about this wheatfield was that the soil was not rich loam but dirty landfill full of rusty pipes, boulders, old tires, and overcoats. It was not farmland but landfill, an extension of the congested downtown of a metropolis where dangerous crosswinds blew, traffic snarled and every inch was precious realty. The absurdity of it all, the risks we took and the hardships we endured were all part of the basic concept. Digging deep is what art is all about.

Introduce a leisurely wheatfield into an island of achievement-craze, culture, and decadence. Confront a highly efficient, rich complex where time is money and money rules. Pit the congestion of the city of competence, sophistication, and crime against the open fields and unspoiled farmlands. The peaceful and content against the achiever. The everlasting against the forever changing. Culture against grass roots. Progress versus an existence without stress. The stone city against soft rural land. Simplicity versus shrewd knowing. What we already know against all that we have yet to learn.

Wheatfield affected many lives and the ripples are extending. Some suggested that I put my wheat up on the wheat exchange and sell it to the highest bidder, or else apply to the government for a farmer's subsidy to prevent me from planting the next year. Reactions ranged from disbelief to astonishment, from ridicule to being moved to tears. A lot of people wrote to thank me for creating *Wheatfield*.

After my harvest the two-acre area facing New York harbor was returned to construction to make room for a billion-dollar luxury-complex. Manhattan closed itself once again to become a fortress, corrupt yet vulnerable. But I think this magnificent metropolis will remember a majestic, amber field. Vulnerability and staying power, the power of a paradox.

The Act

Early in the morning on the first of May, 1982, we began to plant a two-acre wheatfield in lower Manhattan, two blocks from Wall Street and the World Trade Center, facing the Statue of Liberty.

The planting consisted of digging 285 furrows by hand, clearing off rocks and garbage, then placing the seed by hand and covering the furrows with soil. Each furrow took two to three hours.

Since March, over two hundred truckloads of dirty landfill had been dumped on the site consisting of rubble, dirt, rusty pipes, automobile tires, old clothing, and other garbage. Tractors flattened the area and eighty more truckloads of dirt were dumped and spread to constitute one inch of topsoil needed for planting.

We maintained the field for four months, set up an irrigation system, weeded, cleared out wheat smut (a disease that had affected the entire field and wheat everywhere in the country). We put down fertilizers, cleared off rocks, boulders, and wires by hand and sprayed against mildew fungus.

"We" refers to my two faithful assistants and a varying number of volunteers, ranging from one or two to six or seven on a good day.

We harvested the crop on August 16 on a hot, muggy Sunday. The air was stifling and the city stood still. All those Manhattanites who had been watching the field grow from green to golden amber, the stock-

brokers and the economists, office workers, tourists, and others attracted by all the media coverage, stood around in sad silence. Some cried. TV crews were everywhere but they too spoke little and then in a hushed voice.

We harvested almost 1000 pounds of healthy, golden wheat.

Wheatfield—A Confrontation. Battery Park City landfill, New York, New York. 1.8 acres of wheat planted and harvested. © 1982 by Agnes Denes.

Tree Mountain

Tree Mountain is a collaborative, environmental project that touches on global, ecological, social, and cultural issues. It questions our finitude and transcendence, individuality versus teamwork, and measures the value and evolution of a work of art once it enters the environment. *Tree Mountain* is designed to unite the human intellect with the majesty of nature.

Ten thousand trees are planted by the same number of people according to an intricate pattern derived from a mathematical formula. The mathematical expansion changes with one's view and movement around and above the mountain, thus revealing hidden curves and spirals in the design. If seen from space, the human intellect at work over natural formation becomes evident, yet they blend harmoniously.

Projected size of *Tree Mountain* is one to one-and-a-half miles in length, one-tenth to one-half of a mile in width, and oval in shape. Height is site specific and depends on the incline. Both shape and size can be adapted to areas of land reclamation and the preservation of forests.

For the model of *Tree Mountain* I chose silver fir because these trees are dying out, and it would be important to preserve them. Otherwise, any tree can make up the forest as long as it can live three to four hundred years. The trees must outlive the present era and, by surviving, carry our concepts into an unknown time in the future. If our civilization, as we know it, ends or as changes occur, there will be a reminder in the form of a strange forest for our descendents to ponder.

Tree Mountain is a collaborative work in all its aspects from its intricate landscaping and forestry to funding and contractual agreements for its strange, unheard-of land use of three to four centuries. The collaboration expands as ten thousand people come together to plant the trees that will bear their names and remain their property through succeeding generations. People can leave their tree to their heirs, be buried under it, and sell it at auction or by other means. The trees can change ownership, but *Tree Mountain* itself can never be owned or sold, nor can the trees be moved from the forest. *Tree Mountain* represents the concept, the soul of the art, while the trees are a manifestation of it. They are salable, collectible works of art, inheritable commodities, gaining stature, fame, and value as they grow and age as trees. But in the meantime they remain part of a larger whole, the forest. They are individual segments of a single, limited edition. The trees are unique patterns in the design of their universe.

And the trees live on through the centuries—stable and majestic, outliving their owners who created the patterns and the philosophy, but not the tree. There is a strange paradox in this.

Tree Mountain begins its existence when it is completed as a work of art. As the trees grow and wildlife takes over, as decades and centuries pass, *Tree Mountain* becomes the most interesting example of how the passing of time affects a work of art. It can be a thermometer, so to speak, of the evolution of art. Through changing fashions and beliefs, *Tree Mountain* can pass from being a curiosity to being a shrine, from being the possible remnants of a decadent era to being one of the monuments of a great civilization.

Tree Mountain is a living time capsule.

Detail of *Tree Mountain.*

Tree Mountain. Study for environmental work. 10,000 trees. Metallic ink and gouache on mylar. 34¼″ × 96½″. © 1983 by Agnes Denes.

Stelae—Messages from Another Time—
Discoveries of Minds and People

Important excavation from ancient Genova of the Liguria Province, country Italy, European continent, late twentieth century.

A major and unique find, extremely well preserved and restored to near original condition. The inscriptions have been deciphered and appear in translation below bearing the date 1986 A.D.

By studying the meaning of the symbols one arrives at a better understanding of the people who lived toward the end of the second millennium: a fairly advanced technological age in which major scientific discoveries were made that, as we know, had such an enormous effect on later centuries. A significant aspect of these tables is that they include practically all major scientific breakthroughs for this period.

It is appropriate to note here that the very site of this exhibit was a church and monastery at the time, named Santa Maria di Castello, which had been built in an even earlier period, perhaps the thirteenth century.

Vandonia, 6000 A.D.

Transliteration:

1a. b. Energy and mass in Special Relativity

2. Field equations in General Relativity

3. Principle of Least Action (basis of classical mechanics)

4a. Expansion of the universe (the Hubble Law)

4b. The ultimate fate of the universe determined by Ω, the density parameter

5. Energy of photon, the particlelike behavior of waves

6. Fusion of hydrogen into helium (sun's source of energy—hydrogen burning into helium)

7. Photosynthesis—plants storing energy

8. The bases of DNA and RNA as they encode genetic information in chromosomes

9. Maxwell's equation for electromagnetism

10. Nuclear fission reaction in bombs and power plants

11. Thermonuclear fusion in an H-bomb

12a. Schrödinger's wave equation, quantum mechanics, showing wave nature of matter

12b. Uncertainty Principle (uncertainty built into quantum mechanics [Heisenberg])

13a. c. d. Circuit diagram, symbol, and truth table of NAND gate —basic building block of computers

13b. Particle interactions in quantum field theory (Feynman diagram)

14. Wave function of the universe using relativity and quantum mechanics to describe the first moment of the universe

1986 A.D.

Stelae—Messages from Another Time—Discoveries of Minds and People. Installation view. Santa Maria di Castello, Genova, Italy. Hand-carved white carrara marble. 70″ × 37″ × 6″. © 1986 by Agnes Denes.

Stelae—Messages from Another Time—Discoveries of Minds and People. Genova, Italy. Hand-carved pink Portuguese marble. 70″ × 37″ × 6″. © 1986 by Agnes Denes.

Pascal's Perfect Probability Pyramid of the Paradox— The Crystal Pyramid

Crystal Pyramid is a one-of-a-kind superstructure that represents our era as the pyramids of Egypt defined, for all time to come, the Egyptians. It is to be constructed from over 100,000 solid glass blocks for total light transmission and refraction with inverted half vaults shaping the crystal walls adapted to relativity theory and the probability curve. Access to the pyramid is from the ground below through a tunnel that opens into the large interior where myriads of crystalline reflections create the effect of infinity. The pyramid is surrounded by a reflecting pool, which inverts its oblique form.

Crystal Pyramid is a total contradiction to the Egyptian pyramids and their opaque, straight-lined, heavy mass. Its rhythmic form, iridescence, and apparent weightlessness set *Crystal Pyramid* apart from them to represent our era and symbolize our civilization. It is a paradox in concept and design, a temple for meditation, dedicated to the human spirit and skill. It is at this point that *Crystal Pyramid* joins its Egyptian counterparts in combining logic, science, and poetry with engineering skill and architectural tour-de-force to address itself to issues that are timeless.

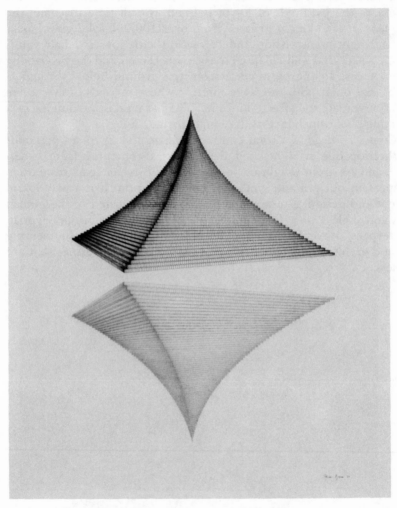

The Reflection. Study for *Crystal Pyramid* in reflecting pool. Ink on vellum. 36″ × 24″. © 1982 by Agnes Denes.

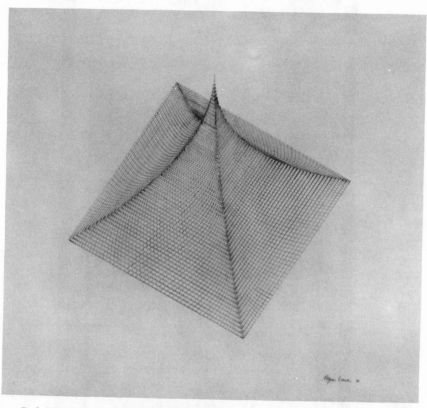

Probability Pyramid in Perspective. Study for *Crystal Pyramid,* bird's-eye view. Silver ink on silk vellum. 34″ × 36″. © 1982 by Agnes Denes.

Telamon Cupboard

Urban Poises

Ben Nicholson

The following essay by Ben Nicholson is a supplementary chapter to his book, The Appliance House *(1991). The Appliance House is, at this point in time, a multiple, composite object: a text, some drawings, models, and collages, an exhibition at Charnley House in Chicago, and a set of principles that might be extended into architecture, urban planning, and specific objects of "public art." The Appliance House might be thought of as a work of conceptual architecture whose goal is to expose the aporias of architectural thought and the hysteria of contemporary architectural practice. Nicholson's six-room "building" is an assemblage of ready-made and highly crafted elements, an elaborate storehouse in which objects to be stored become themselves receptacles for storage. The Kleptoman Cell is one of these rooms, serving the function of study, trophy room, and reliquary. The Telamon Cupboard (which "began its life as a paper collage in the guise of a mirrored bathroom cabinet with an entrance turnstile adhered to its front") is an elaborate forty-receptacle box for storing a collection. The entire structure is called an "appliance house" because (1) it exposes the principles of household appliances with their smooth, high-gloss surfaces and mysterious interiors; (2) its parts and features are "applied to" it in the manner of collage, both in the design stage and in the final process of building; (3) its principles are continually extended, projected, and "applied" to new problems. This third function, the "application of principles," is the thrust of "Urban Poises": in this essay, the concept of the Appliance House moves out into specific sites in the city of Chicago. —*Ed.

Critical Inquiry 16 (Summer 1990)

KLEPTOMAN CHAMBER BULIMIA CHAMBER PYROMAN CHAMBER

OUTSIDE ELEVATION of ½ of the ECCO CHAMBERS

The Poise in the City

The drawing of the Appliance House is stopped. Dead. The House sheds everything but its intention and pushes out into ten "poises"; these are proposals for reworking places within the city of Chicago. A poise is an urban intervention into a place that is suffering from either surfeit or neglect; it might rattle an existing infrastructure or propose a new one out of nothing. Simultaneously, the construction of the Kleptoman Cell will proceed, and it will thus be a prototypical poise; it will make the poises of a more massive scale easier to visualize.

The urban poise is dependent on a particular notion of urban planning: a myriad of actions that can adjust civic life in many places to provoke it towards greater self-esteem. Urban planning is not consecrated by a drawing in the shape of a plan alone, but it must respect the elevation of the stance of an urban spectacle as seen from the sidewalk. The coercion of civic indicators is reappraised by delighting in the figurative stance of the informant city. Small things are done in the city within its existing urban structure so that an edge is applied to what already exists. City blocks might be fractionally altered, holes in the skyline reamed out smooth, and points located strategically so that they can carry their attendant responsibilities. The method is marginally parasitic, for it exists by requiring something else to exist that it cannot readily harbor.

Ten points and places of vulnerability have been chosen in the city that poke at its underbelly. Whilst the poises are given names and specific sites, their viability could be felt equally in a different city using changed names. The Appliance House franchises its intention to various matters of civic consequence, ranging from the weather to shopping to the monumental respect for the dead. Each poise is considered integrally related to the wholeness of the city. If *any* of the poises becomes disassociated from the city or from other poises, the prime tenet of urban existence will have been ignored: the overexertion of one component of urban life will take place at the expense of somebody else.

Ben Nicholson is studio professor of architecture at the Illinois Institute of Technology. His *Appliance House* was published in 1991.

1. Wave Trap Spiracles

The city of Chicago and Lake Michigan are often spoken of in the same breath as if they were fitful lovers. The city exists in its secular hardness, full of intrigue: the lake unknowingly fills a void; its brim laps at the shore and forms an immutable body of water. With the city and lake at such odds, it is no wonder that a park separates and keeps them at bay. Left to its own devices, Lake Michigan would level Chicago, if given enough time to do so. In the interim, there exists a tenuous strip, an aquatic, marginal line, twenty-eight miles long, made of stones, wood, metal, and sand that keeps the sultry lake apart from its quarry, the streets of Chicago. There is currently a $180 million plan afloat, proposed by the Chicago Park District, aimed at appeasing the lake in the hopes that it will not unduly molest the city during the next fifty years.

It is hypnotic to sit on the Lake and watch wave after wave stumble into the flat vertical walls where they break apart. Neither walls nor waves seem to preside over the meeting and neither takes much delight in the other's company. Perhaps it would be better to coerce an affair in which both wall and wave could display their united majesties, a wall invented that invites the waves to show their crests for all to see. Wave trap spiracles can be built to enclose the wave and channel its spurt up into the air to form a nature-forced blowhole so that the daydreamers watching the waves can witness in the vertical column of water the horizontal relentlessness of its force. A one thousand-yard line of thirty spiracles could stand in the water and track through the ejected plumes the angle, force, and consequence of each successive wave of erosive tresses.

2. The Groundless Hold Harmless House

There are some pieces of ground within the city that are invisible. The invisibility exists because the ground has never been sanctified, or if it has been, there is no mark to tell of its former self. These spots ask for a purpose that would promote the surface and raise it above the rubble beneath. They are as prevalent in high-income neighborhoods as they are in low-income neighborhoods, and they are equally latent with possibility.

An invisible piece of ground, which has not yet released its potential, sits in the very center of Chicago on the northwest corner of the Daley Center, kitty-corner to the Dubuffet sculpture outside the State of Illinois building. Four granite slabs collectively measuring 30 feet × 17 feet × 18 inches are perched four feet off the ground and form the lid to the entrance ramp of a subterranean parking garage for the police underneath the Daley Center plaza. In a sculpture-studded place such as this the granite plinth to nothingness forms a place of visual inconsequence upon which no one would climb, for there exists little reason to do so. Because it rests in such a vital public square, it has a potential that could project it far beyond its current use as a purposeless roof to the roller doors of a parking complex; the plinth is now ripe to have upon it something that speaks to the city at large.

Within each city are people who find themselves in circumstances in which a house, an apartment, or tenement block is beyond their control and sometimes, therefore, cannot suit their way of life. Encoded by officials as indigents, scavengers, or misplaced persons, the outwardly mobile move about the city in a manner that is antithetical to suburban dwelling that insists that there are minimum standards under which life thrives. Anything below that line is "contemptible" or at best sad and requires a quick fix of a charitable contribution.

Living in cities outside of houses does not preclude the establishment of a home. Forming a familiarity with things can go far to establish a wall or imaginary roof for the misplaced person. Resting in unfamiliar places is easier once a rapport is struck with the objects that surround the sitter: if the lettering on a bag of cement that is being used as a pillow is reminiscent of something already known, then it facilitates the substitution of cement for feathers; or, close inspection of a tuft of grass for the inhabitant ants within, prior to laying down on it, serves to alleviate the comparative complexities that are beyond it. Once a peace is made with the orbit of things that surround a home, the urban gypsy enters into custodianship of the readied ground.

The establishment of a home for nomadic people requires accommodating the objects carried about, those that need to be brought out

each time the home is reestablished. Whether the object is a carpet that took a year to weave or a bundle of newspapers that have been slept on forty times is immaterial: both objects have value to the users when locating a home. To consider a shopping bag full of newspapers of equal consequence to a Turkoman carpet is difficult, but those who use these objects treasure and treat them with equal care.

A home dedicated to people who refuse to live in one is an anomaly —particularly if it is composed of the careful secretion of the very objects that are considered to be immortal and invaluable to those who tote them. Putting on public display a hobo's objects might be seen as irreverent voyeurism, but if they are placed in a public location that demands statues of eminent politicians, or provocative sculptures, then the stakes are raised beyond voyeurism. The deserved dignity of the urban gypsy might be brought to the public's attention. If the treasures are valued at a price that reflects issues other than the monetary value of their contents, then five orange shopping bags could be deemed worth $2,000 and exchanged for that amount. Tramps would no doubt be intrigued by the interest in their bags as well as the windfall that they might generate.

The Groundless Hold Harmless House could squat upon the granite plinth of the parking garage at Daley Plaza. It could be the twin of the Kleptoman Cell, differing only in that it would sit under a glazed box designed to keep the object just out of reach and shielded from inclement weather. In effect, the house could appropriate the plinth because no one else had thought to use it. This method of commandeering ground would be entirely consistent with its proposed use as a box in which to safely keep things and show to others those artifacts of the houseless, urban dweller. The manner in which the objects are displayed is critical: if the forty nine-inch square boxes comprising the mahogany Telamon Cupboard are filled with the constituents of home for twenty people, then it will have to be made with an attention to craft equalling the attention bestowed upon the objects by those to whom they once belonged. Without a carefully made "frame," such as the Telamon Cupboard might provide, the objects would remain in an anonymous state, despite the fact that they would be no less valuable. By including such objects in a collection placed in public view, life might be made a little easier for those who do not subscribe to the dogmatic existence of living in a house. The contempt, and its associated fear, for those who have had to reject convention might be exchanged for a small measure of respect. To aid and enable in this impossible task, the Groundless House and its contents should be set in a location that would be balanced on the raw nerve ends of the indifferent.

Urban Icons

3. Urban Icons for Mass Transit

The paradox of a bus system in the city is that it is ever-present yet invisible. Once one of its instruments (a bus) arrives, it appears within a whirlwind of cyphers, numbers, and names, so that only the initiated know where it is going. Transit systems spread an all-encompassing web over the city, which touches every part of it with little respect for social graces. A single bus will pass through a diversity of neighborhoods that few people would associate together: it is an instrument of democratic principles.

Little is seen of the transit infrastructure of buses in the city, for the buildings associated with them are sheds rather than carefully assembled acts of intention. At best, there exists at the edge of the street an ugly glass box for people to wait in or a skimpy pole describing the bus's route, while the volatile, charging buses crash past every twenty minutes. If there were some way to give value to the precious commodity of urban travel, in the form of structures, to have them provide as much pleasure in the waiting for a bus as in the act of moving, then the noble sentiment of "Kiss 'n' Ride" might have a better chance of bringing the tender nuptial cheek to meet the panelled sides of the buses.

A series of structures of different sizes, ranging from a single seat with its attendant sign pole to the Kiss 'n' Ride station, could be developed to act as halfway houses between the depths of suburbia and the core of the city. These little buildings could offer hospice to the fleeting urban dweller so that their use need not be only for the wheeled travel-ler. By collecting together the already-existent components of public street welfare (water, seats, seasonal breezes or heat lamps, food, tele-phones, news, and the occasional lavatory), a series of hospices could come to life within the city that would make stepping stones for the fleeting urban voyager and afford a little brightness for those who make the passage in and out from home.

Gym Engines for Exerhouses

4. Gym Engines for Exerhouses

Countless joules of energy are released each day at health clubs by amateur Schwarzeneggers in the service of making sleek, confident bodies. To bring about this form of life, stables of machines are aligned along the walls of the clubs, mirroring the required exertion of each exercise precisely. The health club has become the epitome of onanistic being, exemplified by the body's energy created by the exercisers who are completely swallowed up by the countersprings and balances of the contraptions used.

The turning and shunting mechanisms can be rededicated and the elixir of sweat-drive refocused. The impotent lines of cycles can be joined by a single, common crankshaft to glean the wasted power. The exorciser can work in sympathy with an onlooking recipient: a construction can be built that makes the recipient of the work become more ecstatic than the provider of the energy, who, during the process, will have abandoned an exercise of self-consumption and now performs in the service of others.

The static bicycles can have their imaginary brakes removed, permitting the driving wheels to turn into acts of usefulness. A carousel or propeller that produces summer wind to refresh a bystander might bring the orgasmic cyclist back from his circuitous journey. Water at least can be turbine-pumped to froth up Jacuzzis into which the wheel-severed cyclist can jump once his duty tour has been successfully completed.

Gondola Windows

5. Gondola Windows

If a film were made of a building, a frame of film for each day it lived, it would appear to breathe. A building never remains the same; people constantly add and subtract canopies and terraces from it. There comes a time when it becomes so confusing to look at so many accretions that someone performs a spring-cleaning session and scrapes off the unsightly buildup, under the name of renovation. Rather than scraping the building to its former state, something might be added to the original structure that is better in quality than what existed in the first place; a structure can be entirely cocooned in a second building, like a pearl in a shell.

The extended flatness and sheerness of modernist buildings makes it very difficult to add something on to them, yet a small, spidery contraption, known as the window-cleaning gondola, is attached to every skyscraper. If it is thought of in a way that will further its potential, it may form a pick to enter the glassy surface associated with modernist building. The gondola is composed of a narrow, aluminum platform attached to a gantry off which hangs all manner of ropes, baskets, bottles, and utensils. We imagine the lucky window cleaner to be privy to the full secrets of life behind the windows being cleaned, and the corresponding helplessness experienced by the occupant sealed in behind the dirty glass being washed. Meanwhile, the man on the street wonders if the contraption will fall, if the cleaners suffer severe vertigo, or if lightning often strikes out the insectile devices. The building's owner no doubt wants the ugly little thing to return to its lair as soon as possible so that the building can look exactly as it was once paid to be.

The gondola could be built to match all of these fears. It can be designed to appear as a measured embellishment to the building so that the onlooker would be happy to track its progression each day, like the guests at the hotels beneath the Matterhorn who follow the antics of the mountain climbers, peering at them through powerful mounted telescopes. The building's owner could point out to prospective renters the "brooch" on the building rather than ask it to be shuffled away when someone important is passing by.

The window gondola could extend its raison d'etre by doing things outside of its spit-and-polish livelihood. At the end of the day, it could rest at the base of the building upon a trestle, and perform double duty as a pulpit where rallies could be held. On the inside of the building at every tenth floor, there could be placed a kiosk designed to equal the density of the gondola so that when both are aligned the curtain walls of the building would be gently abraded, allowing a little incision to be cut into the glassy behemoth.

Belligerent Reliquary

6. Belligerent Reliquary

The plain granite slabs forming the Vietnam Veterans Memorial on the Washington Mall have surprised everyone in that thousands of objects are being deposited at the base as anonymous offerings to the memory of those who fell in the Vietnam War. Each day the National Parks Service collects the objects, puts them into plastic Ziplock bags, and delivers them to a team who patiently inventories them and gives a tape-recorded narrative about each object's purpose and origin. The objects range from Congressional Medals of Honor, ballpoint-scribbled flak jackets, pornographic photographs, cigarette packets with hastily scribbled notes on them, and lovingly made boxes filled with carefully arranged treasures from a beloved friend.

The objects are currently being stored in filing cabinets. The items are so diverse, and their value separate from aesthetic consideration, that it is difficult to know what to do with the collection. Their extreme diversity defies categorization: how can a Marlboro cigarette packet, made in 1986, with a letter written on it to someone killed in 1969 from an army buddy who is still living, be categorized? Should it be filed under letters or cigarette packets, under the date it was written, under the name of the deceased or the name of the writer? Every object deposited presents complex interreferences and the disposition of a collection such as this one counters the logic of archival cataloging to the extent that the very notion of category has to be reinvented.

The Kleptoman Cell is suitable for storing diverse collections such as the VVM's artifacts because, as can be seen in the drawings, it permits interfaces between things of great disparity. The manner in which the drawings are teased out and assembled allows various permutations of use to be constructed; the drawings are not made for the building to be completed all in one shot; instead the building can be added to slowly so that a temporal element exists between the building and the objects to be secreted inside of it.

This method of drawing is appropriate for a memorial to people who succumbed to an act of wrenching belligerence. The drawings kinetically unfold a figure, revealing its components as multiple visions. Thus, the Cell has the appearance of an unravelled body exposing its rawness: it then can fold back upon itself whilst placing within its layers many spangles and carefully implanted mementos that infuse life into the body of the building.

House of Crocodiles

7. House of Crocodiles

Zoos have a nasty habit of portraying animals in a landscape that has the semblance of Mother Nature when seen from the vantage point of the observer. The token lake is there, as well as the requisite tree-line, but the crocodiles within the cage probably recognize only the concrete wall and the out-of-reach rim of the pit they are in. They must know they are far from home where they would be submerged in muddy water with only their noses and eyes peeking out of the tepid waterline. Unquestionably the distance between the two worlds is greater than linear measurement can account for.

As long as crocodiles are going to be kept in zoos, why not invite them to assume the stance that everyone knows them to have but is too scared to admit to? Let the crocodiles instill fear into their captors from a cage that sensually turns itself towards the audience. Commission a suburban swimming pool designer and a crocodile handler to build a blue-tiled, kidney-shaped pool for the reptiles. Ask David Hockney to paint and fire a tile mosaic for the bottom of the pool of Mom, Pop, and the kids swimming about. Cast K-mart pool loungers in bronze for the crocs to stretch out on and make a contoured springboard at the deep end for them to slither off. Build a changing room with two entrances (boys and girls) for the crocodiles and mount on its walls the requisite sticks that everyone knows are stuck between crocodile jaws to keep their mouths ajar.

It is little known that a crocodile can outrun a deer by launching itself forward with a powerful flick of its tail and then down its prey whilst moving at thirty MPH. Prepare a runway for the crocodiles so that at feeding time, 2:00 P.M., the family of crocodiles can pounce forward and scare the living daylights out of Ed and Bonnie out on a trip to the zoo, for surely that is why they came to the zoo in the first place!

Ecco Chamber of Civic Turpitude

8. Ecco Chamber of Civic Turpitude

The documentary entitled "King: In Remembrance of Martin" was made by a team of British filmmakers. It documents the life of Martin Luther King, Jr., and then goes on to describe the present conditions of inner-city housing projects. The film portrays life in the Cabrini-Green Homes in Chicago, focusing on the work of a monk who lived in the project. A sequence was shot showing him in his white habit running towards a group of youngsters in a playground. He does this whenever he hears of impending violence; he runs into the group, placing his body between the gun muzzle and the targeted youth in an act of corporeal sacrifice that is supremely generous. In the film he is also shown spreading out on the floor of his apartment scores of wallet-sized photographs of kids who have died in the square plaza bounded by concrete high-rise apartments. This particular square has the tragic reputation of being the piece of ground upon which more people have died through violence than any other in the United States outside times of declared war.

In principle, there ought to be a way to retain the housing stock there and make redundant the compassionate services of the monk. If an act of architecture can be part of a campaign to help confront and dissolve urban turpitude, then surely it is worth considering the placement of an artifice on the spot where the monk runs in order to effect the disassembling of violence.

An ecco chamber for civic turpitude could be assembled in the city with much the same purpose as the Belligerent Reliquary. A fledgling urban group called Mothers against Gangs has been formed by women who have lost children to inner-city turmoil. They might like to tend and care for such a building and be given it for their own purposes. The restorative act of manually building something oneself might begin to dislodge the urban pain. The making of buildings, especially meticulously made edifices, can exorcise malignant thoughts that otherwise would migrate and abrade themselves in the city in some other undoing way.

9. Hancock Chest

The Magnificent Mile of opulent shopping on Michigan Avenue is a most compelling web of high-consumer culture that virtually everybody loves the opportunity to be thrust into. The Mile has been reassembled over the past fifteen years into a corridor of behemoth skyscrapers filled with paradisiacal galleries that dispense the glowing fares the world has to offer. Pedestrians walk from one fortified superstore to the next, making mad, reluctant dashes between cars and lampposts amidst the zone of open space. In the seeming center of it all is the enigmatic Water Tower, a white elephant, left over from a former age that appears beached among the soaring buildings. Apart from the Water Tower's grass plot, there is only one plaza where a shopper can sit and seek refuge from the seller's wicket: it is located at the base of the John Hancock Tower.

The Jack-and-Bean-Stalk grandeur of the Hancock Tower has, at its base, a hole that conjures up a vision of the spot where the giant fell to the ground and formed his imprint in the earth, marking his grave. It may also be the location of the giant's full chest of gold that Jack secreted away. The plaza is potent because of this implicit story and because the hole is currently nothing more than a void with an inner lining of barbers, restaurants, and copy centers: it has no allure. The stone seats at the bottom of the hole perennially wait for someone to sit on them, but who is interested in resting in a hole with cobwebs and piles of leaves under which there is no chance of finding the accompanying "little folk"?

Now the Magnificent Mile is nearly completed. With no more superstores being built, perhaps the hole beneath the Hancock is ready to sprout something in it that will invigorate the shoppers and thrill the expansionist marketeers. The hole could have set into it a chest, projecting twelve feet above ground level, that has inside it a spectacle that would thrill and dazzle even the most jaded shopper.

Put on racks within this chest the entire inventory of a department store's shoe collection, estimated at one hundred thousand pairs if the store is to remain competitive. This would be a collection that even Imelda, the infamous shoe hoarder, would balk at. A chest on Magnificent Mile would permit the "bull-in-the-china-shop" syndrome to be witnessed, a place for the hot-trotting consumer culture to gorge itself into insatiability. Then, once the yards of shoes begin to lose their luster, the endless appetites of the participants could invite Ralph Lauren to reinvent the world entirely and not be crimped by his seasonal spread on the first twelve pages of the *New York Times Magazine*. With a center stage of merchandising such as this, a grandchild of the World's Fair (the World's Unfair), perhaps the drunken wonder-

ment of how much stuff we can bear for how much longer could fall into the laps of the intoxicated shoppers.

The emblazoned chest (its dumbstruck stasis immune to the petty wranglings of its lustered program) could have upon its roof a bar and grill so that the triumphant shoppers could stand upon the back of the chest below, and, in the manner of imperial hunters, prod their umbrellas into the steely skin of the building. Elevated a mere twelve feet above the ground, against the soaring, conquered Bean-Stalk Hancock, the hunter/shoppers could survey the streets, imbibe crushed passion fruit, and plan the next sortie to collect things to add to their inventory of possessions.

Hancock Chest

10. Garbage Receptacles

There is enough rumor currently banging about to impress even the most disinterested that there is an ensuing crisis of urban garbage. The landfills are topping out, yet the consumer culture is still content to spend lavish amounts on packaging in order to lend a sense of excellence to a substance of dubious quality. The fallacious presentation of the worthiness of an object is a burden that landfill has to bear the brunt of directly. The establishment of designated places to deposit specific sorts of garbage might be something that the city planner, in league with a trashologist, could do to defuse the current burden of packaged opulence. One or two carefully positioned schemes, places to ceremoniously do away with the very objects that surround us, could effect change by jolting the "lapsidaisical" into taking action to deal with the severe problem of materials abuse.

Ken Dunn, director of Resource Center, Chicago, related a story about someone who used trash to poetically confront his own shortcomings. Mr. Dunn was telephoned and asked to pick up a large quantity of bottles from a private home. When he arrived, he was shown to the garage in which were carefully assembled pallets of boxes containing one-half-gallon jugs of gin. Over several years, the man had drunk them all, reboxed the empty bottles, and then stored the sober fruits of his life in the garage until it had been completely filled up with boxes. He explained that he had done this as a reminder of his "little habit." If this understanding were extended to the city at large, then perhaps the city's parallel difficulty would be clear as gin, too.

Initially the perfect site for a didactic garbage receptacle would be the parking lot in front of the Museum of Science and Industry. Families could take the kids to the exhibits in the museum and drop off their old clothing, newspapers, pop cans, and bottles into a carefully made construction that would permit them to participate in the ultimate exhibit. Perhaps beginning as a vat of boiling quartz rock, bottles could be dropped from a great height into the fiery soup with a resounding splash. The glass could then be cast into ingots to form the future walls of the receptacle. Paper could be incinerated in sheets of flame to melt aluminum; old armchairs could be dropped from a great height to expose the folly of wishing to have newness at the expense of what is no longer wanted. The city garbage dumps could be gleaned for perfectly serviceable objects that the kids could watch as they were wantonly destroyed by a man wielding two wrecking hammers, one in each hand. The opportunity for the museum to rapaciously smash bottles against a steel wall might exorcise that selfsame violence currently reserved for the streets, particularly if the cents exchanged for the recyclable materials goes into the pockets of the street-smart paravigilantes.

Garbage Receptacles

Art and Censorship

Richard Serra

The United States government destroyed *Tilted Arc* on 15 March 1989.[1]
Exercising proprietary rights, authorities of the General Services
Administration (GSA) ordered the destruction of the public sculpture that
their own agency had commissioned ten years earlier.[2] The government's
position, which was affirmed by the courts, was that "as a threshold matter,
Serra sold his 'speech' to the Government. . . . As such, his 'speech' became

This article is based on a speech given in Des Moines, Iowa on 25 October 1989.

1. On 15 March 1989, *Tilted Arc* was dismantled and removed from its site at the Federal
Plaza in New York City. *Tilted Arc* was specifically created for this site, and its removal from
this location resulted in the work's destruction.

Site-specific works

are determined by the topography of the site, whether it is urban, landscape or an archi-
tectural enclosure. My works become part of and are built into the structure of the site,
and often restructure, both conceptually and perceptually, the organization of the
site. . . . The historical concept of placing sculpture on a pedestal was to establish a sepa-
ration between the sculpture and the viewer. I am interested in a behavioral space in
which the viewer interacts with the sculpture in its context. . . . Space becomes the sum
of successive perceptions of the place. The viewer becomes the subject. [Richard Serra,
"Selected Statements Arguing in Support of *Tilted Arc*," in *Richard Serra's "Tilted Arc*,"
ed. Clara Weyergraf-Serra and Martha Buskirk (Eindhoven, 1988), pp. 64–65]

2. For the court's affirmation of the government's proprietary rights, see *Serra v. United
States General Services Administration* 847 F.2d 1045, 1051 (2d Cir. 1988); reprt. in *Richard
Serra's "Tilted Arc*," pp. 259–68. The court's position turns in part on an understanding of the
contract for *Tilted Arc*'s commission. For additional information on this contract, see Serra,
"Selected Statements Arguing in Support of *Tilted Arc*," p. 66. The inadequacies of the GSA's
contract are detailed in Barbara Hoffman's complete legal analysis of the case, "*Tilted Arc*:
The Legal Angle," in *Public Art, Public Controversy: The "Tilted Arc" on Trial*, ed. Sherrill
Jordan et. al (New York, 1987), pp. 35–37. For a history of the GSA's Art-in-Architecture

Critical Inquiry 17 (Spring 1991)

Government property in 1981, when he received full payment for his work. . . . An owner's '[p]roperty rights in a physical thing [allow him] to possess, use and dispose of it.'"[3] This is an incredible statement by the government. If nothing else, it affirms the government's commitment to private property over the interests of art or free expression. It means that if the government owns the book, it can burn it; if the government has bought your speech, it can mutilate, modify, censor, or even destroy it. The right to property supersedes all other rights: the right to freedom of speech, the right to freedom of expression, the right to protection of one's creative work.

In the United States, property rights are afforded protection, but moral rights are not. Up until 1989, the United States adamantly refused to join the Berne Copyright Convention, the first multilateral copyright treaty, now ratified by seventy-eight countries. The American government refused to comply because the Berne Convention grants moral rights to authors. This international policy was—and is—incompatible with United States copyright law, which recognizes only economic rights. Although ten states have enacted some form of moral rights legislation, federal copyright laws tend to prevail, and those are still wholly economic in their motivation. Indeed, the recent pressure for the United States to agree, at least in part, to the terms of the Berne Convention came only as a result of a dramatic increase in the international piracy of American records and films.

In September 1986, Senator Edward M. Kennedy of Massachusetts first introduced a bill called the Visual Artists Rights Act. This bill attempts to amend federal copyright laws to incorporate some aspects of international moral rights protection. The Kennedy bill would prohibit the intentional distortion, mutilation, or destruction of works of art after they have been sold. Moreover, the act would empower artists to claim authorship, to receive royalties on subsequent sales, and to disclaim their authorship if the work were distorted.[4] This legislation would have

Program, see Judith H. Balfe and Margaret J. Wyszomirski, "The Commissioning of a Work of Public Sculpture," in *Public Art, Public Controversy*, pp. 18–27. See also "General Services Administration Factsheet Concerning the Art-in-Architecture Program for Federal Programs," in *Richard Serra's "Tilted Arc,"* pp. 21–22.

3. "Brief Filed by the Defendants, United States Court of Appeals for the Second Circuit, January 26, 1988 (edited)," in *Richard Serra's "Tilted Arc,"* p. 253.

4. Although this section appeared in the original version of Kennedy's bill, the current version provides for a study of resale royalties.

Richard Serra is known for his large-scale site-specific works in landscapes, urban environments, and museums.

prevented Clement Greenberg and the other executors of David Smith's estate from authorizing the stripping of paint from several of Smith's later sculptures so that they would resemble his earlier—and more marketable—unpainted sculptures. Such moral rights legislation would have prevented a Japanese bank in New York from removing and destroying a sculpture by Isamu Noguchi simply because the bank president did not like it. And such legislation would have prevented the United States government from destroying *Tilted Arc.*

If Senator Kennedy's bill were enacted, it would be a legal acknowledgement that art can be something other than a mere commercial product. The bill makes clear that the basic economic protection now offered by United States copyright law is insufficient. The bill recognizes that moral rights are independent from the work as property and these rights supersede—or at least coincide with—any pecuniary interest in the work. Moreover, the bill acknowledges that granting protection to moral rights serves society's interests in maintaining the integrity of its artworks and in promoting accurate information about authorship and art.

On 1 March 1989, the Berne Convention Implementation Act became U.S. law.[5] On 13 March 1989, on learning that the government had started to dismantle *Tilted Arc,* I went before the United States District Court in New York City, seeking a stay for the destruction so that my lawyers would have time to study the applicability of the Berne Convention to my case. I expected—as would be the case in other countries that were signatories to the treaty—to be protected by the moral rights clause, which gives an artist the right to object to "any distortion, mutilation or other modification" that is "prejudicial to his honor and reputation," even after his work is sold. I learned, however, that in my case—and others like it—the treaty ratified by Congress is a virtually meaningless piece of paper in that it excludes the key moral rights clause. Those responsible for the censorship of the treaty are the powerful lobbies of magazine, newspaper, and book publishers. Fearful of losing economic control over authors and faced with the probability of numerous copyright suits, these lobbies pressured Congress into omitting that part of the Berne Convention Implementation Act which provided moral rights protection.[6] Thus, pub-

5. In October 1988 both the United States Senate and the House of Representatives passed the Berne Convention Implementation Act of 1988 (P. L. 100–568), which made the necessary changes in the United States copyright law (17 USC §§ 101–914 [1978]) for adherence to the Berne Convention. On 20 October 1988, the Berne Convention was ratified, and on 31 October 1988 President Reagan signed into law the copyright amendments, making the United States the seventy-eighth member of the Convention.

6. The moral rights provision of the Berne Convention states:

Article 6bis.
1) Independently of the author's economic rights, and even after the transfer of the said rights, the author shall have the right to claim authorship of the work and to object to any distortion, mutilation or other modification of, or other derogatory action in relation

lishers can continue to crop photographs, magazine and book publishers can continue to mutilate manuscripts, black-and-white films can continue to be colorized, and the federal government can destroy art.

A key issue in my case, as in all First Amendment cases, was the right of the defendant to curtail free speech based on dislike of the content.[7] Here the court stated that the aesthetic dislike is sufficient reason to destroy a work of art: "To the extent that GSA's decision may have been motivated by the sculpture's lack of aesthetic appeal, the decision was entirely permissible."[8] Hilton Kramer has asked, "Should public standards of decency and civility be observed in determining which works of art or art events are to be selected for the Government's support?"[9] He answers his rhetorical question affirmatively and insinuates that *Tilted Arc* was uncivil and comes to the conclusion that it was rightfully destroyed:

> What proved to be so bitterly offensive to the community that "Tilted Arc" was commissioned to serve was its total lack of amenity— indeed, its stated goal of provoking the most negative and disruptive response to the site the sculpture dominated with an arrogant disregard for the mental well-being and physical convenience of the people who were obliged to come into contact with the work in the course of their daily employment. ["A," p. 7]

Kramer goes on to say that it was my wish to "deconstruct and otherwise render uninhabitable the public site the sculpture was designed to occupy" ("A," p. 7).

to, the said work, which would be prejudicial to his honor or reputation.

 2) The rights granted to the author in accordance with the preceding paragraph shall, after his death, be maintained, at least until the expiry of the economic rights
. . . .

 3) The means of redress for safeguarding the rights granted by this Article shall be governed by the legislation of the country where protection is claimed.

This section of the Berne Convention was ratified by Congress in this fashion: "The provisions of the Berne Convention, the adherence of the United States thereto, and satisfaction of the United States obligations thereunder, do not expand or reduce any right of an author of a work, whether claimed under Federal, State, or the common law—(1) to claim authorship of the work; or (2) to object to any distortion, mutilation, or other modification of, or other derogatory action in relation to, the work, that would prejudice the author's honor or reputation." [P. L. 100–568, §3]

 7. See "Appeal Filed by Richard Serra in the United States Court of Appeals for the Second Circuit, December 15, 1987," in *Richard Serra's "Tilted Arc,"* pp. 225–50. For example, counsel drew an analogy to *Board of Education, Island Trees Union Free School District v. Pico* (1982), which held that library books could not be removed simply because the board disliked the content of the texts (ibid., pp. 243–45).

 8. *Serra* v. *United States General Services Administration,* in *Richard Serra's "Tilted Arc,"* p. 266.

 9. Hilton Kramer, "Is Art Above the Laws of Decency?" *New York Times,* 2 July 1989, sec. 2; hereafter abbreviated "A."

All of Kramer's statements concerning my intentions and the effect of the sculpture are fabricated so that he can place blame on me for having violated an equally fabricated standard of civility. *Tilted Arc* was not destroyed because the sculpture was uncivil but because the government wanted to set a precedent in which it could demonstrate its right to censor and destroy speech. What Kramer conveniently sweeps under the rug is the important fact that *Tilted Arc* was a First Amendment case and that the government by destroying *Tilted Arc* violated my right to free speech.

In the same *New York Times* article, Kramer applauds the Corcoran Gallery for having cancelled an exhibition of Mapplethorpe photographs. The photos Kramer objects to render men, in Kramer's words, "as nothing but sexual—which is to say, homosexual—objects." Images of this sort, according to Kramer, "cannot be regarded as anything but a violation of public decency." For those reasons, Kramer concludes, the National Endowment for the Arts (NEA) should not have contributed its funds to support its public exhibition ("A," p. 7). Once again he accused the artist of having violated a public standard, which in Mapplethorpe's case is the standard of decency. The penalty for this violation is the exclusion of his speech from public viewing and the withdrawal of public funds to make the work available to the public.

Kramer's article is part of a larger radical conservative agenda. The initiative Kramer took in the *New York Times* was called for by Patrick Buchanan in May and June of 1989 in the *New York Post* and the *Washington Times* where he announced "a cultural revolution in the 90's as sweeping as the political revolution of the 80's." It's worth quoting Buchanan at length:

> Culture—music, literature, art—is the visible expression of what is within a nation's soul, its deepest values, its cherished beliefs. America's soul simply cannot be so far gone in corruption as the trash and junk filling so many museums and defacing so many buildings would suggest. As with our rivers and lakes, we need to clean up our culture; for it is a well from which we all must drink. Just as poisoned land will yield up poisonous fruit, so a polluted culture, left to fester and stink can destroy a nation's soul. . . . We should not subsidize decadence.[10]

Let me quote another leader of a cultural revolution:

> It is not only the task of art and artists to communicate, more than that it is their task to form and create, to eradicate the sick and to pave

10. Patrick Buchanan, "Losing the War for America's Culture?" *Washington Times*, 22 May 1989, sec. D.

the way for the healthy. Art should not only be good art, art must reflect our national soul. In the end, art can only be good if it means something to the people for which it is made.[11]

What Buchanan called for and what Kramer helped to justify, Senator Jesse Helms brought in front of the Senate. He asked the Senate to accept an amendment that would bar federal arts funds from being used "to promote, disseminate, or produce indecent or obscene materials, including but not limited to depictions of sadomasochism, homoeroticism, the exploitation of children, or individuals engaged in sex acts."[12] The Helms amendment was replaced by the supposedly more moderate Yates amendment.[13] Nonetheless, Helms's fundamental diatribe was successful in that the Senate passed an amendment which gives the government the right to judge the content of art.

The Yates amendment, which was approved by the Senate, calls for denying federal money for art deemed obscene. It is based on a definition of obscenity as given by a 1973 Supreme Court decision in *Miller* v. *California*.[14] In *Miller*, the Supreme Court prescribed three tests for obscenity: a work must appeal to prurient interests, contain patently offensive portrayals of specific sexual conduct, and lack serious literary, artistic, political, or scientific value.[15] The decision about whether something is obscene is to be made by a local jury, applying community standards. Does this mean that the material in question can be tolerated by one community and another community will criminalize its author? What about Salman Rushdie?

Conservatives and Democrats agree that taxpayers' money should not be spent on art which carries an obscene content; Kramer wants publicly funded art to conform to the standards of decency and civility; Helms does not want the NEA to fund indecency and obscenity; and the Democratic majority in the Senate supported an amendment that will enable the government to deny federal money for art deemed obscene. The central premise in all these statements, proposals, and amendments is that obscenity can be defined—that there is actually a standard of decency which excludes obscenity. The assumption of a universal standard is presumptuous. There aren't any homogenous standards in a heterogeneous society. There is no univocal voice. Whose standards are we talking about? Who dictates these standards?

It seems a rather extreme measure to impose an arbitrary standard of obscenity on the whole of society. Gays, as one group of this heterogene-

11. Joseph Goebbels to Wilhelm Furtwängler, 11 Apr. 1933, in Hildegard Brenner, *Die Kunstpolitik des Nationalsozialismus* (Hamburg, 1963), pp. 178–79; my translation.

12. 135 Cong. Rec., 101st Cong., 1st sess., 29 Sept. 1989, S12210.

13. Ibid., S12211.

14. *Miller* v. *California*, 413 U.S. 15 (1973).

15. Ibid.

ous society, for example, have the right to recognize themselves in any art form or manner they choose. Gays cannot be denied their images of sexuality, and they cannot be denied public funds to support the public presentation of these images. Gays are a part of this public. Why should heterosexuals impose their standard of "decency" or "obscenity" on homosexuals? The history of art is filled with images of the debasement, torture, and rape of women. Is that part of the accepted heterosexual definition of decency? It is obvious that the initiative against obscenity in the arts is not directed against heterosexual indecencies but that its subcontext is homophobia. Jesse Helms, in particular, makes no effort to hide the fact that part of his political program is based on homophobia. In an earlier amendment Helms wanted to prohibit federal funds from being used for AIDS education; he argued that the government would thereby encourage or condone homosexual acts. He also stated publicly that no matter what issue comes up, if you attack homosexuals, you can't lose.

The position I am advocating is the same as Floyd Abrams, a noted constitutional lawyer, who stated:

> "While Congress is legally entitled to withdraw endowment funding, the First Amendment doesn't allow Congress to pick and choose who gets money and who doesn't. You can't punish people who don't adhere to Congress's version of art they like. Even if they want to protect the public, the basic legal reality is that funding may not exclude constitutionally protected speech."[16]

The argument ought not to be about assumed standards. We should not get involved in line drawing and definitions of decency and obscenity. There is no reason to participate in this fundamentalist discourse. Taxpayers' dollars ought to support all forms of expression as guaranteed by the First Amendment. Gays pay taxes. Taxation must include the right to representation. Ideas, images, descriptions of realities that are part of everyday language cannot be forbidden from entering into the discourse of art. All decisions regarding speech ought to be made in a nondiscriminatory manner. Government agencies allocating funds for art cannot favor one form of speech over another. Preferences or opinions, even if shared by a majority, are nonrelevant judgments and improper grounds for exclusion. To repeat: If government only allocates dollars for certain forms of art and not others, the government abolishes the First Amendment. If anything, the First Amendment protects the diversity of speech. Government cannot exclude because to exclude is to censor.

Kramer, as well as Helms and Yates, argued that the introduction of obscenity clauses into the NEA funding guidelines was not an attempt at

16. Grace Glueck, "A Congressman Confronts a Hostile Art World," *New York Times,* 16 Sept. 1989.

censorship because there was no effort to prevent publication or distribution of obscene material. Instead, they argued that they were merely barring the use of taxpayers' money for such projects. Taxpayers' money ought to be spent to protect the standards of the Constitution and not to protect bogus standards of decency and civility.

Previously the NEA panels were required only to recognize "artistic and cultural significance" and "professional excellence." Now the head of the NEA must add to these intentionally and exclusively art-related criteria the politically charged criterion of obscenity. I question that obscenity is a matter for the judicial system, but I am certain that it is not for the NEA and politicians to determine. The NEA is no longer politically independent and there is no doubt that its independence will erode even further once the Senate's commission begins to review the NEA's grant-making procedure and determine whether there should be standards in addition to the new obscenity standard that has been forced on the NEA. The twelve-member commission reviewing the NEA guidelines is a purely political commission. It consists of four members appointed by the Speaker of the House, four by the president pro tempore of the Senate, and four by the President. For the time being, John E. Frohnmayer, chairman of the NEA, has taken it upon himself to reverse peer panel recommendations on grants to artists who might use the grant money to produce potentially obscene material. Those artists considered "harmless" and worthy of NEA funding are asked to sign away their right to free speech by signing a guarantee that they will not use the NEA monies to produce obscenities.

It is obvious that the Mapplethorpe case set in motion for the NEA what the *Tilted Arc* case set in motion for the GSA. The *Tilted Arc* case was used to change fundamentally the guidelines of the GSA's Art-in-Architecture Program. The peer panel selection was weakened because every panel will now select under community pressures or will try to avoid community protest. The contract between the artist and the GSA was changed. The new guidelines now overtly favor the government, which can cancel the contract at any stage of the planning process, and it excludes the realization of site-specific projects in that it explicitly states that artworks commissioned by the GSA can be removed from their federal sites at any time. Every artist who agrees to have a work commissioned by the GSA or funded by the NEA will thereby become a collaborator and active agent of governmental censorship.

An Interview with Barbara Kruger

W. J. T. Mitchell

MITCHELL: Could we begin by discussing the problem of public art?
When we spoke a few weeks ago, you expressed some uneasiness
with the notion of public art, and I wonder if you could expand on
that a bit.

KRUGER: Well, you yourself lodged it as the "problem" of public art and
I don't really find it problematic inasmuch as I really don't give it
very much thought. I think on a broader level I could say that my
"problem" is with categorization and naming: how does one consti-
tute art and how does one constitute a public? Sometimes I think
that if architecture is a slab of meat, then so-called public art is a
piece of garnish laying next to it. It has a kind of decorative func-
tion. Now I'm not saying that it always has to be that way—at all—
and I think perhaps that many of my colleagues are working to
change that now. But all too often, it seems the case.

MITCHELL: Do you think of your own art, insofar as it's engaged with
the commercial public sphere—that is, with advertising, publicity,
mass media, and other technologies for influencing a consumer
public—that it is automatically a form of public art? Or does it
stand in opposition to public art?

KRUGER: I have a question for you: what is a public sphere which is an
uncommercial public sphere?

MITCHELL: I'm thinking of a utopian notion such as Habermas's idea of
the liberal bourgeois sphere of the culture-debating public. You
may recall how he opposes that to a culture-consuming public,

Critical Inquiry 17 (Winter 1991)

which he thinks of as mainly consuming images and as being spectatorial. He contrasts it with the culture-debating public, which he associates with the literary.

KRUGER: I live and speak through a body which is constructed by moments which are formed by the velocity of power and money. So I don't see this division between what is commercial and what is not commercial. I see rather a broad, nonending flow of moments which are informed if not motored by exchange.

MITCHELL: But do you see yourself as "going with the flow," as they used to say, or intervening in it?

KRUGER: Again, I think that the word *oppositional* becomes problematized because it's binary. It has to do with anti's and pro's, or whatever, and basically I feel that there are many of us who are working to make certain displacements, certain changes, who are invested in questions rather than the surety of knowledge. And I think that those are the ways that we displace that flow a little or redirect it.

MITCHELL: When someone feels like they're either intervening or redirecting a flow like the circulation of capital or publicity, I want to ask what they have to push off against that allows them to swim upstream or to make eddies against the current. I realize we're speaking very figuratively here, but you're awfully good with figures. Is it a sense of solidarity—you said others are also engaged in doing this sort of thing, trying to disrupt the flow, intervene in the circuits in some way? Is it the fact that there are others that gives you some way of having leverage?

KRUGER: Yes, in that one hopes to make a space for another kind of viewer. But I think that there are those of us who don't see ourselves as guardians of culture. We hope for a place which allows for differences and tolerances. What we are doing is trying to construct another kind of spectator who has not yet been seen or heard.

MITCHELL: You mean a kind of innocent spectator, who hasn't been seduced yet?

KRUGER: Oh, no, I didn't say anything about innocence.

MITCHELL: You said it was someone who hasn't been approached yet?

KRUGER: No, I said someone who in fact has not had control over the devices of their own representation. Now to me that doesn't have anything to do with innocence. I'm not talking about discourses of innocence or morality or anything like that. I'm just saying that we

Barbara Kruger is an artist who works with words and pictures.
W. J. T. Mitchell, editor of *Critical Inquiry,* is Gaylord Donnelly Distinguished Professor of English and art at the University of Chicago.

have always been represented rather than tried to represent ourselves.

MITCHELL: Would you say the issue, then, is empowerment rather than innocence?

KRUGER: Well, the question certainly is one of the constructions of power and how they work and what perpetuates them and what trips them. Sure. Absolutely.

MITCHELL: Let me ask you another question more specifically directed at some of your own work. I noticed that a couple of your pieces at least, I'm sure more than two, have in a somewhat technical sense been works of public art—that is, they were not only in a public space, but they had some kind of support from a public agency and public funding. The one I'm thinking of specifically is the "We Don't Need Another Hero" billboard, which in one version—I think it may have been the Chicago version—it said "A Foster and Kleiser Public Service Message" along the bottom of it. Did you have control over that text, or was that part of the billboard company's . . . ?

KRUGER: Of what text?

MITCHELL: The "A Foster and Kleiser Public Service Message."

KRUGER: Oh, no, they just had that on the billboard. That was in California. And I was so *happy* that it was there, because it in fact puts these words in the mouths of this corporate group which I think is great! To see that sort of enterprise saying "we don't need another hero" is terrific! I wish that they would practice what they preach.

MITCHELL: Yes. "This is a public service message. This is not something that comes from the art world."

KRUGER: But it really isn't something that comes from the art world because I don't feel like I'm something that comes exclusively from the art world. And it basically is a line from a Tina Turner song from a Mad Max movie, and it's a plea to reexamine hierarchies, and I don't see it as coming from any vocational ghetto, one or the other.

MITCHELL: We started to talk last time about the Little Tokyo controversy which looks like a classic engagement in the public art battles of the eighties. It's recently been connected with previous controversies over unpopular works of public art. I wonder if you could say a little more about your point of view on that controversy, what you think it meant, and the way it has worked out for you.

KRUGER: I don't see it tied to any other so-called controversies around so-called public art because to me, the process was one of negotiation. I learned a lot from it, I really liked the people who I spoke to and spoke to me and we had a very generative exchange. I basically don't feel that I'm like some mediator between God and the public who comes into a space and has got an inspiration and that's it. To

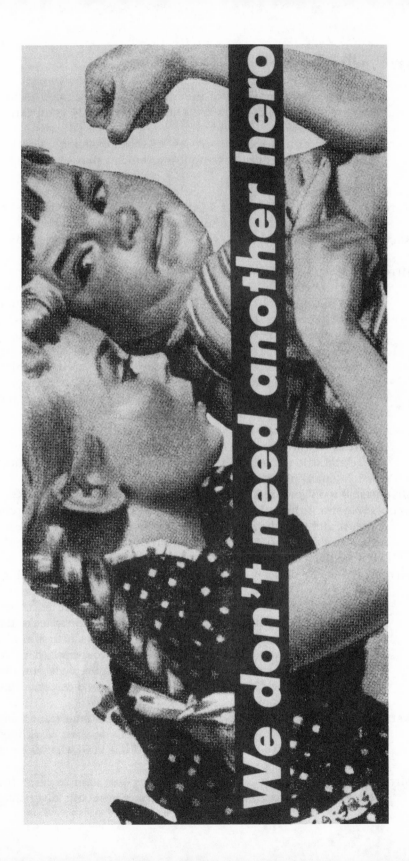

me, all my work comes out of the idea of a social relation. And I
hope that all my work—regardless of where it's seen—is an exten-
sion of that relation.

MITCHELL: So you think that the process of social exchange, political
negotiation, that went on around it is as much a part of the object
as the thing on the wall?

KRUGER: Sure. Absolutely.

MITCHELL: Let me switch tracks a little bit and move over to the art
world, a place you say you're not from, at least not exclusively.

KRUGER: Well, to say "from" . . . the only reason I said that is because
you said that "this message came from the art world."

MITCHELL: Much of your work seems quite capable of leaving the art
world if it ever felt it had to be there—that is, when I say "the art
world" I'm thinking of physical places like the gallery or museum.
Your work seems in some sense independent of that, it makes its
way in the larger sphere of publicity—billboards, bumper stickers,
postcards, and posters—yet it also seems, to use a loaded word,
"destined" to return to the gallery and museum. What do you think
is the effect of this kind of circuit, the circulation of your images—
or anybody else's images—between the spaces of the art object and
the spaces of publicity?

KRUGER: Well, I don't see them as separate spaces. I'm interested in
pictures and words because they have specific powers to define who
we are and who we aren't. And those pictures and words can func-
tion in as many places as possible.

MITCHELL: But do you think those spaces are undifferentiated or alike?

KRUGER: No, no, I think that they're different, that there are different
contexts and that the contexts themselves create different mean-
ings. I don't want to collapse the difference of those spaces *at all*,
but it would be nice to occupy as many of them as possible.

MITCHELL: I agree. It seems to me that one of the interesting things
about them is that as they move between these different places, it's
as if they pick up momentum from one place that might be carried
into another one, so that something that appears in the space of the
postcard, or the shopping bag, or the poster, looks at first as if it
belongs there but also doesn't belong there. Do you think that that
kind of double take of the image belonging to its place but also
looking like it came from somewhere else is . . . is that something
you're trying to achieve?

KRUGER: Yeah, that could be good. Basically, the most important thing
is that in order for these images and words to do their work they
have to catch the eye of the spectator. And one does what one can
to make that moment possible.

MITCHELL: Do you have any sense of how long you want to catch the
spectator's eye? One thing that always strikes me about advertising

is that there's a whole lot of imagery that's competing for attention. I suppose the measure of success is how it does in that competition and perhaps also how long the image stays with you, some kind of implantation in memory. Are those the sort of criteria that you're using? How do you decide when one of your images is successful?

KRUGER: Well, I really think the criteria change for different images, and certain images are successful in one site and not in another. For instance, there are pictures that I would choose to show in a more intimate gallery space that I wouldn't use as billboards, and . . . well the pictures that are on billboards usually work in both spaces, but I think it's important to realize who your audiences are. I also think that my work is a series of attempts, and some make it for some people and not for others.

MITCHELL: So your notion of success and failure is very much tied to the site, the audience, the particular context that it's addressed to.

KRUGER: Yeah, I don't think in those terms of "success" and "failure," as sort of chiseled somewhere in bronze or something. I think that there are some pieces which have really done their work and have pleased me and others, and that others have found totally ineffective.

MITCHELL: Can you exemplify that a bit for me? What works do you think of as most successful or least successful?

KRUGER: Oh, I can't say since the effectiveness of various works depends on the pleasures of various viewers, and I wouldn't want to make a declaration of "successes."

MITCHELL: What if I were to take a couple images that I think of as epitomizing what strikes me most and what at least I'm puzzled by or what doesn't arrest me, and try them on you?

KRUGER: Okay, but I should say, it's hard for me to talk about specific meanings in specific works because it creates a kind of closure that I'm really wary of. I like people to sort of generate their own meanings, too, and if I start naming, "Well this is what I meant here and this is . . . ," it's too tied to the conventions of a closed reading. But if you want to ask me some things in particular, I'll see how far I can go with it.

MITCHELL: Okay. This isn't so much a matter of meanings as a matter of affect.

KRUGER: Well, yeah, but what's one without the other?

MITCHELL: I don't know. These are the two images: one which I feel I don't understand yet, but it really strikes me and stays with me; and the other one . . . it isn't that it disappears for me, but I feel that perhaps I've exhausted it too quickly. The one that really strikes me and has kind of been haunting me for the last week is the last image in *Love for Sale*, "Remember Me." I told you I wasn't going to

Remember Me

give you an interpretation, but for some reason that image just strikes me and remains deposited indelibly in my memory. Now the other one I was looking at was "You Are Not Yourself," the shattered mirror with the logo "You Are Not Yourself." It's not that I forget the image but it's just that it somehow doesn't keep working. Partly, I guess, it's because I feel like the fragmentation of the image and the fragmentation of the words perhaps translate too easily for me, that there isn't enough resistance between word and image. Does any of this make sense to you?

KRUGER: Yeah, I just think that basically there are viewers for different images and certain viewers can decline that image. I've had much feedback on that second image. Not all of it, but a lot of it comes from women. It's a picture of a woman who's in front of the mirror. So, if in fact the so-called empathetic device in that piece is not sort of ringing your bell, I can certainly understand why. But it also doesn't mean that all identity is structured through gender, necessarily, I'm not saying that. But I'm saying that certain works speak more to certain people.

MITCHELL: Perhaps it's that identity for me isn't structured through a mirror. That that's just not my . . .

KRUGER: That's very interesting. What kind of enzyme are you lacking? That's terrific.

MITCHELL: I don't know. Could be that this is the missing gene.

KRUGER: Or some kind of weird Lacanian lapse and you missed the mirror stage.

MITCHELL: I passed right through it to something else.

KRUGER: I would venture to guess that many people heed their mirrors at least five times a day and that vigilance certainly can structure physical and psychic identity.

MITCHELL: One other image—and I apologize if this seems like a predictable question, but what the heck. The piece "You Invest in the Divinity of the Masterpiece," the Michelangelo creation scene, I take it, is a satire on the ideology of artistic genius, particularly in the trinity of Father, Son, and Michelangelo, suggesting the patriarchal succession of genius. The piece is now the property of the Museum of Modern Art, and I guess this is a question also about places that works occupy and what happens in that place. Do you think in this case the piece is undermined by the place it occupies, or does it undermine the place?

KRUGER: Neither. I think the binary form of *either/or* is not a necessary handle.

MITCHELL: Then my question is, is there a third way of seeing this which is better than those two alternatives?

KRUGER: Oh, well there are thirds, fourths, and fifths for sure. I wouldn't be that deluded as to think that I'm going to undermine

You invest in the

divinity

of the masterpiece

the power of the trustees of the Museum of Modern Art. I basically *knew* when that piece was sold that it was sold to MOMA and luckily the curator who was working there *knew* how much it meant to me, that that work, of the works that they were looking at, be the one that they should have. It seems to me that very seldom does one have a chance to address the power relations of an institution from within that institution in that way. Ironically, the second time was when I curated the show "Picturing Greatness," also at MOMA. To me, life is far more complex than either being pure or co-opted. I don't think anyone exists outside the gravitational pull of power and exchange. I believe that we can be effective when we come to terms with concrete social realities rather than a deluded sense of utopianism. So I'm very *pleased* that the work is there, I'm very *pleased* that people come to museums, and I'm *convinced* that a lot of people, if not most people, who go to museums don't know why they're there, except this strange need to affiliate with what they think is high-class "culcha." I don't go to museums very much, but every time I go I remember the kind of staging ground for power that they can be. I would be only too happy to—I'd love to—be in there to make other assertions and to plant some doubts and ask some questions. Absolutely.

MITCHELL: You said before that no one is completely outside the market, the circuit of exchange. On the other side, would you say that no one is completely inside of it?

KRUGER: No, I wouldn't say that. Again because I think that there are more than two ways to look at this, and it's not just the old "in and out." So, no I wouldn't say that. I'd say that all of us in some way—and this is not to collapse differences of nationhood and differences of culture—I definitely think that we are all touched by the constructions of exchange. Yeah, absolutely.

MITCHELL: But do you think we're determined by them? Completely?

KRUGER: To some degree, yes. I can't say what percentage, but of course, sure.

MITCHELL: Can I ask you some questions about pictures and words? I wanted to ask you first whether you have a sense of traditional functions or characteristic roles played by word and image that you are trying to work against. If you want I'll elaborate that, or I'll just stop and let you . . .

KRUGER: Okay, elaborate.

MITCHELL: Elaborate. Okay. Kate Linker, in her introduction to *Love For Sale*, says that your pictures entice and your words accost, and that seemed like a handy formula.

KRUGER: Sometimes it could be the opposite, too. There is no recipe. At times it is just as Kate has written it. Yes, that is very true. But I think it needn't always be that way.

MITCHELL: In your book, you also talked about one of the dialectics of your work being the attempt to bring together the ingratiation of wishful thinking with the criticality of knowing better. Do you think that those two functions—which seem dialectically related: one perhaps involved with the kind of thing that Linker means when she talks about "enticement," that is ingratiation; the other one with criticality—that the composite form of word and image lends itself to the playing-off as contrary messages in that way?

KRUGER: I think it can, but I think that there are so many different kinds of playings-off. I think it's easy to be witty with pictures, and be seductive with pictures and words, and all that is very nice. But I think that it's important for me to somehow, through a collection of words and images, to somehow try to picture—or objectify, or visualize—how it might feel sometimes to be alive today. That's what my work, hopefully, is about, to some degree.

MITCHELL: Let me put the image-word relation in terms of gender, or ask you to do that. Do you have a sense of . . . here you have a semiotic opposition with word and image, and you're also very concerned with the general problem of difference and with the specific difference inscribed in gender. Could you say something about how word and image—how that difference—plays against gender difference?

KRUGER: Plays against gender difference?

MITCHELL: Or plays on it.

KRUGER: No, I don't think that there is a particular methodology that sort of operates across the board. No, not really. Do you want to maybe rephrase that?

MITCHELL: Well, for instance, one of the things I notice about your representations of women is that they often involve the text as a female speaker. It sounds as if the implied "I" is female and the addressee is male. This looks to me like a deliberate going against the grain of certain traditional ways of organizing words and images. I don't need to tell you that little girls are brought up to think of themselves as things to be looked at. You can go back to the Old Testament to find sentiments like "a silent woman is the gift of God."

KRUGER: Oh, let me write that down.

MITCHELL: So, what I'm asking is, do you think that the media themselves come with traditional codes and associations?

KRUGER: I don't think that they're encoded in a *specific* way all the time. I think that frequently people think that there are conspiracies of admittance, and in fact it's not. It's just that people are socialized in cultures in specific ways, and they take that socialization into their lives, and into their jobs, and into their successes, and into their failures. Of course. So there have been stereotypes, and as Barthes

said, the stereotype exists where the body is absent. When that embodiment—not just in a literal sense of embodiment—but when that which is embodied, or lives, is no longer there, there is a rampant sort of rushing-in of caricature and stereotype and repetition. Of course.

MITCHELL: Is part of the agenda of your images, then, to re-embody, or to restore the body to these stereotypes?

KRUGER: Yeah—and I hate to get to you on these words, but I wouldn't call it an agenda—but I would say that I am interested in sort of, in not just displacing and questioning stereotypes—of course I'm interested in that—but I also think that stereotype is a very powerful form and that stereotype sort of lives and grows off of that which was true, but since the body is absent, it can no longer be proven. It becomes a trace which cannot be removed. Stereotype functions like a stain. It becomes a memory of the body on a certain level, and it's very problematic. But I think that when we "smash" those stereotypes, we have to make sure and think hard about what we're replacing them with and if they should be replaced.

MITCHELL: If stereotypes are stains, what is the bleach?

KRUGER: Well, I wouldn't say that there is a recipe, and I wouldn't say "bleach." Bleach is something which is so encoded in this racist culture that the notion of whitening as an antidote is something that should be avoided.

MITCHELL: So you just want to stop with the stain.

KRUGER: I don't want to get things whiter. If anything, I would hope when I say that basically to create new spectators with new meanings, I would hope to be speaking for spectators who are women, and hopefully colleagues of mine who are spectators and people of color. Now that doesn't mean that women and people of color can't create horrendous stereotypes also. Of course they can. But hopefully one who has had one's spirit tread upon can remember not to tread upon the spirit of others.

MITCHELL: Most of your work with the problem of difference has focused on gender. Are you interested in or working on problems with ethnicity, since that certainly involves a whole other problematic of embodiment?

KRUGER: Well, I think about that all the time. I think about it in terms of race, and culture. I think about it when I teach. I think about it in a series of posters that I do and of projects for public spaces, but I also—unlike a number of artists—feel very uncomfortable and do not want to speak for another. I basically feel that now is the time for people of color to do work which represents their experience, and I support that, and have written about that work as a writer, but do not want to speak for others. I basically feel that

right now people of color can do a better job of representing themselves than white people can of representing them. It's about time.

MITCHELL: Let me just take one further step with the problem of word and image, and try to tie it back into the issue of public art. I'm interested in the combining of words and images in the art of publicity and in traditional public art, the old-fashioned monument. Let me just give you a little background on what I'm thinking here. The traditional public art, say, of the nineteenth century, is supposed to have been universally readable, or at least it's often invoked that way, as something that the whole public could relate to. Everybody knows what the Statue of Liberty was supposed to mean, what it "says." When modern works of public art are criticized, they're often characterized as "unreadable" in contrast to traditional works which were supposedly universally popular. The modernist monument seems to be a kind of private symbol which has been inserted into the public space, as I think you said, the garnish next to the roast beef. So it looks as if modernism kept the monument in terms of its scale, and egotism, and its placement in a public site, but it eliminated the public access to meaning. This is all a kind of complicated preamble to asking whether it might be possible that word-image composite work—especially coming out of the sphere of advertising and commercial publicity— might make possible a new kind of public art. I know this is to bring you back to something you said you're not terribly in love with, or you have some problem with, the whole issue of public art. But, does this question make sense to you?

KRUGER: Yeah, I think that there is an accessibility to pictures and words that we have learned to read very fluently through advertising and through the technological development of photography and film and video. Obviously. But that's not the same as really making meanings, because film, and, well, television, really, and advertising—even though it wants to do the opposite—let's just talk about television—it's basically not about making meaning. It's about dissolving meaning. To reach out and touch a very relaxed, numbed-out, vegged-out viewer. Although we are always hearing about access to information, more cable stations than ever, But it's not about the specificity of information, about notions of history, about how life was lived, or even how it's lived now. It's about another kind of space. It's about, as Baudrillard has said, "the space of fascination," rather than the space of reading. "Fascinating" in the way that Barthes says that stupidity is fascinating. It's this sort of incredible moment which sort of rivets us through its constancy, through its unreadability because it's not made to be read or seen, or really it's made to be seen but not watched. I think that we can use the fluency of that form and its ability to ingratiate,

but perhaps also try to create meanings, too. Not just re-create the spectacle formally, but to take the formalities of the spectacle and put some meaning into it. Not just make a statement about the dispersion of meaning, but make it meaningful.

MITCHELL: That's what I was hoping you were going to say. My next question was whether you feel there's still some place for the unreadable image or object (which I've always thought of as one of the modernist canons: the idea that an image has mystery and aura and can't be deciphered).

KRUGER: But that's not what I'm saying. That is *not* what I'm saying.

MITCHELL: You're speaking of another kind of unreadability.

KRUGER: I'm not saying that something should be unreadable. I'm saying that it should be *readable*, but it should suggest different meanings or that it should give a meaning. I'm saying that what we have now is about meaninglessness, through its familiarity, accessibility, not through its obscurity. Whereas modernism, or what I take it to be (you've used the word), was meaningless to people because of its inaccessibility. What the media have done today is make a thing meaningless through its accessibility. And what I'm interested in is taking that accessibility and making meaning. I'm interested in dealing with complexity, yes. But not necessarily to the end of any romance with the obscure.

MITCHELL: There was one other question I wanted to ask you, and that's about interviews. The old idea about artists was that they weren't supposed to give interviews. The work was supposed to speak for itself. How do you feel about interviews?

KRUGER: I think that the work does speak for itself to some degree—absolutely. But I also feel that we're living in a time when an artist does not have to be interpreted by others. Artists can "have" words. So it's not like I think I'm going to blow my cover if I open my mouth.

MITCHELL: Well, you certainly haven't blown your cover today.

Fine Furs

David Antin

Let me begin with a simple memory. I was sitting in my dining room having a cup of coffee in the early afternoon before going off to meet somebody at the university; and I remembered, probably because my dining room faces west and looks toward the water, and because the sun was coming in through the window, a summer a long time ago—I was probably five—and sitting on the beach in New York at Rockaway, when a small biplane appeared over the water and began a series of climbs and turns and rolls, emitting a white trail that gradually turned into a sequence of furry letters that slowly spelled out the message

I. J. FOX
FINE FURS

I had just learned how to read and I read it slowly. And while I thought it was wonderful for the fox to write with such fine furry letters, I was a little irritated with the fox, who I thought was very stuck up to brag like that, no matter how fine his furs, because in my reading it was this J. Fox who was bragging about his fur, which I imagined was as white as the letters that spelled out his name, and it took me a little while before I realized that it was not the fox who had authored the message, but someone who made a business of skinning foxes and providing their furs to wealthy ladies at a price.

But my image of those beautiful white letters, formed so elegantly by

Critical Inquiry 19 (Autumn 1992)

the plane and over such a long time, that I had to wait to find out what the words were, and had to remember them as they began to disappear—by the time it said FURS, FOX had begun to blur and the "I" had begun to vanish—my sense of sitting on the beach in the bright light of a clear blue sky, and the new pleasure of reading, gave me such a physical experience of the act of reading that I thought it would be nice to do a poem that way, a skypoem. So being reasonably practical I went to the yellow pages and I started looking to see all the people who do skywriting.

But times had changed. There weren't all those people who did sky-writing. In fact there was nobody in the San Diego or Los Angeles yellow pages who did skywriting. There were people listed who did aerial adver-tising by dragging signs and banners across the sky, but nobody who did any writing. So I started to call the local airports. It took a lot of time and a lot of calls, but I found out from somebody at the Santa Monica airport

David Antin is a poet, critic, and performance artist. His critical, speculative, and narrative talk performances have been published in two volumes of "talk pieces," and a third, *what it means to be avant-garde,* will be published in 1993. He is also a professor of visual arts at the University of California, San Diego.

that there was a group located in the Cypress area who used to do it around Los Angeles, but he thought they were lying low because they were in a bit of trouble with the FAA. He gave me a name and a phone number, and it turned out that this group, called Skytypers, could do sky-writing or, more accurately, skytyping, because they used five planes and a dot matrix method with a computerized program in which the five planes flew straight across the sky in formation at an altitude of about ten thousand feet, each plane putting up part of each letter.

When I finally reached them, or they reached me, because I got only an answerphone and they had to call back, I told this guy, "I'm interested in putting some words up in the sky." He said, "That's all right. I do advertisements all the time." I said, "No, that's not it. I want to put up a poem. In the sky." And he said, "As long as it's not too long or obscene you can do it." I said, "That's not going to be the problem. It won't be too long and it won't be obscene. I'm not specially interested at the moment in writing erotic poetry in the sky." So he asked me, "What made you think of it?" and I started to tell him about I. J. FOX, and he said, "FINE FURS. That was my father." I said, "Oh? It was your father?" He said, "Yeah, in fact I was doing it a few years later when my father got tired of it. I was sixteen years old and I couldn't get a driver's license in New York, and my mother used to drive me out to the airport so I could fly this plane over the beach to write COCA COLA."

So Gregg Stinis and I had a kind of sentimental connection, and he gave me a very cheap price. He said, "If you want me to print your message on a day that I know I'm going to be in the air, you can have it for $650 a line. If I have to commit to a date without knowing that, it'll be a bit more." "Well," I asked, "can I specify the time?" He said, "You can specify the time. But I can't be responsible for any time when the sky is overcast, because everything is written in water vapor and that's what the clouds are made of. Water vapor doesn't show against water vapor." "So what happens then?" "We do it for you the next day at the same price."

As it turned out, there were other limitations. There are always limitations. He told me I could have eighteen to twenty-three letters to a line, no more. Twenty-three letters if you don't use *M* or *W*. *M*s and *W*s count as two. This is one of the great formal properties of skypoems; and a three-line poem consisting of eighteen letters to a line, or twenty-three if you don't use *M* or *W*, becomes a little bit harder than a haiku if you're trying to write idiomatic English. Because letters are much less natural to English than syllables are to Japanese.

So then I had this dream of an epic poem stretching across the United States over twenty or thirty years, three or four lines a year—at two thousand bucks a shot—gradually being written for people who would never see all of it. Which didn't bother me in the least. Partly because I'm not such a public-spirited citizen, or maybe because I have no very clear idea of what a public is. Though I suspect from the way it's usually treated by

the people who appear to perform in its interest that the public must be a disadvantaged and somewhat retarded part of our population.

But more specifically, I have a somewhat looser idea of the relations between writing and reading. I was counting on a certain randomness of interest among the onlookers. Some would know about the skypoem in advance and come to a central viewing place where they'd be waiting for it, because they'd read about it or been invited. Some might drift in when they saw the others gathering. Some might happen to be looking up while they were walking on the beach or driving on the highway. Some might pick it up in the middle or at the end, and some might leave before the end because they had to or because they didn't care to stay. And I liked it that way. I have a certain attraction to more or less democratic artworks that don't coerce your attention because they respect your independence—or maybe they're aristocratic because they're indifferent to your existence. But I wanted to do a poem that was outside of a book, and outside the range of the poetry magazine or small press distribution.

I have an extraordinarily prestigious publisher, who believes that the publication of books is a hermetic activity, and he manages to hide our books with great care, valuing them and protecting them. He's a lovely man, a poet himself, Jay Laughlin of New Directions. But a skypoem is put up at an altitude of ten thousand feet. Each letter is twelve hundred feet high, each line is five and a half miles long and can be seen over an area of three hundred square miles from the ground. So I thought it would be nice to do a skypoem, because I had my image of that sitting on the beach pleasure, and I thought I would offer it to people with a text that would keep changing while it was disappearing.

I had a text in mind—a beginning text for my micromonumental epic poem. It took me a long time to develop it. It didn't come right away. I needed a line that would keep changing its sense from phrase to phrase. I knew that it would take two to two and a half minutes to put up each line, and I wanted to stretch out that time—the time between lines, but also the time between changes. So I inserted a blank space one word long at the end of each phrase.

IF WE GET IT TOGETHER

which took a couple of minutes to put up. And then because I wanted the line to disappear, I arranged to be in radio contact with the planes from the ground so I could tell them, "Don't come back yet!" and they would make a long pass to the north, from which they couldn't see the line anymore, till I saw the line disappear and called them back to start the next phrase right below where the first one had been

CAN THEY TAKE IT APART

after which they'd go away and I'd wait for that line to disappear so I could
call them back to finish up with

OR ONLY IF WE LET THEM

The poem was essentially aimed to offer the pleasures of reading to
whoever cared. I remember they asked me on a television program after
the second one of these skypoems, which I did for the La Jolla Museum on
Labor Day a year later—they had me on one of these daytime television
programs where a sprightly blonde lady and a sprightly blonde man ask
you sprightly questions in a television manner—and they said to me, "You
put up a poem in the air. What's a poem?" So I thought for a moment and I
said, "A poem's a commercial that isn't selling anything." "Okay," they
said, "how much did it cost?"

Now because it was four lines long and because of the complications
involved in booking my Skytypers for Labor Day, and the cost to the
museum for publicity and a mailing, the expenses finally came to some-
what less than ten thousand dollars for the whole art event. Which I told
them. And they said, "That's very expensive." I said, "Well it's expensive
as poems go, but it's cheap as public artworks go—if you think of some-
thing like Serra's *Tilted Arc.* But think of it this way—if an artwork is
discursive—if an artwork is some kind of talk—the nice thing about this
one is it goes away fast, if you don't like it. And if you do like it, you
remember it. But it takes an awful lot of energy to get rid of *Tilted Arc.*"

One of the interesting difficulties of discursive artworks is that if they
are protected as free speech, they will become the first forms of free
speech that could violate zoning ordinances. And that's a rather odd
issue—because the durative property of speech is not related to its discur-
sive significance, or more bluntly, discourse is biodegradeable in mind.
And most things that people call public art objects won't go away. Which is
unfortunate. Because often you want to take a look at them and send them
on their way after they've used up their meaningfulness.

But this is difficult, because often their meaningfulness is exhausted
very quickly. In ten minutes? I have often thought that the typical art look
since the 1960s was the ten-second glance. It seems to have been devel-
oped by most of the pop artists and minimalists, and I don't think I've ever
seen anybody standing in front of a seventies or eighties work for forty-
five minutes the way we probably all remember standing in front of a
painting or sculpture in the Museum of Modern Art in our childhood. But
maybe there are such anachronisms and there are a few people who might
look at a contemporary artwork for forty-five minutes. Though I believe
it would be somewhat more likely for them to think of it for forty-five min-
utes, however unlikely that might be. But looking at it for forty-five min-

utes seems somewhat dubious—unless what they're looking at is a performance piece that happens to last just forty-five minutes.

Now I didn't know how to get this funded. I didn't want to lay out two thousand dollars, and I was doing another public artwork on a radio station in Los Angeles. All radio is in a sense public. Airwaves are public. They have been temporarily surrendered to private companies in the interest of the public by our government, which always acts in our interest. And because these private companies do things that are in the public interest from time to time, they are given control of pathways of definite size through this partitioned public airspace, that they are allowed to treat as toll roads, which are commonly known as stations or channels. These companies then control all transmission over these roads, which are in that sense not public, but this transmission over them can be received by anyone with an appropriate receiver, so that the reception is in fact public. And the nature of this one-way traffic from the private and privileged company to the passive and underprivileged consumer may have gone a long way toward defining the public as an underdeveloped and incapable entity consisting of a collection of more or less isolated needy individuals.

Now this was a station that acted somewhat more in the interest of the public in Los Angeles than many. It was a listener-funded one, KPFK, and was therefore funded fairly directly by its own public. And I was offered the opportunity undemocratically to do an artwork over its airwaves. There was no board of supervisors, no selection committee. Jackie Apple said, "David, would you like to do an artwork for radio?" I said, "Sure, when is it?" She gave me a date, and I prepared a piece to go out over the airwaves. And it was a talk piece of sorts. Part of it was prerecorded in a complicated way, and part of it was an improvisation that I undertook to interact with the recorded part, and it all went out live over the radio. And the whole piece was rather complicated to arrange. So we spent a lot of time up there in Los Angeles working it out. During a lunchbreak Jackie asked me about my plans for new work and I happened to mention my idea for a skypoem. She said, "Why don't you call up Henry Korn?" who was then the director of the Santa Monica Arts Commission. I called up Henry Korn, and Henry Korn said, "What a great idea! You think you can do it on Decoration Day?" He happened to have two thousand dollars and an open slot for an artwork on Decoration Day, so it got done.

This is the only way I have ever gotten a public artwork done. Some benevolent despot happens to be in power, and has two or three or ten thousand dollars to spend, or the amount of money you need. He likes your plan. He isn't afraid you're going to rape the public, and he tells you to go ahead. That's the way I got to do the radio piece for KPFK. Jackie Apple was producing a series of performance pieces with Astro Artz, the publishers of *High Performance* magazine, together with KPFK in Los Angeles. She asked me for a work, I said okay and did it. In this kind of sit-

uation the only kind of thing that can stop you is some kind of technical problem like a power failure or forest fire.

We had a forest fire over the Cleveland National Forest when we were putting up the skypoem over San Diego. The planes were based in Palm Springs and had difficulty coming in. They were flying through great clouds of smoke, and had difficulty believing they were going to put the piece up. But we were on the ground in the parking lot of the La Jolla Museum, and we kept assuring them by radio that the sky was clear over La Jolla and they would be able to put the poem up. But when they got there, about half an hour late, the computer in one of the planes went down, and the pilot had to release his water vapor with a handswitch on timings called out over the radio from the lead plane by Gregg, who was acting as flight commander. And the poem still went up, though I realized there were a few fragile aspects to this kind of work.

The next time I had the resources to do a poem like this, Gregg and his fliers were negotiating with the Olympics, and the Olympic committee had a lot more money than we did. So I lost my Skytypers to Korea. But though there were serious problems, this was the nearly ideal public artwork for me. If people didn't like it, it went away. If the money was available and the weather was all right, nobody worried about what I was going to do. Except Gregg. He said, "Send me the words." I sent him the words. He said, "Okay. I don't know what it means. It's fine."

But I've also been involved in several public artworks of another kind. In the spring of 1985 an art person—Pat Fuller—called me on the telephone. At that time she was living in North Carolina and working as a consultant to the Art in Public Places program of Miami, and she said to me, "David, how would you like to write a proposal for a public artwork in an airport?" They were inviting some good people—Nam June Paik, Max Neuhaus, Robert Irwin, and a few others, all of whom I knew. So I said I would think about it, and if I could think of anything that made sense to me, I would submit a proposal.

Now as I reflected on my experience of airports, the one thing I remembered most intensely was all the time you spend waiting around with nothing to do. Or maybe you have a lot to do, but it's hard to do it, because you're waiting for something or someone, for how long you don't really know, and you have to continually look up or listen to catch some sudden appearance or muffled instruction that won't let you settle down in this airless, poorly lit space filled with other people intermittently wandering or rushing about or distractedly waiting around just like you. So I thought I would try to design something for all of those people waiting around.

What I imagined was a large monitor or lightboard in a part of the terminal where people had lots of time to kill, on which I would run an uncut newswire—the kind the newspapers get to cull their stories from by radical shortening and revision—which I would randomly interrupt with

segments of my kind of poetry, a more or less colloquial mix of stories, one-liners, and aphorisms, sometimes in English sometimes Spanish, because this was Miami International Airport. And my idea was that the news was something like an airport. Predictable in general and surprising in detail. *There is an earthquake in Turkey. Japanese workers want more leisure time. Black people are killed in South Africa. Drought keeps people from watering lawns in Southern California. Traffic accidents ruin holidays in France.* Reported in a language that's always the same, spoken by nobody and seemingly generated by a kind of reporting machine.

So I proposed to break into this linguistic nonspace with intermittent samples of a more personal language, to try to establish a temporary human space in this dislocated transition zone. I wrote up the proposal and sent it off to Miami. In mid-July I got a letter from Cesar Trasobares, the Executive Director of Art in Public Places of Dade County, inviting me to participate "in an open-ended, forward-looking process to place art in an airport setting," and informing me I was one of a group of four artists who had been chosen by a selection panel of three curators, who had recommended us to nine advisors, two Art-in-Public-Places trust liaisons, and three staff members in a meeting that took place under the eyes of three observers. The selection panel's recommendations had been accepted and I was invited to come to Miami to tour the site.

In September I flew to Miami and was taken around by Cesar and Antolin, a couple of courtly Cuban professionals, to meet some of the program's administrators and to a marvellous Cuban restaurant for lunch. I got myself installed in the airport motel, where it seems I spent most of my days prowling around the endless terminals and lobbies or hanging around the motel coffee shop, eavesdropping on the conversations of sleek-looking Latin businessmen, gun runners, counterrevolutionaries, and dope dealers and their splendidly painted girlfriends or wives, when I wasn't going to meetings with administrators or wandering around downtown Miami, while I waited to meet with the airport director. According to my gentle Cubans, Richard Judy was an impatient corporate dragon who made the final decisions on everything. They said he was very busy and they warned me to be brief.

He turned out to be your standard Anglo corporate executive. He shook my hand and came right to the point. "So what do you want to do in our airport?"

"I want to put up a newswire on a few of your signboards and interrupt it from time to time with some stories and jokes that I'll write in English and Spanish."

"Sounds okay to me," he said, and our meeting was over.

But Cesar told me that they were going to need a more elaborate statement of my plans. So I flew back home and wrote up as detailed an account as I could, considering that I didn't have the slightest idea of what kind of text I was going to write or how I was going to manage the interac-

tion of my material with the newswire, where I wanted to put the electronic signboards, what kind of signboards I needed or where I could get them. At the end of January, Cesar told me they had approved my plans and they were preparing a contract. When it arrived, it was a contract for a proposal that required a three-dimensional model, drawings, and a budget, which I was supposed to have completed by July, although this was the middle of May. The contract had been sitting in the Dade County lawyers' offices since January.

So my work started in July 1986. First I had to find a wire service that would rent us their lines and let me interrupt their text with mine. Then I could deal with the control system and the display. Working through the barriers of the AP's initial suspicions about my text—it would be obscene, outrageous, slanderous—I finally convinced Susan Burgstiner, their marketing manager, that it would be okay. This took me to February of 1987. She turned me on to Tim Fitzpatrick, who ran a software company named EPI in Minnesota, and by May 1987 we had a prototype system pretty well thought out.

The prototype was going to require two computers, a small LED signboard, and three controlling devices: a filter module designed to "listen" to the AP stories, take off their headers, maybe reject long strings of stock market quotations and do some buffering—store up news stories to supply from its memory if the AP wire were to crash; a scheduler module to read a schedule control file that I would design to set and vary the pace and scale of the feed of my material into the AP news text, and a remote control module that would let somebody seated at a remote PC at a remote site update the poem text and the schedule control file, and from time to time call for a phone signal from the controller PC to make sure that the system was working. Not counting the cost of the AP newswire— about nine hundred dollars a month—or the phone lines, or my own expenses, the hardware and software for the complete development of this model came to something around twenty thousand dollars.

I sent a detailed account of the plan and a budget to the Art in Public Places Offices at the end of May 1987, and some time in the fall I got a letter from them asking me also to give them a precise proposal for the final installation in the airport. Working with Fitzpatrick by telephone, I was able to get this done by January 1988, and Cesar seemed pretty happy with it. Happy enough to send me the rest of my artist's fee for the proposal, and in March they sent me a draft of a new contract for development of the prototype and told me to check it out with my lawyer.

The contract seemed all right but was slightly weird. First it misstated the amount of money I had already been paid—"Whereas, the Art in Public Places Trust has paid the Artist $12000." They'd paid me ten thousand dollars. Second, it suggested that the people down there had no idea what the artwork was, because the contract read, "Whereas, the computer technology comprising the artwork requires the Artist to further develop his

design." This was nonsense. The computer technology didn't "comprise the artwork"; it was merely a support for the work's existence.

Then a new element appeared in the contract. During the course of my negotiations with Miami, Robert Irwin had apparently escalated himself out of the ranks of us project artists to "Master Planner" for the disposition of all the artworks in the airport. In the words of the contract, "'Master Planner' means Robert Irwin." The contract went on to specify that "Whereas the Artist has been apprised of Robert Irwin's Master Plan for the Miami International Airport." I hadn't seen anything I would have called a master plan, only an elaborate commentary Robert had made on the South Florida environment and Miami, and on some of the artistic possibilities of the airport, which he'd asked me to look over. This didn't look like a problem, although the contract required that I select a site for my work in consultation with airport officials, Robert Irwin, and the Art in Public Places staff because the only logical sites were fairly obvious—the places where people had to hang around with lots of time to kill. And finally the contract stated reassuringly that "the Artist's initial proposal submission has been reviewed and recommended for design development by a panel of the Trust's Advisory Committee." In late March I gave the contract to a lawyer to clean up a few minor absurdities and by April I heard from Miami that the project had been killed.

Now I don't really know why it was killed. I made a lot of phone calls and sent a lot of letters, but I never got to talk to my amiable Cuban friend again, although he was still the director of the program. An entirely new young woman named Mary suddenly appeared to handle all communications with me, and from her I learned about a variety of new problems. The costs seemed to be unanticipatedly high for the prototype. The advisory committee wasn't sure that something similar hadn't been done before. Some of its members were worried that interference with the news of the day might prove disturbing to some constituencies among the airport travellers.

I wrote letters reclarifying the work and its intentions. I offered to come out and meet personally with everyone concerned, to explain what I was doing and why it was distinctive. Why it cost this much. But it was all to no point. It was against procedural rules for artists to talk to the committee. My letters went unanswered. At length I was told that a new advisory committee had come into being, reviewed my plan and decided it was an excellent work for an art gallery but not for an airport. Later I heard that all the other airport projects, including Robert Irwin's master plan, had also been junked. Finally and somewhat indirectly, I heard from friends in Miami that the whole Miami Art in Public Places program was swamped in financial problems and had gone on hold.

Now I have no complaints—at least not personal ones. I was well paid, though not exorbitantly, if you consider the amount of time I spent on the project. But I really would have liked to see the work go up in the airport. I

would have liked to make annual updates of my poetic texts. I could have been the first poet in the world to have a maintenance contract with an airport. But mostly I felt sorry for the people who had helped me—for Tim Fitzpatrick out in Minnesota, who had already put in so much time working out the software design with me, for Susan Burgstiner at AP, who probably went out on a limb for me with their bureaucracy to let a poet mess with their newswire, and for all the weary travellers waiting for planes out of Miami who could have had something more amusing to do than eat junk food or work out their expense accounts or get ink all over their hands and eyestrain from reading over and over again their already outdated newspapers. But instead it evaporated like a dry ice sculpture.

Now it's possible that this whole thing was about money, but I don't think so. Twenty, thirty thousand dollars, though a considerable amount of money to a human being, is small change to an airport. And no one asked if there was a possibility of reducing the costs in any event. But there was one aspect of the project that was probably related to its failure. It wasn't the scale. The skypoems were much larger. It was the duration. My newspoem was as near to a permanent installation as anything imaginable. It could have gone on for years, for as long as the Miami International Airport lasted, as long as the AP wire continued to transmit and phone company lines persisted in working. Skypoems are gone in twenty minutes. And this is the major point of most of the issues surrounding so-called public art. Permanence.

Nobody knows who the public is or what it wants or needs. Or whether it should be considered singular or plural. Though there are many people claiming to act on its behalf or speak in its name. And no one is quite sure what space belongs to it or to them, though that usually seems to be only what's left over when all of the other spaces have been appropriated, walled, shut, fenced, or screened off by whatever groups or individuals can enforce private claims to them. So what we are left with are discards and transition spaces, spaces for a kind of temporary and idle occupation like lounging, strolling, and hanging around—streets, squares, parks, beaches, bus stops, subway stations, railroad and airport terminals. And since all of these have been increasingly encroached upon and restricted by various authorities in the urban renewal and spread of the suburban mall culture of the last twenty years, the idea of permanent appropriation of yet more of this common space by an artwork seems to be of great moment, and seriously debatable by all the constituencies who might desire access to that space or lay claim to it, or by all the people who can claim to speak for them. So the issue is permanent appropriation of space. Once something is going to be permanent everybody cares about it.

This issue becomes even more pressing for a contemporary art world embedded in a society that smothers discourse under an avalanche of indestructible and trashy objects, to which it responds by laying more weight on the discursive properties of artworks than on their objectlike

status, or at least on the discourses implied by the nature and structure of these art objects. So it becomes reasonable to consider artworks a kind of speech, and to protect them with all the freedom of speech. But then they become the first examples of speech that can collect dust, block traffic, and violate zoning ordinances, as well as the sensibilities of some constituency that will surely appear, or will appear to appear, as soon as the work takes its place in one of these contested spaces.

So to mute this contest before it occurs, to prevent the placement in public space of any artwork that could conceivably give offense to anyone, an army of bureaucrats is usually placed securely around it, whose nominal job is to protect the space, but whose eventual concern is to protect themselves. Because the basic form of American bureaucracy is to cover your ass. And you cover your ass with paper, and you paper people to death. And everybody papers everybody else to death, because everybody is afraid of being held responsible for doing something that might disturb somebody.

We would probably have very much better public art if everybody wasn't afraid of disturbing people, because they knew you could eventually wheel the art away. I would like to suggest that you could make the most disturbing public art in the world and nobody would give a damn, because you would know that after some limited time it would go away. The way all good discourse goes away. I don't think public art installations should be permanent. I think they should be wreckable. I think we should have a ceremony of destruction and remove them regularly. I think works like Serra's work should after some specifically limited time have been publically destroyed in an honorable fashion. Honoring its creator in a ritual fashion. This ritual would not have meant that the work was bad, but that it had said what it had to say. In this sense I believe that the court was right. There was no reason for Serra to iterate his single utterance forever. Perhaps the right to repeat yourself endlessly in a given space is not freedom of speech. It may become a form of tyranny.

On the other hand some of the most effective public artworks I've ever seen—like Suzanne Lacy's "Whisper Project"—went away. And one of the great things about artworks that go away is they remain in your mind. And you can use them. They can become part of other artworks. While if they clutter up the space, you eventually have insufficient space to put up anything else. So from my point of view removal is a greater problem than preservation.

This is one of the greatest problems of architecture. How to get rid of buildings economically and efficiently that no longer serve their own or any useful purpose and are choking up our streets. And in view of the buildings that have been going up for the last ten to twenty years in the United States the problem is becoming calamitous. A number of years ago I gave a talk on this subject at an architecture school; and it wasn't very popular then, but perhaps its time has come. I suggested that the problem

of architecture is not how to make it, but how to get rid of it. The biggest problem in our cities is destroying no longer useful buildings—discarded shopping malls, useless high rises. My solution was soluble architecture— buildings provided with a plumbing system into which you could drop catalytic pills that would cause them to dissolve and run out through their own pipes into the sewer where they belong.

Index

Figures indicated by boldface.